First published in the UK in 2013 by
Apple Press
7 Greenland Street
London NW1 0ND
United Kingdom
www.apple-press.com

Amazing New Looks
and Inspiration from the
Top Celebrity Makeup Artist

Face to Face

SCOTT BARNES

with Alyssa Giacobbe

APPLE

contents

foreword by kim kardashian

SCOTT AND I FIRST MET FIVE YEARS AGO, over dinner in Los Angeles with some mutual friends. If you know me, you know that I'm a total beauty fanatic. It's pretty much an obsession. I love everything about it: the lashes, the shimmer, the glamour as a whole. I love sitting in an artist's chair and just letting them do their thing; I could literally enjoy that experience every single day. I used to dream of becoming a makeup artist—still do, actually! After a photo shoot, I know so many people in my business who'll just wipe off their makeup and go home. What a waste! I'll keep my makeup on as long as I can, until it doesn't look good anymore.

So of course I knew who Scott was. I had admired him from afar for his work with Jennifer Lopez and other gorgeous women. Still, I had no idea just how far his talent extended until I had the chance to sit in his chair myself. At that dinner, we decided to stage a photo shoot, just for fun. We didn't have a purpose in mind; we just knew we wanted to play around. I was honored.

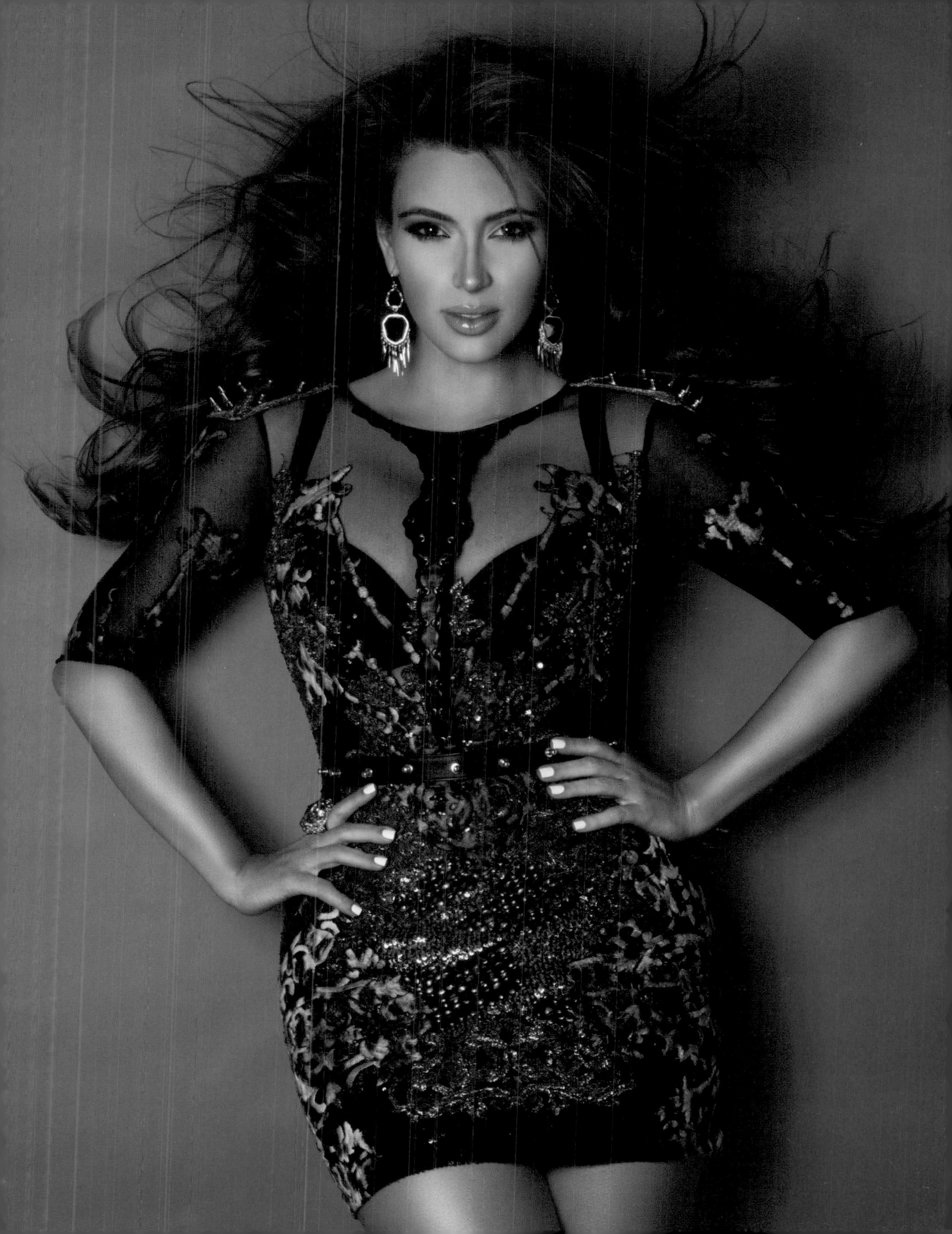

Well, let me tell you: The day was so much fun. Though Scott is one of the hardest working professionals I've ever met, he's also one of the easiest to be around; there's this sweetness and light about him. And his enthusiasm is infectious. When you're there sitting in his chair, it's like you're the only person in the world. It's very exciting. There's this sense of great possibility when he tells you he wants to pull something out of you, something you never saw yourself. He sat me down and said straight out: I want to give you some attitude! He did this smoky eye that was just phenomenal, and in fact, that image ended up in Scott's first book, *About Face*. To this day, it remains one of my absolute favorites. And we've been working together ever since.

Even though I trust Scott implicitly, I'm still often surprised by what he can do and how dramatically he can transform a face. He contours like no one I've ever worked with; it's like fine art. He's taught me how to use bronzer and why highlighting and contouring matters: how it can change a face. But he's not about making you into someone you're not. Even after his most over-the-top transformations, it's still you that emerges at the end. Maybe it's some little piece of you that you never knew existed, but it's you. What's more, he brings out the drama that I love, but in a soft way, by focusing in on one or two specific features—for me, it's usually the eyes or the cheekbones. So although it's different, it's also natural.

When applied correctly, makeup can be an empowering tool. When I take the time to look my best—those are the days I feel strongest and most confident. I feel like I can go out and do anything. I can go into a business meeting or have a working lunch and if I know I look great, I also know that my self-assuredness—my faith in myself and my abilities—will come across in other ways. If you feel great, you automatically convey this message to the world: "I have it together, I know what I want, and I know how to get it." And taking care of yourself is the first step in helping foster that attitude. Think about it. Think about when you're really sick and at home in your sweatpants and lying around in bed. If you never get up, you continue to feel that way—just blah. But if you get up, get in the shower, and put on some real clothes and a little makeup, you start to feel like yourself again. It's that simple. Bottom line: If you feel good about how you look, you'll exude confidence and preparedness without even trying.

Of course, I'm not saying you need to get glammed up and lashed out every day. That's not necessary. I don't do that. But I am saying that it's important to remember that looking good takes time and effort. It is not easy. It's not supposed to be. Even if you're born with some advantages, you still have to work hard at reaching your full potential. And there's nothing wrong with that. Getting dressed in a cute outfit, doing your hair and makeup, working out, caring for your skin, eating right—all of it takes

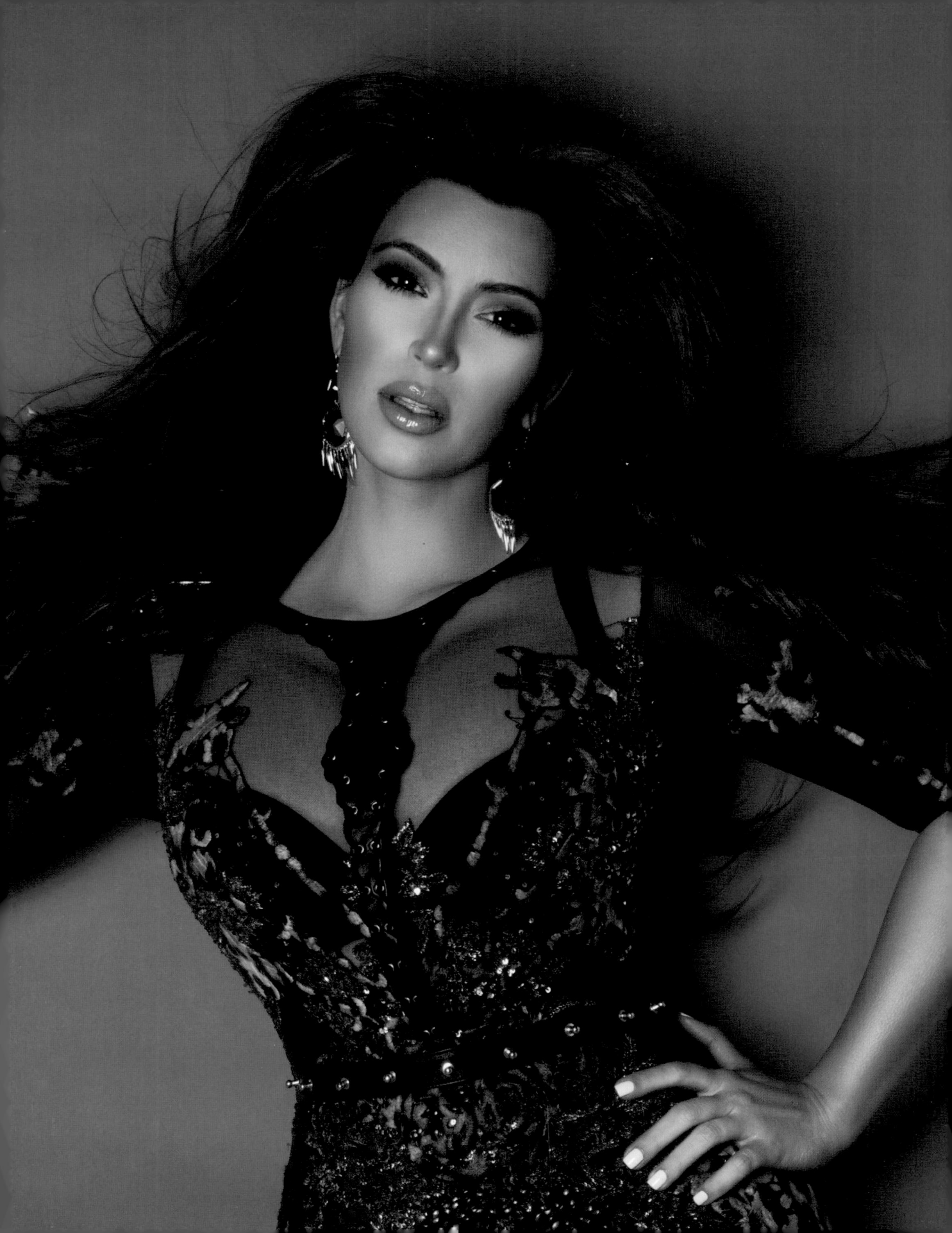

time and effort, but it's well worth it for all the rewards you will reap. Even if the biggest reward is that you feel proud of yourself. That alone is no small thing.

I think there's a time in everyone's life when they don't feel pretty or they con t love everything about themselves. I've certainly felt that way—believe me! That's okay. It's ncrmal. That's when you need to remember to take care of yourself from every which angle. For me, that means getting to the gym, eating good food, and spending time with my family and friends. Surrounding yourself with positivity is the first step in keeping the negativity out. I know it's a c iché, and people say it all the time, but beauty really does come from the inside out. You honestly can't be pretty—truly pretty—if you're feeling down. Take care of yourself in every way you possibly know how. You deserve that much—we all do.

I hope that the wisdom and beauty within this book can help you find so much wisdom and beauty within yourself. I am honored to call Scott a friend and a teacher. Now he's yours, too.

Love,

Kim

The future enters into us, in order to **transform** itself in us, long before it happens.

—Rainer Maria Rilke

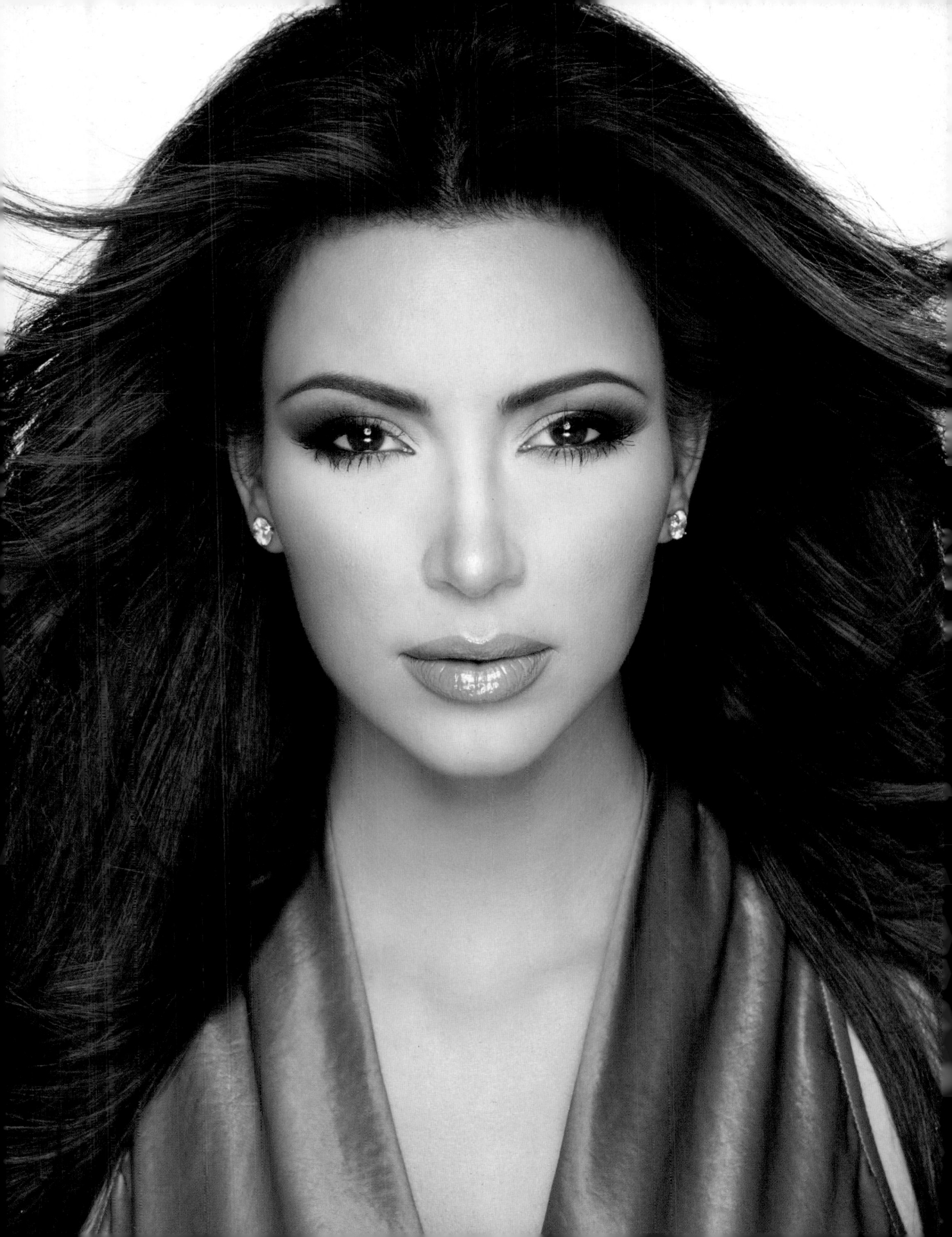

introduction
a hollywood story

Life takes us in so many different directions. We can plan all we want, but we also have to learn to recognize the signs that may call for us to change the plan. This is something I've learned as I've gotten older—and something I always tell my clients and friends—but has never been more personally relevant than it has been in the past year. As I began writing this book about transformations, I embarked on my own personal transformation. For many years, I made my home, and based my career, in New York City. It was a place that provided me with so many wonderful opportunities and moments of inspiration, from the lights of Broadway to the ubiquitous yellow taxis to the amazing diversity you see at any given moment on any given Manhattan street. New York is a city where everyone can belong, simply because there is no majority—not really. There, differences make you part of a whole that is defined by individuality. Everyone fits in simply because no one does.

But I began to see that I needed a change—of scenery, at least. I'd been coming to Los Angeles to work throughout the years and finally, on one trip early last year, decided to stay. I just never looked back. I sent for my things, and my dog, in New York, and I set to work establishing my new life in L.A. It wasn't easy, as big changes never are (they're not supposed to be). But I had the help of lots of amazing friends—old and new—and I had my work. I also drew from what became, for me, one of L.A.'s most attractive qualities: its unimaginable energy.

There is something about L.A. that is incredibly uplifting, and invigorating, and full of sun and hope and possibility.

And so L.A. itself—the city, its people—became a great inspiration for my work and this book. While beauty is universal, it's also quite regional. What works in New York doesn't always work in L.A. Los Angeles is much more exaggerated in a lot of ways. People come here because they want to be famous. They want to be stars. And so they make their appearance shine in a way that many of even the most beautiful and stylish New Yorkers don't. In L.A., there's not really such a thing as subtlety, not like there is in New York. That's because in L.A., subtlety won't get you noticed. Subtlety doesn't always photograph well. Subtlety can be . . . too subtle.

In addition to location, my inspiration has also been derived from the very personal, and I could not have created the book I did without my professional partner and great love Frank Galasso—by far the best thing to happen to me in Los Angeles. Frank and I met on a photo shoot. There was an immediate attraction—we shared a similar sense of humor and work aesthetic—but it was important to us to establish a strong friendship first. We took it slow—which is so not L.A.! And we learned that we were, in fact, incredibly compatible, though it might not have been so obvious to everyone around us. That's because Frank has this tough exterior. He's a former Versace model and a body builder, with a very strong personality. But he's also very guarded (while I'm the

complete opposite). He can be imposing when you first meet him: confident, insanely talented, and not overly friendly.

But I wasn't buying it. Slowly, surely, I got to see what was beneath that exterior. Which is where I found the parts that really mattered: A man who is smart, funny, and, ultimately, a big mushball. The true beauty.

Why am I telling you all of this? Because it's important—to my story and to yours. Who among us has not been floored, altered, turned around, and completely rocked by love? But the best sort of love is the kind that makes you a better, more all-around beautiful person. Through Frank, I was able to tap into more of myself. His love, support, and most of all, friendship was a beacon in this new, fast-paced, crazy Hollywood world I found myself in. He's offered me so much inspiration and pushed me out of the box countless times. Whenever I got scared or over-whelmed, wanting to back out, he'd encourage me to keep going. He, and love, have challenged me in the best ways.

There's a movement happening today in Hollywood, a sort of need to push the envelope that you see across all genres: film, TV, and music, especially. In some ways, the need to be provocative is a timeless one, but more than ever, there's a desire to break through boundaries, an express-yourself mentality that prevails over all other attitudes. The look in L.A. now—and it's what I love most about this place—is "anything goes." The trend is precisely that there are

no trends. There are influences, there are icons, and there are legends—and I chose to pay homage to more than a few of those in this book—but there are far more individual, one-of-a-kind, never-before-seen people here in L.A. than ever before, some of whom call on the past to inspire their look of today but many who don't. Here in L.A., you can be anyone you want to be.

When selecting personalities to take part in this book, I looked for people with independence, originality, and, of course, inner beauty. The actresses, singers, dancers, performers, models, and other professionals I chose to feature in *Face to Face* are trailblazers and wholly representative of the new Hollywood. The artists I chose to work alongside me in trans-forming our women are at the top of their game, well connected to the Hollywood who's who, and well versed in what modern women want now and what they'll want next. Above all, when envisioning this book, I wanted it to be so far from boring. Because creativity is never boring. L.A. is never boring.

I still spend plenty of time in New York, visiting friends and, of course, working. It's still an amazingly powerful city, and one that can never be replaced in my heart. Someday, I may return. What I've learned is that nothing in life is either-or—it's not New York or Los Angeles any more than it's black or white. The key to life, to beauty, is to find yourself inside yourself. What's that old expression? Wherever you go, there you are? I hope that learning to express yourself through color and light can help get you there. It's helped me.

the glam squad

MIKE RUIZ, PHOTOGRAPHY

I actually first came to L.A. to be a model, and I spent more than a decade earning a living that way. But then I got a camera as a gift, and something just clicked, so to speak. Growing up in Montreal, I had a childhood that led me to have a very rich fantasy life. I was gay and living in a very blue-collar, intolerant community. I had brothers who were much older. So I was alone a lot, but my fantasies carried me through. In those fantasies, everything was colorful and beautiful and flawless. I made that manifest in my adult life through my work. That beauty and perfection became part of my aesthetic, and my voice, and as a photographer I take my pictures to a point of perfection that's slightly surreal. And that's what Scott does with makeup. He takes a face and makes it otherworldly. And you see the results and think, who can look like that on a daily basis? The answer is, no one can. But for a day, Scott gives everyone a piece of that fantasy. The work is about creating a more beautiful reality for ourselves. That's what Scott and I do.

I first met Scott five years ago, and he spoke of this book even back then. As a photographer I specialize in beauty—I've shot campaigns for L'Oréal, Garnier, Jafra, and AlfaParf, among others, and have worked with beautiful women like Kim Kardashian, Katy Perry, and Nicki Minaj—and so the idea of doing an entire book about beauty was awesome. Plus, I love the way Scott makes my job so easy. I've been reading fashion magazines since I was a kid and have always been familiar with the work of the best makeup artists. There were a certain few with a precise skill that's not really practiced so much today—except, of course, by Scott. He's like one of those old-school masters. All I have to do is throw a light on someone and she comes away looking incredible. That's another way Scott and I are compatible: Just as he emphasizes how light falls on the face, so do I, though in a very different way. Together, though, it's magic.

I recently released a book of my own on which Scott collaborated—a book of super-stylized portraits of men called *Pretty Masculine*. It aimed to deconstruct the stereotype of masculinity by showing a series of hyper-masculine guys portrayed in a softer, pretty, elegant way. I like to take things out of context, which is why this book was also so intriguing to me. I love theatrics, and on my own I'm well known for my transformations. I like making people look larger than life and portraying a different side of them that people haven't seen before. So I get a big kick out of other artists who have the same ability to do that. The most amazing experience of this entire process was seeing Kelly Rowland transformed into a cat. She wasn't even human anymore. It was unreal.

FRANK GALASSO, HAIR

A fabulous haircut can be a woman's best accessory. It's transformative in itself: Good hair can make a real difference in how you feel about yourself, the level of confidence you exude. I knew this from a young age, somehow. I knew that I wanted to work in fashion since I was a teenager growing up in Melbourne. I worked in Sydney for a few years before moving to Milan to work with Gianni Versace. But Los Angeles was home for me: It was during a work trip here that I fell in love with the energy and sun and vibrancy of L.A. It's a city of so many personalities: It's obsessed with beauty, creativity, and, of course, entertainment, but it's also a very ambitious and driven city as well. They say New York is the city that never sleeps, but L.A. is the city that never rests.

Since moving to L.A., I've been lucky enough to work with a diverse range of amazing celebrities, everyone from Nelly Furtado, Kim Kardashian, and Nicole Scherzinger to Gwyneth Paltrow and Barbra Streisand, whose hair color I did for six years. I've styled for countless magazines, including *Elle*, *GQ*, *Maxim*, and *Interview*, and received praise from hundreds of publications around the world, including being named one of the ten best hairdressers in the world by *Elle UK*. I actually started out primarily as a hair colorist, an art form that is similar in approach to makeup; the two go hand-in-hand. You color hair based on what will best complement the skin, sometimes in the least obvious way. After a color, I'd blowdry clients, and they began to notice I was really good at that, too, and started commissioning me to style their hair for events or photo shoots. That's basically how I built my brand. I never pursued a freelance career; it just sort of fell into my lap because it was something that other people noticed I was good at.

Over thirty years as a stylist, I've developed an aesthetic, for sure: I'm sort of an all or nothing guy, you could say. I like big, beautiful, long hair, or I like short and chic. I tend to steer clients away from medium-length hair, which I think is neither here nor there. To me, it doesn't say much about you. It says, I'm an average person with average style, without a point of view either way. Okay, maybe that's extreme. But I do feel very strongly that your hairstyle reflects your personality and what you want to project about yourself and that it's always with you—good or bad. So it's important to make it good.

That doesn't mean you need to be edgy and fashion forward all the time. But you should be stylish, which is achievable without necessarily looking like you have a "hairdo" or like you're trying too hard. I recently opened a new salon with Scott, called Barnes & Galasso, and I see just as many clients who work in entertainment or business as I do actresses or musicians. You don't need to be famous to pull off a fabulous hairstyle. But a fabulous hairstyle can make you feel like a million bucks, for sure.

As a hairdresser, I work with a lot of makeup artists. But when you see what Scott does, the results are just steps and steps above. He makes the rest of us look even better.

TRACEY SUTTER, NAILS

As a kid, I was an obsessive nail biter. To cover up my habit I learned how to give myself manicures. I remember going out and buying a bunch of supplies: polishes, glitters, tools, and whatnot. I taught myself and just had so much fun with it. The rest is, as they say, history.

Not everyone understands the notion, but nails truly complete a person's look. They say a lot about how you choose to express yourself. And they can make or break an outfit. You might not notice when someone has nice, clean, manicured nails, but boy do you notice when they don't. That's why I consider good nails to be the unsung heroes of beauty.

I've worked in Hollywood for more than twenty years. It's such a busy, electrifying world, where what's hot is constantly changing. As a nail artist, I love setting new trends and revisiting past trends, too, perhaps adding my own modern twist. My job is to give a look that last needed "pop," whether that's for a photograph, red carpet event, or just running-around-town casual. On any given day, that could mean anything from a traditional, ladylike French manicure to the "new" French, with colored tips. I might create over-the-top swirls and patterns by dipping nails in

water laced with polish or go with a straight, matte black. Some looks call for a simple, natural nail. The possibilities are literally endless. Nails are a wearable art and an easy way to make someone happy, even if just for a day. That's why I love my job.

Working with Scott on this book was so very exciting and exhilarating. The inspiration that he evokes—and his pure energy and talent—is awesome. No one understands the importance of complete and total beauty—not missing a single detail—more than Scott. But most of all, I enjoy his big heart. Over the years I've known him (we first met while shooting Mary J. Blige and hit it off straightaway), we've collaborated on countless projects and even shared clients. In one of my favorite memories, we were having a party at his house after a very long shoot. He'd just bought a karaoke machine. We made cosmos and bought balloons and threw glitter all over the floor and just sang and sang and laughed our heads off.

SAMMY AND JUDY, "THE KIDS," WARDROBE

We've been best friends since the seventh grade. We grew up in a suburb of Los Angeles and met while cutting class. We quickly found out that we both shared a passion for style and fashion and we probably always knew we'd work together some day. Eight years ago, we started a styling team. We called ourselves "The Kids" because we were so young, and because we tended to work with people who were much older, that's what everyone else was calling us. Although our aesthetics are very different—Sammy is inspired by the '80s, club kids, new wave, and hip-hop, while Judy is inspired by looks that are classic, chic, and feminine—our philosophies complement one another. Sort of like an opposites attract vibe. It just works.

We got into styling first through costume design and both worked as wardrobe stylists on the reality show *Pussycat Dolls Present: Girlicious*. From there, we moved into editorial, red-carpet, and commercial styling—we've worked with clients like Carla Gugino, Kelly Rowland, Miranda Cosgrove, and Lil' Kim, as well as magazines like *Harper's Bazaar, Esquire, Nylon,* and *Flaunt.* We like to say our specialty is that we do everything. But our first love will always be costume design. We love collecting fashion, vintage pieces, and props that can be used as accessories and have begun to create our own original designs. We have an accessory line in the works as well that will combine our two personalities.

We met Scott not long before we started this project through our mutual friend, Erika Jayne, and we hit it off immediately. It turns out that we'd worked with several of the women in this book before—like Erika and Kelly, as well as Kim, Paris, and Kristin—but many of the women were new to us. Our philosophy mirrors that of the book, in a way: We look at styling as transforming, whether it's a simple look or high fashion. With clothes, you're always sort of transforming yourself. Sometimes it's a dramatic change, and other times it's just an improved version of yourself. Most of our clients want to look amazing, but not like they're trying too hard. We think the idea of using fashion to become whatever you want to be should be achievable to all—yet also inspirational—and we try to make it appear that way through our work.

What's been the most fulfilling aspect of working with Scott on this book is that it's been a true collaboration: We are able to share our vision for the individuals and the book as a whole. Even though there's a general theme of transformation, every celebrity or model has brought her own flavor to the project. Every picture tells its own story—different in its own way, but connected. That's what fashion, and personal style, is all about.

The key to life, to beauty, is to find **yourself** inside yourself.

the power of trans- formation

WHO ARE YOU? WHO DO YOU WANT TO BE? Do you dream of being at the top of your field? A better sister/friend/daughter? An inspiration to others? These are questions you might ask yourself as you get out of bed each morning. These are also questions I ask women whenever I'm about to apply their makeup—really. Because makeup, at least in my mind, isn't about creating something entirely new or even covering up what's already there; it's about taking the gifts a woman already has and putting them to their best possible use. It's about expressing who you are on the inside.

That's because being your best self isn't exclusively about looks—not at all. In my first book, *About Face*, I talked a lot about the power of transformation, how—if you let it—makeup can help you transcend whatever mood, shape, or state of mind you're experiencing at any given moment. At the same time, the better you feel about yourself on the inside, the more beautiful you'll appear to others on the outside. It's a cliché, sure, but beauty really does start from within (and hey—if you've got someone who gets paid to apply makeup telling you that, it's got to be true, right?). And so your first assignment as part of this book is to stop being such a critic and start appreciating who you are, flaws and all. Your face will thank you for it.

What I hope to do in this book, more than anything, is inspire you to try new things, to push the envelope, to unleash your innermost goddess. Because that's what makeup is meant to do. As humans, we have a rich and storied history with makeup, having called on it, in some form, to transform ourselves for thousands and thousands of years. "A woman without paint," wrote the Roman philosopher Plautus, "is like food without salt." Ancient Egyptians, that glamorous bunch, created early cosmetics using copper and lead ore—a rudimentary kohl—while Greeks used berries and Persians used henna dyes to stain their lips, cheeks, and hair. Recently, British archeologists uncovered seashells containing red and yellow pigments—primitive makeup compacts—proving that Neanderthals wore makeup as long ago as 50,000 years.

But there's proof, too, that wearing makeup has never been solely about altering our appearance—it's about expressing how we feel. In eighteenth-century France, red lips and flushed cheeks symbolized that a woman had a fun-loving spirit; twentieth-century entrepreneurs Helena Rubinstein and Elizabeth Arden marketed cosmetics to women as a means to independence, confidence, and equality. Wearing bright red lipstick to a 1930s suffrage parade, for instance, symbolized a woman could do as she pleased. Later, in her groundbreaking 1999 book, *Survival of the Prettiest*, Harvard Medical School psychologist Nancy Etcoff argued that beauty is not a social construct but, in fact, a built-in ideal—that is, we're born to love what, and who, is beautiful. Scientific studies have proved that human beings are hard-wired to respond more positively to beautiful people; we like, trust, and value them more.

Whether you believe that or not, makeup can certainly help you feel better about yourself and inspire confidence, which, in turn, can help you reap great rewards in so many areas of your life, from work to family to fun. And this goes for women everywhere—not just those here in Los Angeles who make a career out of looking good. Feeling good about yourself needn't be a job, but it shouldn't be a luxury, either. But I know how busy modern women are. You have everything—except time. Women consistently tell me that they simply cannot commit to an hour in front of the bathroom mirror each morning. Or that they don't have time between work and an evening out to go home and reapply makeup. It's not that you aren't interested in looking your best. It's that there simply aren't enough hours in the day.

The women I work with regularly are insanely busy, like you, often packing into a single day an appearance on a talk show, a lunch with friends, an afternoon meeting, a trip to the gym, and a red-carpet event. What works for one might not work for the next. That's where the practical lessons of *Face to Face* come in.

By now, you might already know a little bit about me and how I approach makeup. If you don't, here are two important principles to remember: I work to play up the best of what you have and always take my cues from the light. Before I apply even the tiniest bit of makeup, I take the time to notice how different facial features reflect light in different ways. Then, I highlight and contour accordingly. To me, contouring is the most important aspect to applying makeup, even when we're talking about creating a natural look; a little contouring can literally change your appearance in ways you've never imagined. In this book, I'll show you how to approach makeup from my point of view and make the light work for you, how to tailor your makeup to the different situations you might find yourself in throughout the day, how to get it done both beautifully and efficiently, and, most important, how to dream big and have fun.

While *About Face* served as a sort of primer on the basic techniques of applying makeup, *Face to Face* builds on that knowledge to invite you to explore an array of looks. There's still a lot of practical advice, of course, with tips that'll take you from your 8 a.m. meeting to a romantic dinner or night on the town and help you build on the foundation you've created in the morning without simply piling on more layers. The really pressed-for-time will appreciate my six simple steps to creating the perfect face in 15 minutes. But *Face to Face* is inspirational and imaginative, too. Now that you know the basics, you'll learn how to use makeup as an accessory to fit your ever-changing mood. Like how to be the ultimate minimalist—how to play up your best feature by minimizing others—and how to make the "natural" look work for a night on the town. You'll also find the answer to the hands-down number one question I get asked by both the ultra-famous and the not: How do I create the perfect smoky eye?

Also included: How to wade through the endless products at the drugstore and the department store and how to know where to spend your money (one word: moisturizer!) as well as where to save ($50 eyeliner? Not necessary!). And for those special occasions, like weddings, parties, or your own red-carpet events, I'll show you—with the help of some of my most beautiful and talented friends—how to be the most glowing woman in the room. Celebrity testimonials will let you in on what these women have learned about makeup and the power that they can harness from the simple act of taking time to care about how they look.

And because good skin is the absolute best makeup trick, I'll spend time telling you about skin-care rituals that will protect and save your skin throughout all seasons, including lots of quick and easy home remedies and dietary changes (not to mention super-simple solutions, like to get more sleep). As with anything good, presenting your best face requires a bit of discipline, but the rewards are so worth it. I think you'll agree.

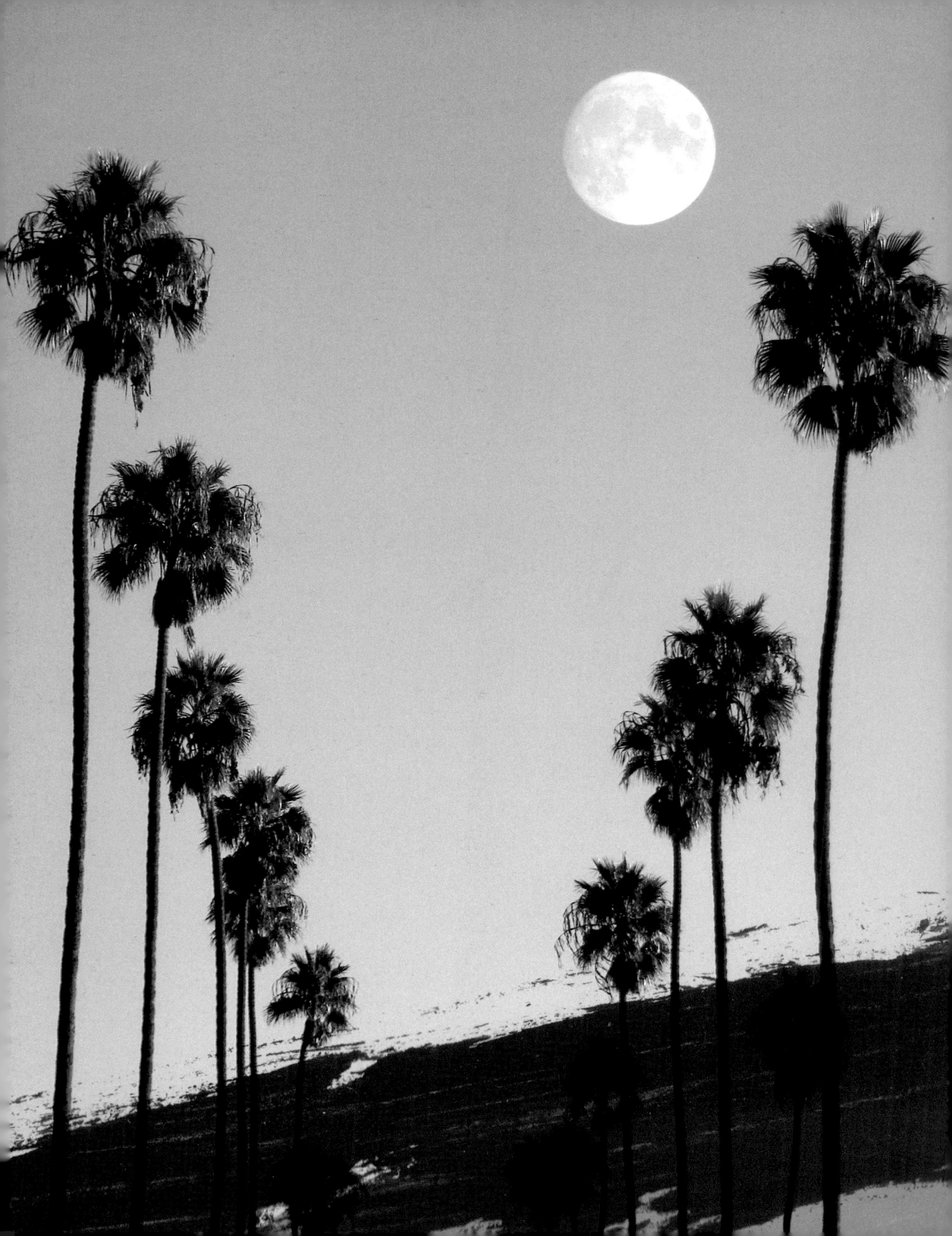

makeup that transforms

Hollywood is a place that lets you realize your wildest fantasies, where you can become whatever version of yourself you aspire to be, or even someone else completely. That's what's so great about this town and why for decades people have come here with the goal of making their dreams come true. Every day, so many Hollywood starlets look in the mirror and ask themselves: Who do I want to be today? (I know I do.) But you don't have to live in Hollywood in order to change the way you see yourself. How about calling on your alter ego to channel your imagination, reach your full potential, and transform? With makeup, anything is possible. So ask yourself: Who do *you* want to be?

the hollywood starlet

MARILYN MONROE IS ABOUT AS HOLLYWOOD AS YOU CAN GET, and a personally significant icon, too: Not long after I moved to Los Angeles, I found out that the very apartment I'm living in once housed none other than Norma Jean herself. Now, I think I feel her spirit every so often, especially when I'm having a bad day or wondering whether I made the right decision to leave New York for the craziness of Hollywood.

Transforming this model into Marilyn Monroe began with the eyes. I wanted to give her a traditional cat eye, which just oozes glamour, to create a sleepy, sexy, bedroom sort of feel. That called for heavier liquid liner on the lids and a strip of false lashes.

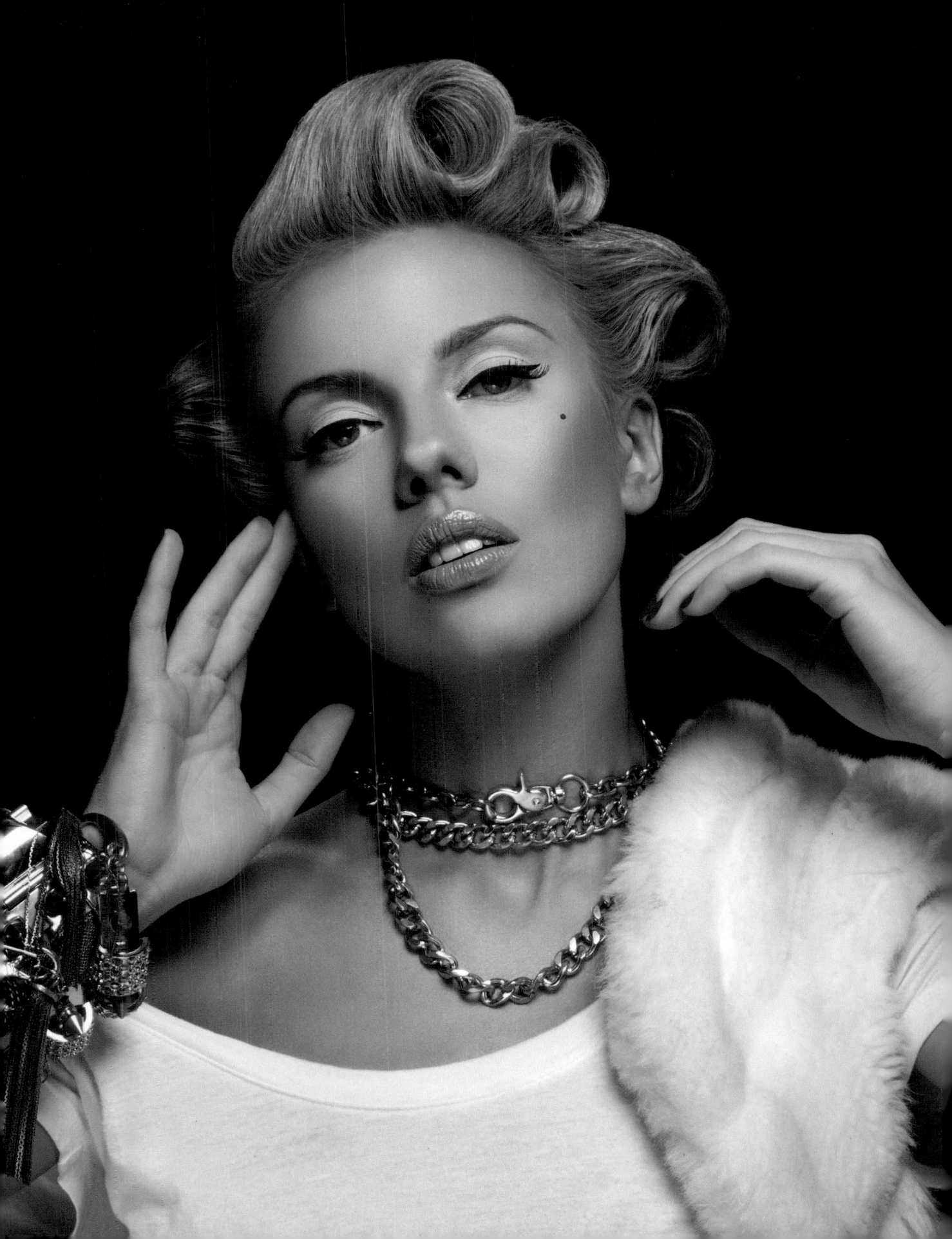

HOW TO: CAT EYES

Creating a cat eye is easier than it looks. First, rim the eyes with a standard black eyeliner. Not too heavy—just enough to provide a base. When working with the liquid eyeliner, you want to start by removing excess liquid from the wand. Here, I went with a deep black liner, but navy and green and even silver can also be fun. Play around with what works best for you or for the occasion. If you're going to a formal event, it's best to stick with black or navy. But if you're going out dancing, for drinks with the girls, or to a holiday party, really, anything goes. Don't be afraid to experiment.

1 To remove the excess liquid, wave the liner wand in the air (don't roll it on a tissue—you'll only pick up bits of fuzz). Then place the liner tip at the inner corner of your top eyelid and draw a straight line all the way across. Don't worry if the line appears jagged—you'll need to draw the line two or three times to create the full effect, so there's plenty of time to even out smudges. If you need to drag the liner across in sections or dab at the lash line to fill it in, that's fine, too.

2 Next, to create the cat-eye wing, simply extend the tail of the drawn-on liner past the eye, being sure to keep it on an upward angle. The further out you take the line, the more dramatic your cat eye will be. Then think about what you want to do with the rest of the eye. I like to leave the lower lashes bare or apply a single coat of mascara. On the lids, white eye shadow worked to create the retro feeling I wanted here, while serving to play up the eyes even more. But you can also use beige, silver, or other metallic, or go all the way with it and apply a black shadow to the lids. Just make sure you're not being too dramatic for the occasion; that is, a black-on-black cat eye might not be the wisest choice for a job interview, a wedding, or, for that matter, a funeral.

3 Here, for the full Marilyn effect, I decided to apply a beauty mark on the model's upper cheekbone using the same black liquid eyeliner. Just a dot of liner is enough. Then, to turn the dot into a natural-looking beauty mark, I used an eyeliner brush to apply a tan eye shadow on top of the dot. Use your finger to gently press the shadow into the dot, so that the shadow stays put and absorbs a bit into the black liner. Keeping the lips in a natural or light coral tone works best because you don't want anything to compete with the eyes. Then use a dusting of translucent powder all over the face to set. I think Miss Marilyn would approve, don't you?

TIP: For dramatic curls, use an old-school roller set on wet hair. Let air-dry.

PRODUCTS

> Lancôme Artliner liquid eyeliner in black

> Maybelline Expert Eyes pencil in velvet black

> Dior Addict Extreme lipstick in Pink Icon

> Make Up For Ever eye shadow in white

> Make Up For Ever translucent setting powder

FRANK ON HAIR

In the 1950s, hair was all about roller sets and pink curlers. I kept that aesthetic in mind as inspiration for our Marilyn Monroe look, but wanted the end result to appear still set-looking, like she's getting ready to brush her hair out and go somewhere—a sort of pin-curl-come-undone look, like you've caught her in the middle of the act (always a sexy concept!). To start, I applied Oribe Volum'sta on wet hair, and I used a traditional roller set to create the curls, which I let air-dry for a bit before going over them with the hairdryer on the hottest setting. After drying, I used a hot curling iron to give the curls definition. Lastly, I set the look with a bit of Oribe Original Pomade and an all-over spray of Joico's JoiFix Firm.

TIP: Bright polishes—like cherry red—work best on short nails.

TIP: Use a brown eye shadow over black eyeliner to create a beauty mark that's both long-lasting and natural-looking.

the italian siren

MAGALI AMADEI is a French model who came into her own along with Linda Evangelista, Cindy Crawford, and Christy Turlington and was part of that "original supermodel" crowd in the early '90s. She appeared on the cover of nearly every fashion magazine out there and became the face for many brands, including L'Oréal, Dove, and Blumarine. She was discovered as a teenager while studying ballet in France and offered a modeling contract. But she never really intended to be a model forever. Later, she became an actress, appearing in *The Wedding Planner*, *Taxi*, and HBO's *The Mind of the Married Man* and in a handful of off-Broadway plays. More recently, her image appeared in black-and-white photos in a scene in *Sex and the City*, the movie, as "the smart girl who fell in love" and had to auction off all her jewelry. Magali has also been important as a spokeswoman for the American Anorexia/Bulimia Association, advocating for healthier standards for models working in the fashion industry.

Though French, Magali has the look of a classic Italian siren, with olive skin, bold, elegant features, and a certain photographic magnetism. Her whole career she's been told she looks like Sophia Loren, and that's what I went with here. This is a girl you want to see on a Vespa, don't you think? And while she already had a strong Italian girl look going for her, I worked to pull it out even more, with a cat eye, strong cheeks, and, of course, impeccable brows.

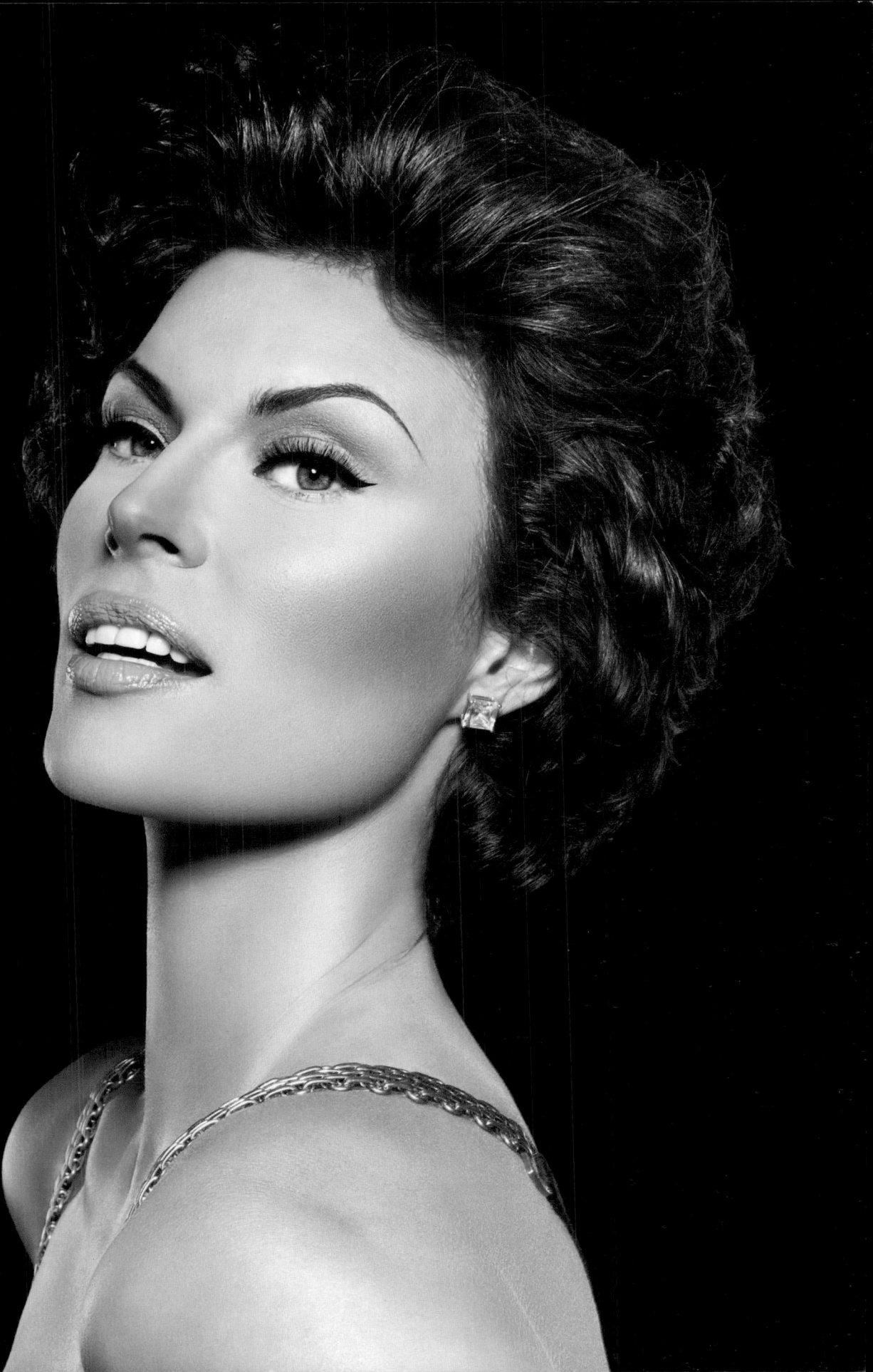

HOW TO: PERFECT ARCHES

Eyebrows are one of the face's most prominent features, especially for Italian and other dark-haired women. A stunning, well-shaped eyebrow can transform a face and be, in my opinion, as effective as a facelift (and cheaper, too!). I always recommend shaping brows with a brow razor—not the same razor you use on your legs, but one made just for the brows and face and found in most drugstores. Unlike tweezers, razors don't do permanent damage to the hair follicle. They also allow for greater control when shaping and help brows lie flatter. At the same time, you want to aim for a look that's manicured and neat, but not perfect. A bit of a natural look is ideal.

1 Using a razor comb, thin and shape brows. Work mainly from the bottom, using only a small amount of grooming on the top of brows. To use a razor comb, lift the brow with the razor and turn in the opposite direction. Always put a comb beneath the razor to avoid taking away too much hair. The idea is to shape your brows in a way that will lift and open up your eyes.

2 You can use tweezers to pluck any stragglers, but not near the ends of the brow closest to your nose. Your brows should begin a little closer to your nose than the inner corner of your eyes, and you don't want to remove too much hair. Always strive for minimal plucking to avoid permanently damaging the hair follicles. Once the follicle is removed, it takes much longer for the brow to grow back. And because brow styles change all the time, you want to give yourself the option of growing out your brows later on, if you want.

When shaping, you want to follow the natural arch of your brows, which typically sits just above the center of your pupil.

3 Fill in any holes with an eyebrow pencil one shade lighter than the color of your brows. The pencil will work in two ways: First, the wax from the pencil will help smooth down the hair. Second, the darker hairs already create depth, so filling in with a lighter color will result in a dark eyebrow but not look overdrawn.

4 Naturally bushy brows can be played up for a wild, sexy look by taking a boar's hair eyebrow brush to the brows, sweeping them upward. You can apply this technique to the entire brow or just to a few hairs closest to the nose, like I did here. Spray some hairspray onto the brush in advance for extra hold. Bushy brows can be a great complement to smoky eyes because they lend a softer, airier feel and help avoid severity.

5 Another trick: To temporarily tame bushy or furry brows without shaving or plucking, use your fingers to apply a bit of stiff hair wax to the brow, sweeping upward. Then, use a credit card to push down the eyebrow and pinch the hairs together to create a thinner brow—no plucking required. Apply a bit of hairspray to your fingers and press the brow hair gently to set.

TIP: Spray some hairspray onto a boar's head eyebrow brush for extra hold.

PRODUCTS

> Lancôme Le Crayone Poudre eyebrow pencil n Mahogany

> Lancôme Artliner liquid eyeliner in black

> Maybelline Expert Eyes pencil in velvet black

> Bobbi Brown blush in Tawny

> Anastasia brow gel

FRANK ON HAIR

This is a classic "Italian top," a hairstyle that was huge in the 1950s and worn by many Italian film stars, including Sophia Loren and Gina Lollobrigida It swept America, and soon stars like Connie Francis and Brigitte Bardot were sporting Italian tops. It was sort of the Italian version of a pixie, or a short bouffant, meant to be less fussy but more sassy. To achieve this look, I set Magali's hair with a traditional roller set while wet, then dried the hair and removed the rollers. I used Joico's JoiFix to keep it in place, but ran my fingers through it for a more "undone" look. The key is to make it look effortless and sexy, not set to death.

TIP: When shaping, follow the natural arch of your brows, which typically sits just above the center of your pupil.

trans-formations

candis cayne

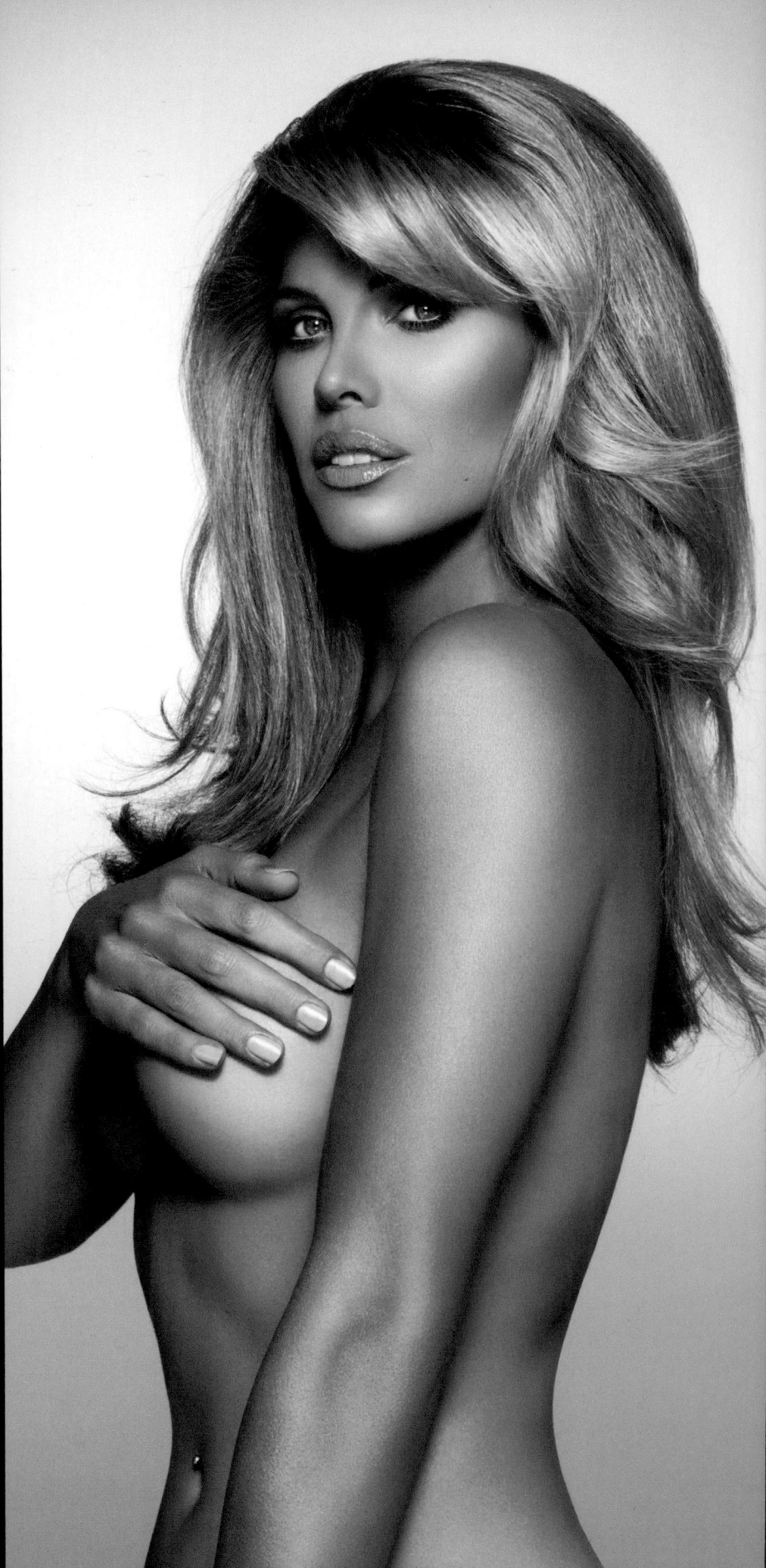

I ASKED CANDIS IF SHE'D LET ME BREAK HER OUT OF HER COMFORT ZONE AND BRING HER BACK TO HER DAYS AS A MAN—AND THEN BACK AGAIN AS A WOMAN. I FIGURED: WHO BETTER TO ILLUSTRATE THE TRANSFORMATIVE POWERS OF MAKEUP, AND THE FLUID NOTIONS OF HOLLYWOOD BEAUTY, THAN A WOMAN WHO HAS SPENT A LIFETIME CHANGING?

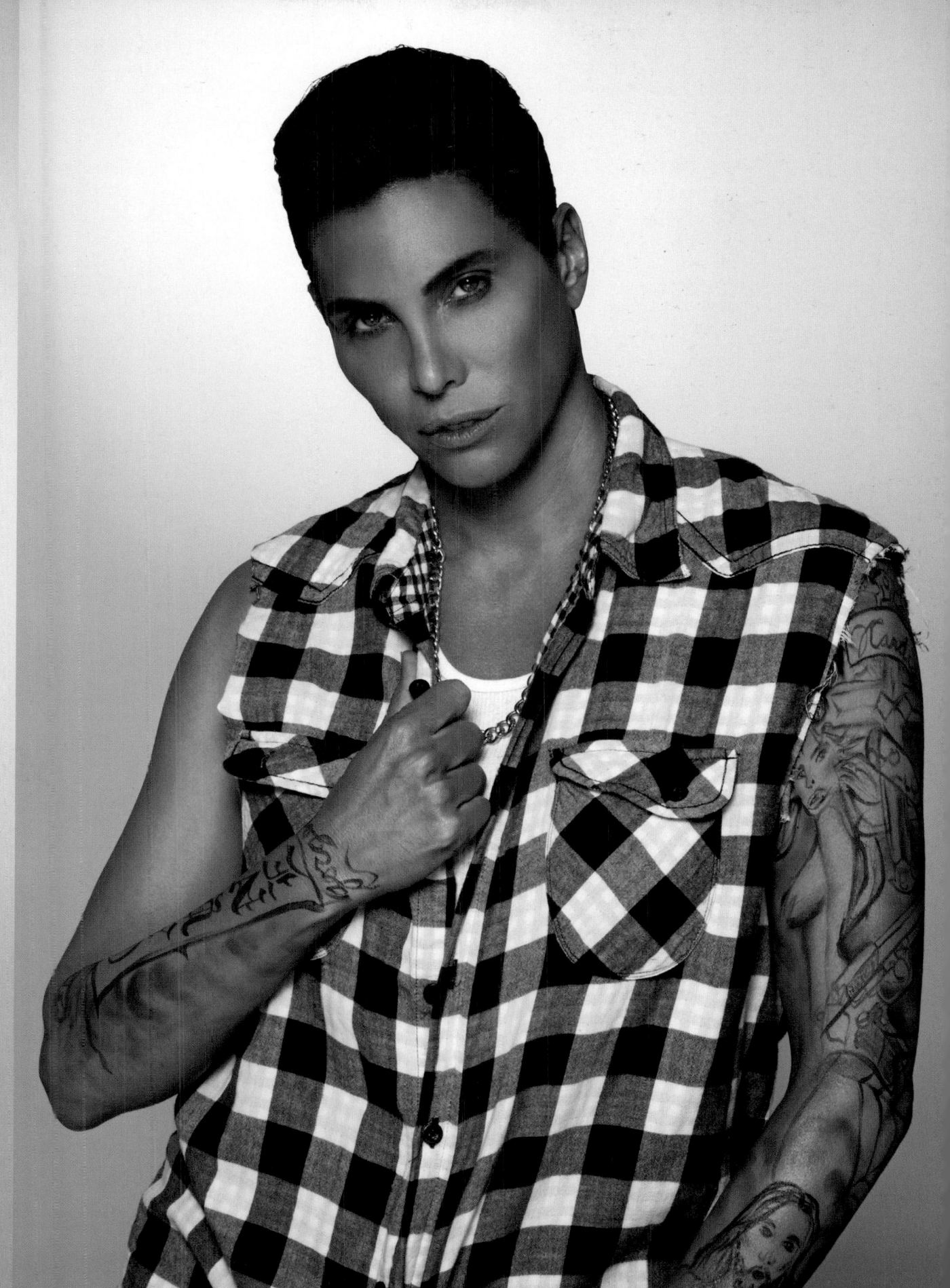

Candis totally blows the doors off the notion of **conventional** beauty.

Candis was born and raised in Hawaii. Her parents are both professors, and because I've had the privilege of meeting them, I can safely say that they're the main reason Candis is so grounded and centered—which, of course, only makes her that much more beautiful.

Candis left Hawaii for New York City in the early '90s, set on becoming a dancer and an actress—and a woman. Candis was born Brendan, but says she always knew she identified more with being female. I first met Candis as she was beginning her physical transition from man to woman. From the very first moment, I thought: This is a person who blows the doors off the notion of conventional beauty. And yet, there's never been a question in my mind that Candis is a real woman. Since then, she's accomplished so much, as an actress (in television shows like *Nip/Tuck* and *Drop Dead Diva*) and as the star of her own popular cabaret performances in New York and here in L.A., where she now lives. But the role that really put her on the map was as Carmelita on the critically beloved ABC drama *Dirty Sexy Money*, in which Candis became the first transgendered actress to land a recurring role in prime time.

For our time together, I asked Candis if she'd let me break her out of her comfort zone and bring her back to her days as a man—and then back again as a woman. I know it's a little confusing, but I figured: Who better to illustrate the transformative powers of makeup, and the fluid notions of Hollywood beauty, than a woman who has spent a lifetime changing? She's the perfect example of someone who has truly looked inside, realized her full potential, and made it happen; the subsequent success she found was inevitable. The funniest part of the whole day was that Candis didn't know how to be a man at all—she felt so uncomfortable! When we brought her back to womanhood again—with very little makeup, she's just that pretty—it was like Christmas morning. She was like, I'm back! I'm a girl again!

Two weeks before the shoot, Candis and I met for coffee near my home in West Hollywood. We hadn't seen each other in a while, so we had a lot of catching up to do. She was dressed super casually, like your typical California girl—jeans, a T-shirt, Ugg boots. Her hair was pulled back and she was wearing not a stitch of makeup. And yet, men were hitting on her left and right. Because we've been friends for so long, I've sort of stopped noticing Candis as anyone but this dear, old friend whom I've always thought was gorgeous because she's such an amazing, light-filled person. Suddenly, though, it dawned on me that I wasn't alone in appreciating her charm. Beauty truly does come in all forms.

kelly rowland

KELLY TOLD ME THAT SHE'D
ALWAYS BEEN FASCINATED BY
CATS. SHE'S A REAL ANIMAL
LOVER AND A BIT OBSESSED
WITH FELINES FOR THEIR
INDEPENDENCE AND BEAUTY.
HER ALTER EGO SEEMED
OBVIOUS: I'D TURN HER
INTO A CAT.

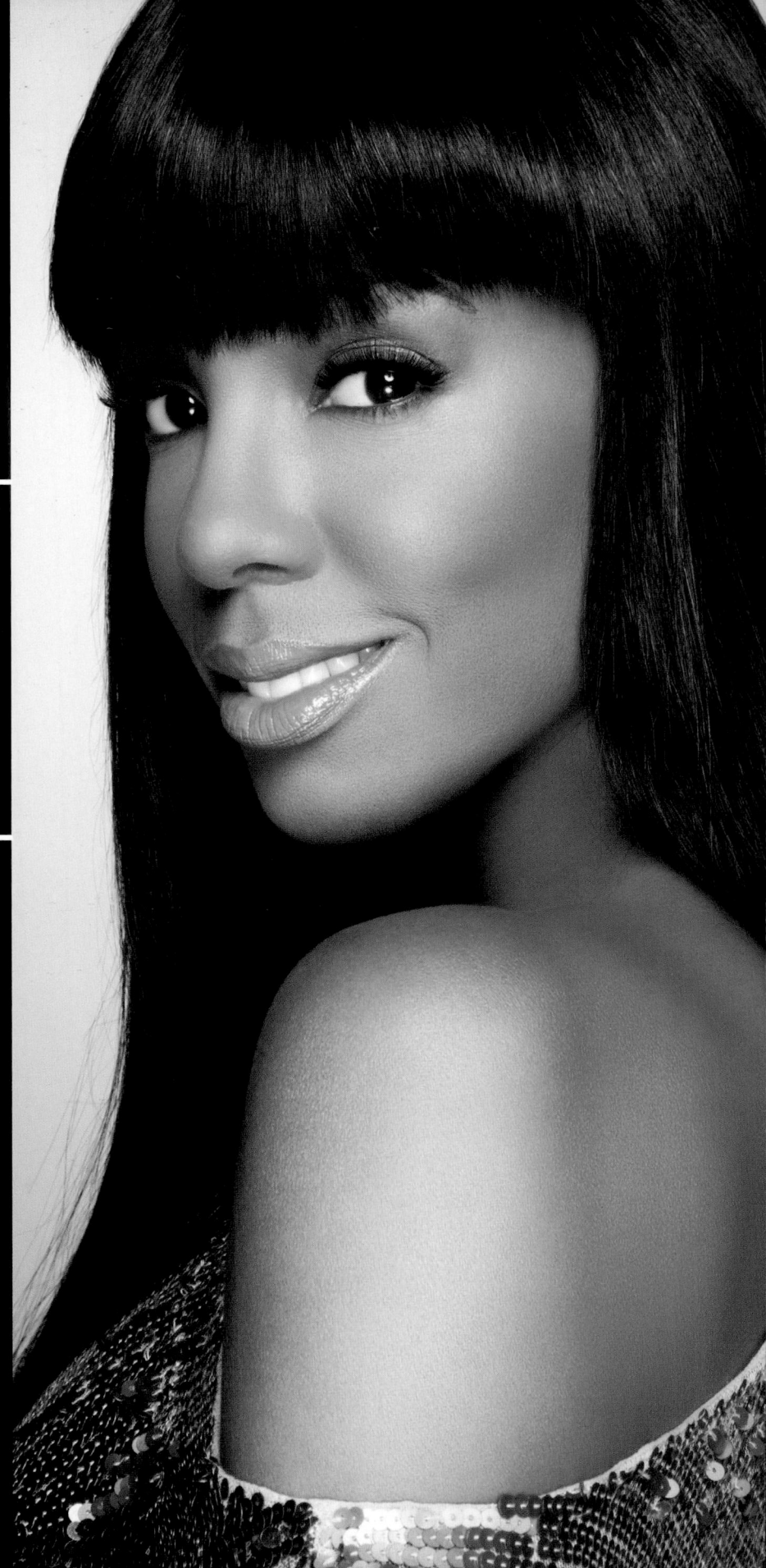

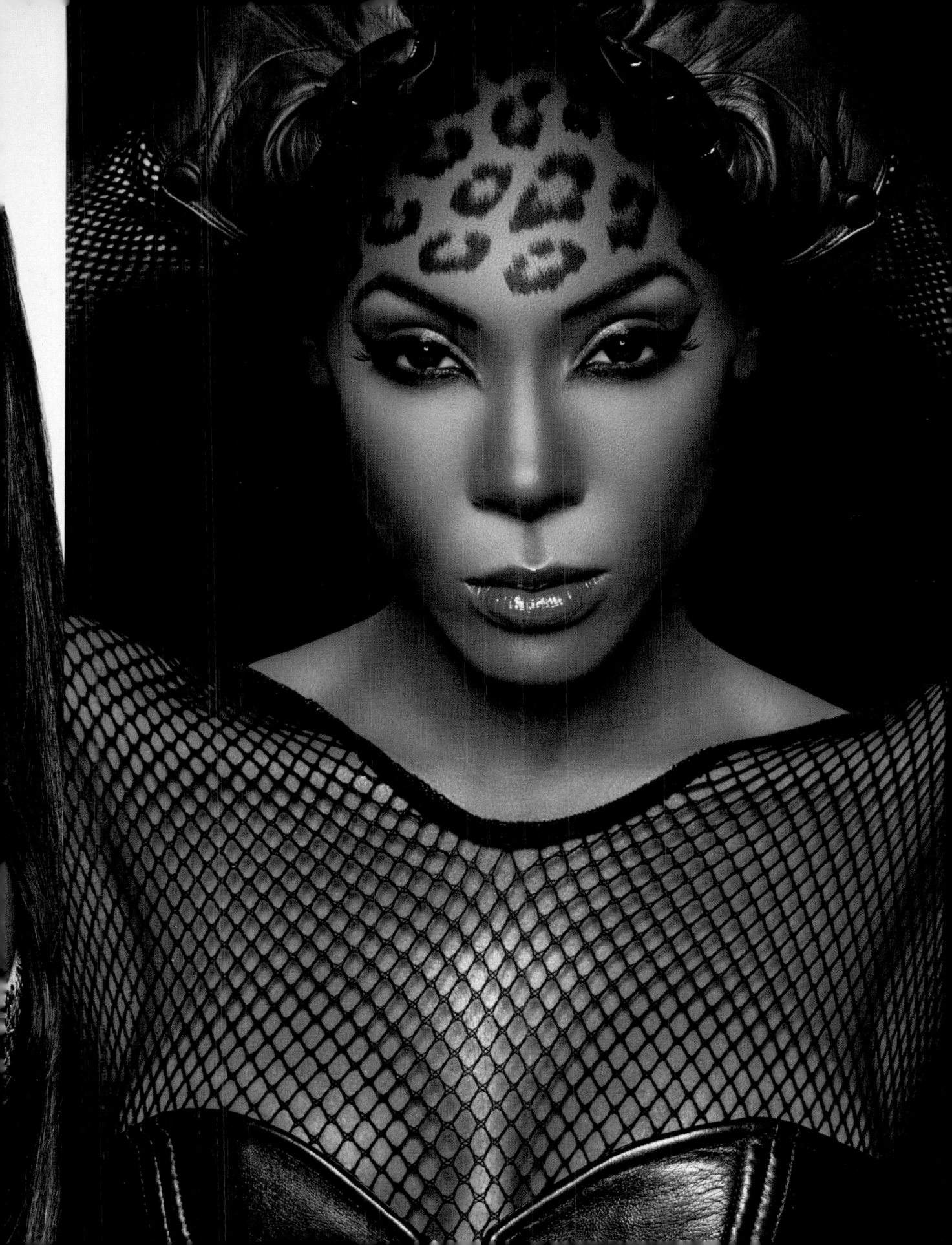

It seemed fitting to turn Kelly into a cat: **She's fierce!**

Kelly is a classic Southern girl, with the most impeccable manners and warm-hearted nature. I don't think I've ever seen her get mad, and we've spent hours and hours together. She's so deserving of all her success. Although she first became famous as a member of the girl group Destiny's Child, she's been insanely successful on her own as a solo artist, selling more than 20 million records since she first struck out on her own in 2002. Her most recent album, *Here I Am*, debuted at number one on Billboard's R&B/hip-hop chart, and she's also appeared as a judge and mentor on the British version of *X Factor*. I've had the good fortune to work with Kelly on a number of videos for *Here I Am*, and I can guarantee that she really is as sweet as she seems.

When I first spoke with Kelly about her transformation, she told me that she'd always been fascinated by cats, ever since she was a little girl. She's a real animal lover and a bit obsessed with cats for their independence and beauty. Her alter ego seemed obvious: I'd turn her into a cat. To create the feline lock, I started with some highlighting and contouring and a burgundy blush along the sides of her cheeks to make her face appear longer and thinner—more

cat-like. Then I gave her a classic cat eye, of course, starting right at the inner corners of her eyes and extending the wing up to the outer edge of her eyebrows. On her lids, I used gold shadow. The spots—the first cat spots I've ever created, I can safely say—were painted on with black cream eye shadow. On her lips, I used a beige lipstick with a swipe of clear gloss.

Afterward, Kelly told me that until this experience, she'd never once looked in the mirror and come away unable to recognize the reflection staring back at her. But she loved that part of the transformation; it was a psychic escape, even if only temporary. Her new motto: Everyone should have the opportunity to be a cat—or at least to be someone else—if only for a day.

erika jayne

ERIKA'S STRENGTH LIES IN HER DRIVE TO DELIVER A TOUR DE FORCE PERFORMANCE, ALWAYS, CONSISTENTLY GIVING HER FANS EVERYTHING THEY EXPECT TO SEE. SHE'S LIKE THE QUEEN OF THE SHOW. THAT'S HOW I CAME UP WITH MY INSPIRATION FOR HER TRANSFORMATION. I WANTED TO CREATE SOMETHING THAT WAS EDGY BUT STILL ERIKA. I THOUGHT, HOW DO I MAKE HER LOOK LIKE AN ARISTOCRAT BUT STILL LET HER BE HER MUSICAL, FUNKY SELF?

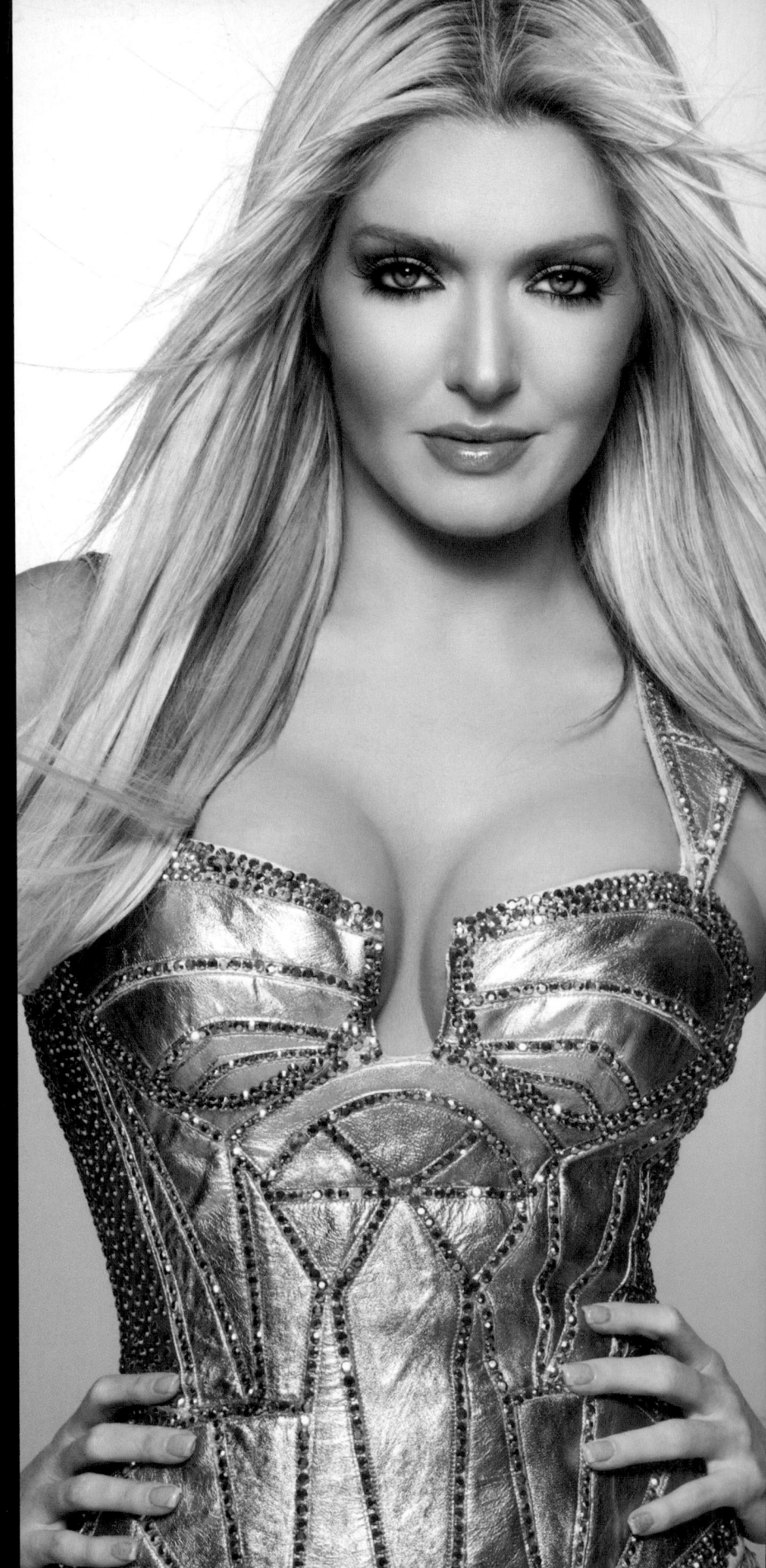

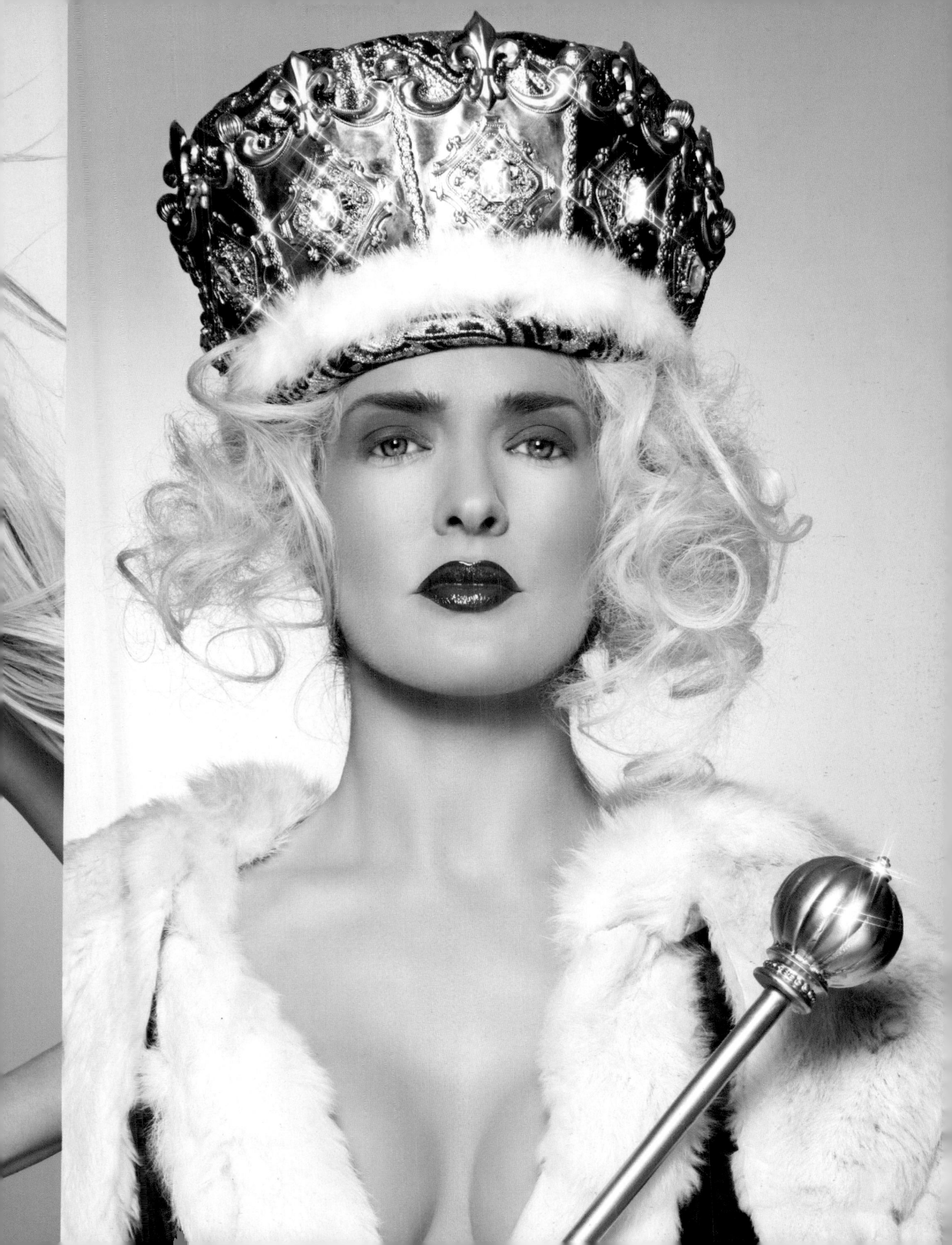

Erika is a great entertainer, with a very **generous**, yet humble, spirit.

Erika Jayne is an Atlanta-born pop star artist and veritable cult figure within the gay community. She's had five consecutive #1 dance hits on the Billboard charts—tracks like "Rollercoaster", "One Hot Pleasure", and her latest smash, "Party People." Her songs are a staple in some of the best clubs in Miami, New York, and L.A. But more than just being excellent at belting out really great music that makes you want to get up and dance, Erika is an ardent supporter of gay rights, performing at gay pride events across the country and campaigning for equality.

I've had the pleasure of meeting and working with Erika on a number of occasions. She is a great entertainer, with a very generous, yet humble, spirit. Her strength lies in her drive to deliver a tour de force performance, always, consistently giving her fans everything they expect to see. She's like the queen of the show. Earlier in her career, she was a pop princess, but now I like to call her Queen of the Queens—and nowhere is her fan base more enthusiastic than here in Hollywood. That's how I came up with my inspiration for her transformation. Erika's typical performance look is very "pop star": eyes that stand out with grays, blacks, and silvers; soft, peachy blush; and lots of individual false eyelashes. But for her transformation, I wanted to create something that was edgy but still Erika. I thought, how do I make her look like an aristocrat but still let her be her musical, funky self?

I didn't use any mascara at all, and on the lids I applied a bright pink blush by Make Up For Ever. The lips are red (Chanel Rouge Allure in Famous) with a pink gloss on top. Luckily, she has great skin, which she works hard to maintain by eating well and getting regular facials. And as queen, she's on top of the world—or, at least, her kingdom—both in looks and in spirit, which, of course, is the marking of a true superstar.

ERIKA SAYS ...

I've known Scott for years. We met and hit it off instantly. When you work with someone like Scott—someone so important in the industry, a man who has literally revolutionized makeup—you just kind of turn yourself over. In general, I identify very much with the idea of transforming and using music and beauty and hair to do it. When I perform, I become someone else. I have an alter ego on stage—I'm definitely not Erika Jayne, the pop singer, twenty-four hours a day. I'm also just a regular woman.

Making me into a queen was his idea, and his alone—I mean, I've got an ego like any creative artist, but I'm not so bold as to call myself a queen! Still, I was so excited to be transformed that I was the perfect victim. I'd have let him do anything. And as a performer, of course I love having the spotlight on me. But I don't see myself as the queen. When you're on stage, and leading a crowd, you do have to carry yourself in a special way, but you don't want to project the image that you're above the audience. That is, you don't want to be *of* the people, like a queen is, but *with* the people. You want to be right there with them, right there in the pit, enjoying the moment as they enjoy it.

I don't do red lips every day or very often at all. When I do my own makeup, it's light lips, light cheeks, some quick eyeliner. I try to keep it clean and easy. At night, I'll go a little heavier on the eye, some smoky liner and mascara. But when you perform, everything is bigger, more expressive, more alive. You want to feel excited and different and encourage your audience to feel the same, to find an escape. You want to help them feel excited for the future. That's where makeup comes in. It really can enhance the specialness of a situation.

I identify very much with the **idea of** transforming, and using music and **beauty** to do it. When I perform, I become someone else.

—Erika Jayne

3

starting the day

LISTEN UP, LADIES (and gents): Just because you're "only" going to work (or to the mall, or out for coffee) doesn't mean you shouldn't pull yourself together properly. Every day is an opportunity to present your best self (and you never know who you'll run into!). I start many of my mornings with a trip to Coffee Bean & Tea Leaf a few blocks from my apartment for a coffee (double espresso, please—I'm not exactly a morning person). Even on my most tired, been-working-nonstop days I make sure I look halfway decent. I'm not saying you should go all glamour shots for your afternoon errands. But if you show up anywhere, even the dry cleaner's, looking like a slob, it's almost guaranteed you'll run into someone who should not see you that way: an ex, a boss, a client. In the next few pages, I'll show you how to create makeup that looks natural without looking like nothing—and which will serve as the base for more advanced styles to come later in the day.

the girl next door

THIS MODEL REMINDED ME OF VANESSA WILLIAMS. She has a really pretty mouth, with full lips and dazzling eyes. Because she has such clear skin and a beautiful skin tone, I thought it was important to keep her skin open—and not lose the ethnicity of her—so I chose to work with burgundy and rose tones. When you have great skin, you give yourself the option of using makeup to enhance your look, not cover it up. After all, makeup is about celebrating who you are, not fighting it.

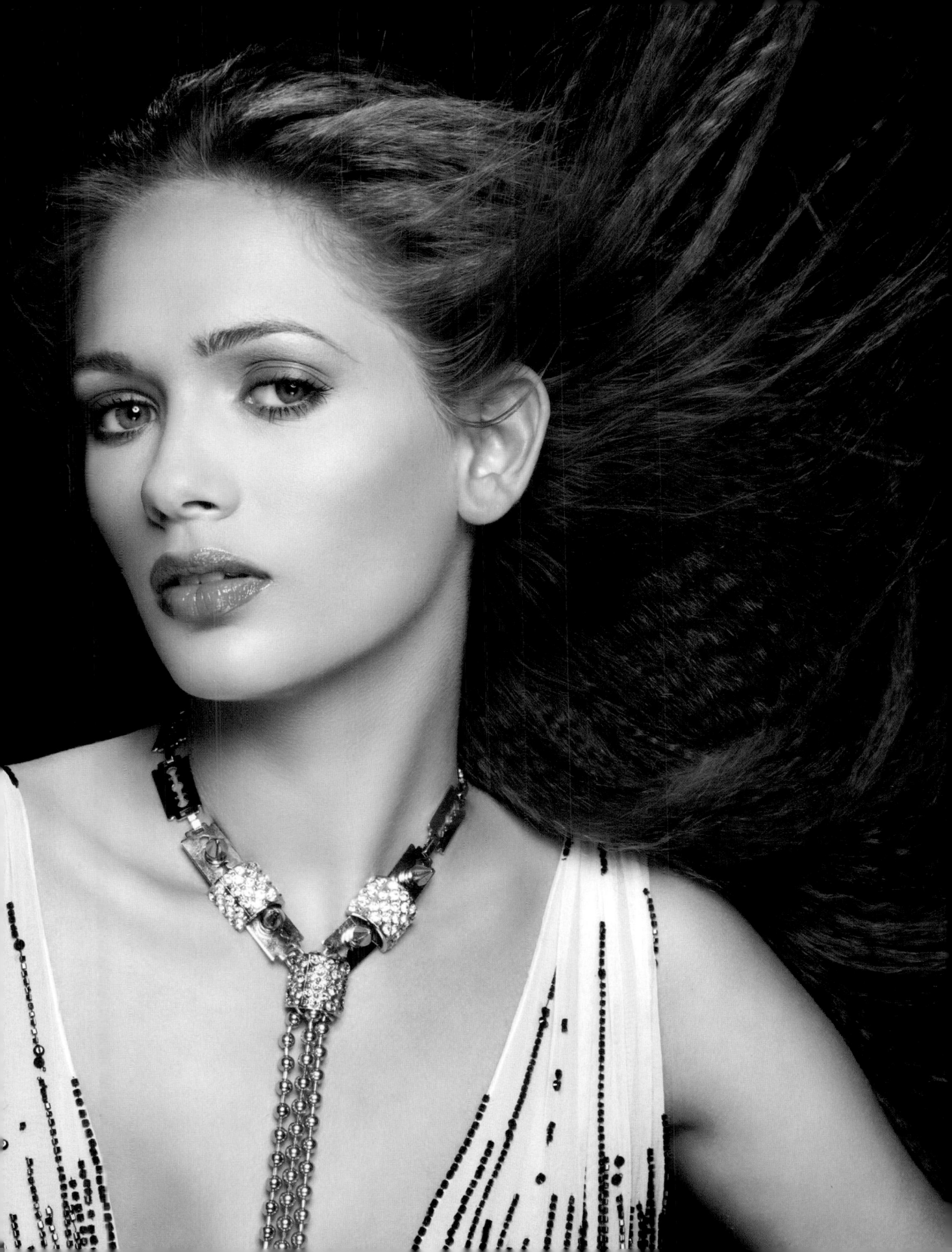

HOW TO: THE PERFECT BASE

Creating the perfect base is easiest when you've been taking care of your skin, which means it's hydrated and as blemish-free as possible. Start with a cream-based foundation in three shades: one that matches the tone of your skin; one that's a single shade darker, for contouring; and a concealer that's lighter, for highlighting. I always use a brush to apply; over the years, I've found that using brushes gives you far better control and smoother blending than using your fingers can.

1 Apply the darker foundation in the following places: beneath the cheekbones, on the sides of your nose, at the inner eye where the bridge of the nose meets the brow bone, and at the temples. Then apply the lighter concealer in these places: beneath the eyes, on top of the cheekbones, beneath the brows, on the bridge of the nose, and at the center of the chin and forehead. Lastly, using a separate brush, apply the foundation that matches your skin tone directly on top of the lighter and darker shades, gently blending in a circular motion. Set with translucent powder, dusting along the T-zone (chin, bridge of the nose, forehead, and under eyes).

2 Once you've got the base down, you can play around with the rest of the face. For this model, I went neutral on the eyes, with a beige palette, no eyeliner, and a single coat of mascara on both the top and the bottom lashes. (I'm a huge fan of using mascara on bottom lashes—it opens up the eyes.) Combined with the fresh, dewy base look, this makes for a great everyday face.

3 For the lips and cheeks, I relied on rose tones to create a "naturally flushed" look. To do this, choose shades that are slightly darker than your actual lips and cheeks. Here, I used a lip pencil and gloss in a berry color, which plays well with yellow skin tones, as opposed to yellow-, beige-, and tan-based lip colors. I applied a small amount of cream blush to the apples of her cheeks. Lastly, I set her brows with a brow brush and a bit of hairspray. And then she was off.

4 Later on, if she's going out, this is an easy look to add more drama to, focusing on playing up those gorgeous green eyes.

5 A note on primers: Primers have become increasingly popular in recent years. Gel- or cream-based, most primers promise to fill in lines or wrinkles and otherwise smooth skin to prep the face for makeup. Although primers can serve a purpose, I generally avoid them. I've found they work great at first, but can too often break down just a few hours later, taking your foundation and concealer with them. Instead, I prefer to make sure the skin is well moisturized before starting any application.

TIP: For the best control and smoothest application, use brushes for applying everything, even foundation and concealer.

I'm a huge fan of using **mascara** on bottom lashes— it opens up the eyes.

PRODUCTS

> Chanel Perfection Lumiere foundation

> Dior Skin loose powder in transparent medium

> Nyx lip liner in Barbie Pink

> Dior Addict lip polish in Fresh Expert

> Maybelline Great Lash mascara in blackest black

FRANK ON HAIR

There's a whole new genre of people being born today, and this girl is a prime example: She's a mix of cultures. She has such an exotic look; her face reminded me of a very pretty lioness. I wanted to keep that exoticism and even play it up. You don't want to make her all sweet and Miss America because then she'd look like any other white girl. Crimping is a very modern way to celebrate ethnic hair, at once playing up and taming coarser textures rather than trying to flatiron the hair into oblivion. What's more, you don't even need one of those '80s-era crimpers: You can use your flatiron to achieve this look, pressing the hair together horizontally in increments all the way down the hair from top to bottom. When I was done, I set the look with a very fine mist of Joico's JoiMist Firm hairspray.

TIP: Yellow skin tones call for berry lips—think raspberries.

TIP: When creating the perfect base, go easy. A light touch now will let you build on a look, reapplying later in the day without having to worry about a caked-on face.

How to: Approach cosmetic procedures

Women always ask me: Should I start doing fillers? Do I need a peel? Everyone these days is obsessed with anti-aging. That's why it's entirely possible—and here in L.A. too often probable—to go overboard. It's addictive! But in my opinion, there is nothing worse than applying makeup to a face that's been overfilled and frozen. It's smooth, sure, but it's expressionless, and it's too obvious. You don't want your enhanced cheekbones or your unnaturally pouty lips stealing the spotlight away from the rest of your beautiful face. The point of cosmetic procedures, as far as I'm concerned, is to make you look refreshed and well-rested.

So here's how I answer: Take a look around you. Where you live and who you surround yourself with really do matter. Here in L.A., there are more of the extremely groomed, plucked, augmented, and bleached, but there's also more of the extremely natural, the women who eat vegan, do yoga for three hours a day, and would never inject anything. In New York, there are more professional women who'd opt for injectables, but do so generally in a more natural, subtle, "I don't want anyone to know" way. In L.A., there's a tendency to want everyone to know everything.

Once you know the sort of look you might fancy, find a good, board-certified doctor. (I'll always steer you away from "quickie" med spas.) Describe to your doctor the look you're going for, and ask when she thinks might be a good time to start. As I mentioned, I tend to like a more natural look, which can often be achieved by starting out early to work more preventatively: a little—and I mean a little—Botox in your late twenties or early thirties can nearly prevent those wrinkles from ever developing at all. Then maybe you smooth the laugh lines or those folds near your mouth as you get into your mid-thirties, using injectable fillers like Restalyne and Juvéderm. You might also consider chemical or laser peels. But don't overpeel—once every other month is usually enough.

the effortless beauty

SHORT HAIR IS SOMETIMES ASSOCIATED WITH BEING VERY BOYISH, and depending on your height and body type, short hair can indeed lend an androgynous look. In fact, our next model may be best known for her androgynous work with Prada, though in those ads she looks nothing like she does here. (Androgyny is very much in fashion, and she works constantly.) But on her off days, she wants to look like a woman. And as a mom, she wants the look to be low-maintenance. That's why she has short hair in the first place.

There's no reason not to be pretty if you have short hair. In fact, short hair can be even more chic than long hair—just ask Frank, who's known around L.A. for his short cuts. The key is to create balance, which means keeping your makeup feminine and pretty. A softer look works well in this instance. Think about it: The haircut is fairly severe. You don't want the face to be.

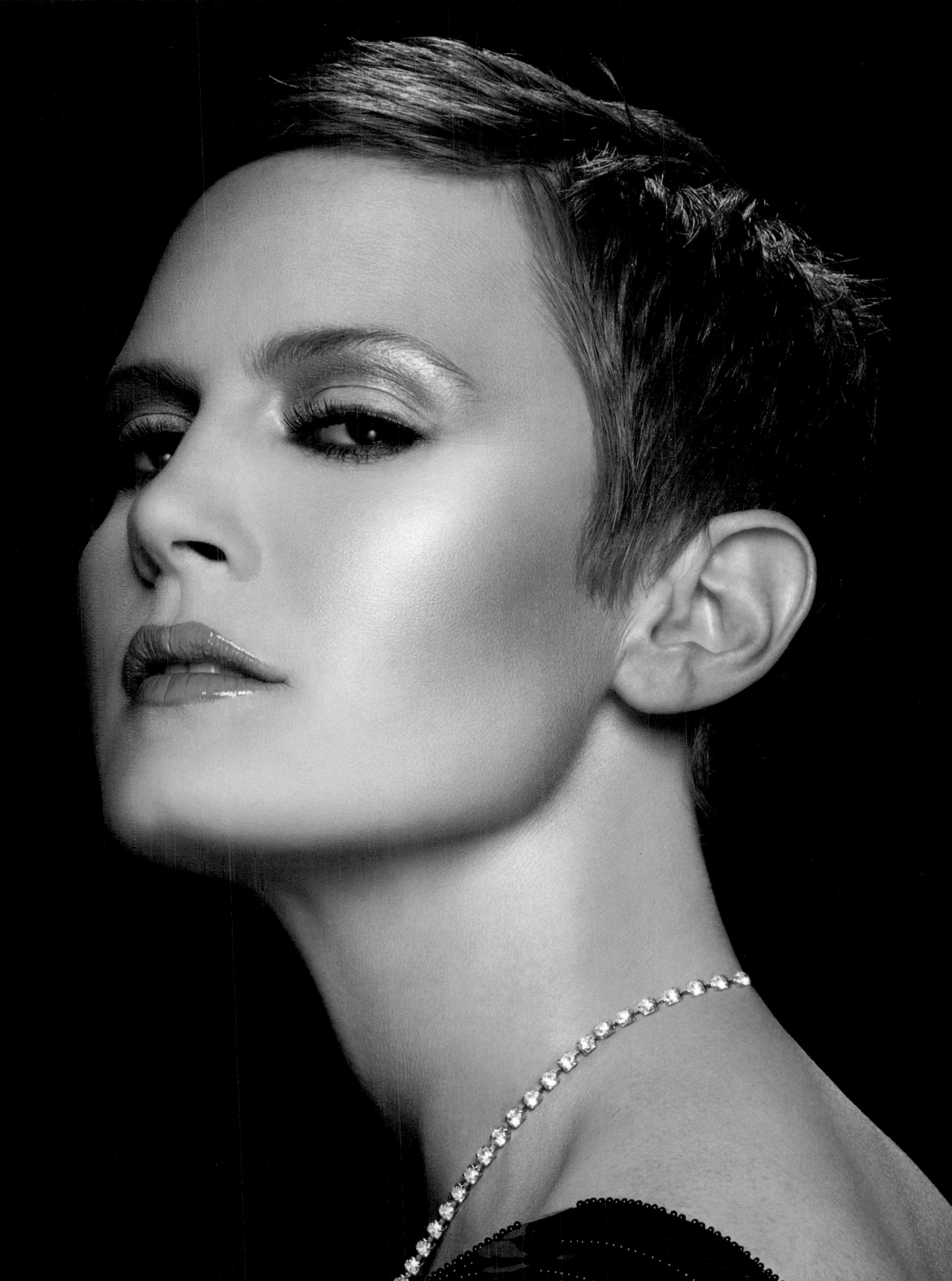

HOW TO: HIGHLIGHTING

Highlighting is essential in creating a no-makeup makeup look. For this model, I tried to frame her makeup around the color of her hair so that her lips, eyes, cheeks, and hair all coordinate, which gives a more natural appearance. A monochromatic palette will also make her blue eyes really pop. I skipped the contouring and went right to the highlighting. Highlighting seems like it could be complicated—people think it will make them look "shiny," and that's absolutely not true. In fact, it's really quite simple.

1 Choose a cream foundation or concealer that's one or two shades lighter than your natural skin tone. I used a pink highlighter on this model. Although a lot of pale-skinned women make the mistake of using a white highlighter, white highlighter can often turn warm skin ashy, so I tend to avoid it, even on the palest skin tones. Using a highlighter brush, apply the foundation using light, feathery strokes on top of the cheekbones, on the brow bone, beneath the eyes, and on the bridge of the nose. If your skin is in good condition, you won't even need to apply foundation on top of this, though I did here. I chose a gold-toned foundation, because gold works well to neutralize the ruddy skin that's common in redheads.

2 To highlight the cheeks, choose a shimmery highlight if you're pale. If you're dark-skinned, choose a highlighter with a warm, coppery tone. Using a highlighter brush, apply a light dusting to the top of the cheekbones, at the place where the light hits your cheeks the most—just enough to make them noticeable. Don't go overboard: When it comes to highlighter, more is not more.

3 The rest of the face should remain fairly neutral. On this model's eyes, I used an auburn eyeliner and shades of honey and auburn shadows. This worked to create a soft effect that's quite pleasing to look at, while downplaying such features as a small eyelid and a masculine brow bone. On her cheeks, I chose an iridescent blush. I kept her lips peachy-neutral, which helped downplay her thin lips.

4 In the end, we created a striking, yet subtle, look that can take her anywhere: to work, to pick up the kids, out to dinner. With a few layers of mascara, she can easily dramatize this look for evening.

TIP: Use gold foundation to balance out ruddy skin.

TIP: Choose a shimmery highlight if you're pale. If you're dark-skinned, choose a highlighter with a warm, coppery tone.

PRODUCTS

> Bobbi Brown Foundation stick in Porcelain and Honey

> Nars blush in Super Orgasm

> Guerlain Terracotta bronzing powder in 01

> Anastasia highlighting crème in Aspen

> Lancôme Le Stylo eyeliner in Bronze

FRANK ON HAIR

First of all, there's no such thing as a "boyish" cut. Having a short cut in no way likens you to a boy. I'm actually known for my short haircuts because I never cut a woman's hair like a man's. That's a common mistake. But I think short cuts on women need to have soft edges and a full crown. Otherwise, it can look too severe and "hard." I never cut a woman's hair so short that I need to use a razor; why would a woman want stubble on the back of her neck?

I find short hair very stylish on a woman. If you've got a really great short haircut, you can run around in a T-shirt and jeans and look amazing. Many women are afraid to go short. But if you can pull your hair back in a bun and look good, you'll look good with short hair. And it's so easy to manage: For this model, I did nothing but run a bit of Oribe Original Pomade through her hair to get a piece-y look. So easy.

TIP: Glowy doesn't mean greasy. Translucent powders are a great way to let skin shine through in a natural, more matte way.

trans-formations



ivana milicevic

BECAUSE IVANA HAS ALWAYS REMINDED ME OF DEBORAH HARRY—AND OF MY OWN YOUTH—I DECIDED TO TRANSFORM HER INTO MY ADOLESCENT ICON. I THOUGHT, WHO COULD DO BLONDIE BETTER THAN HER?

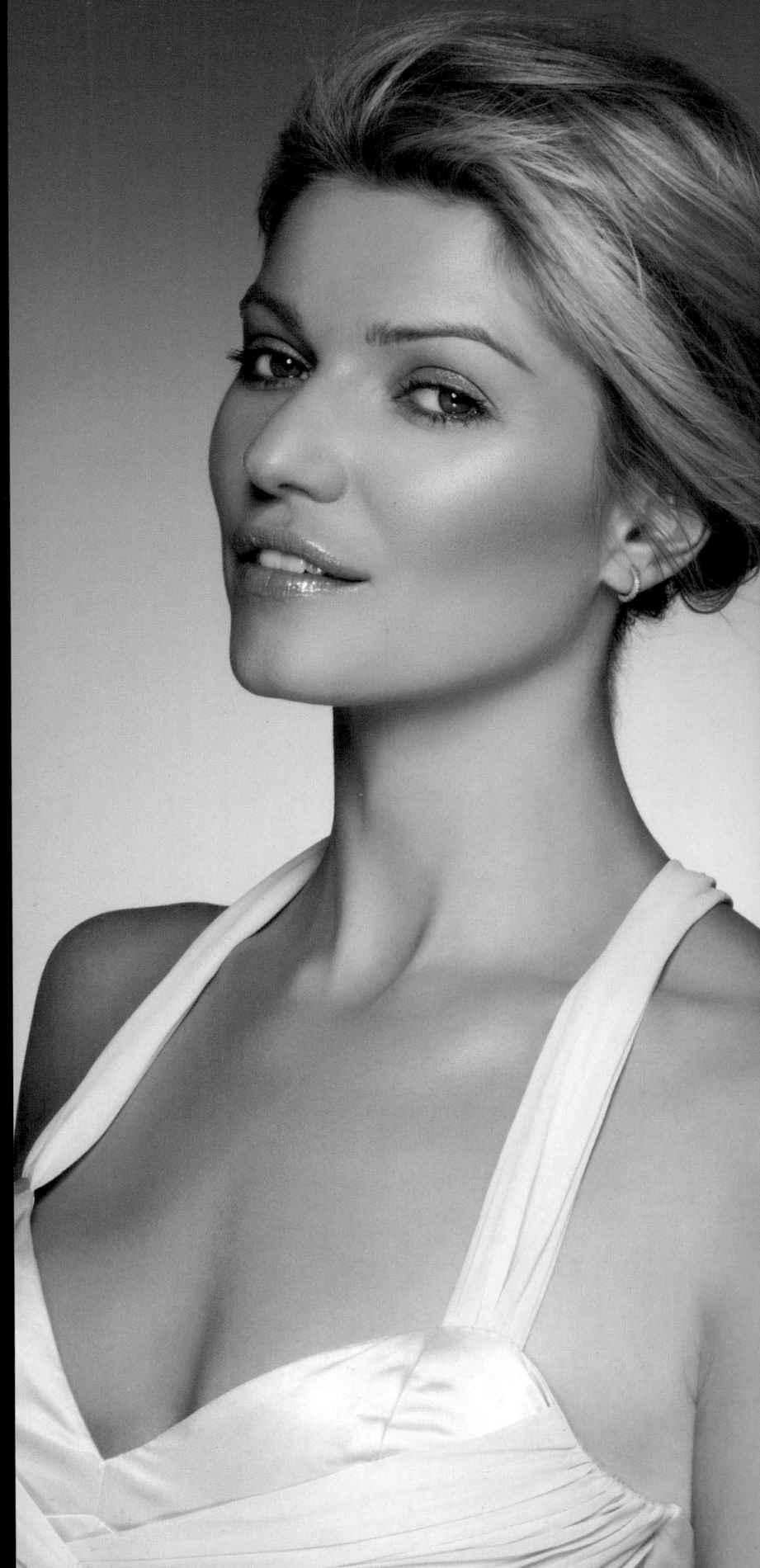

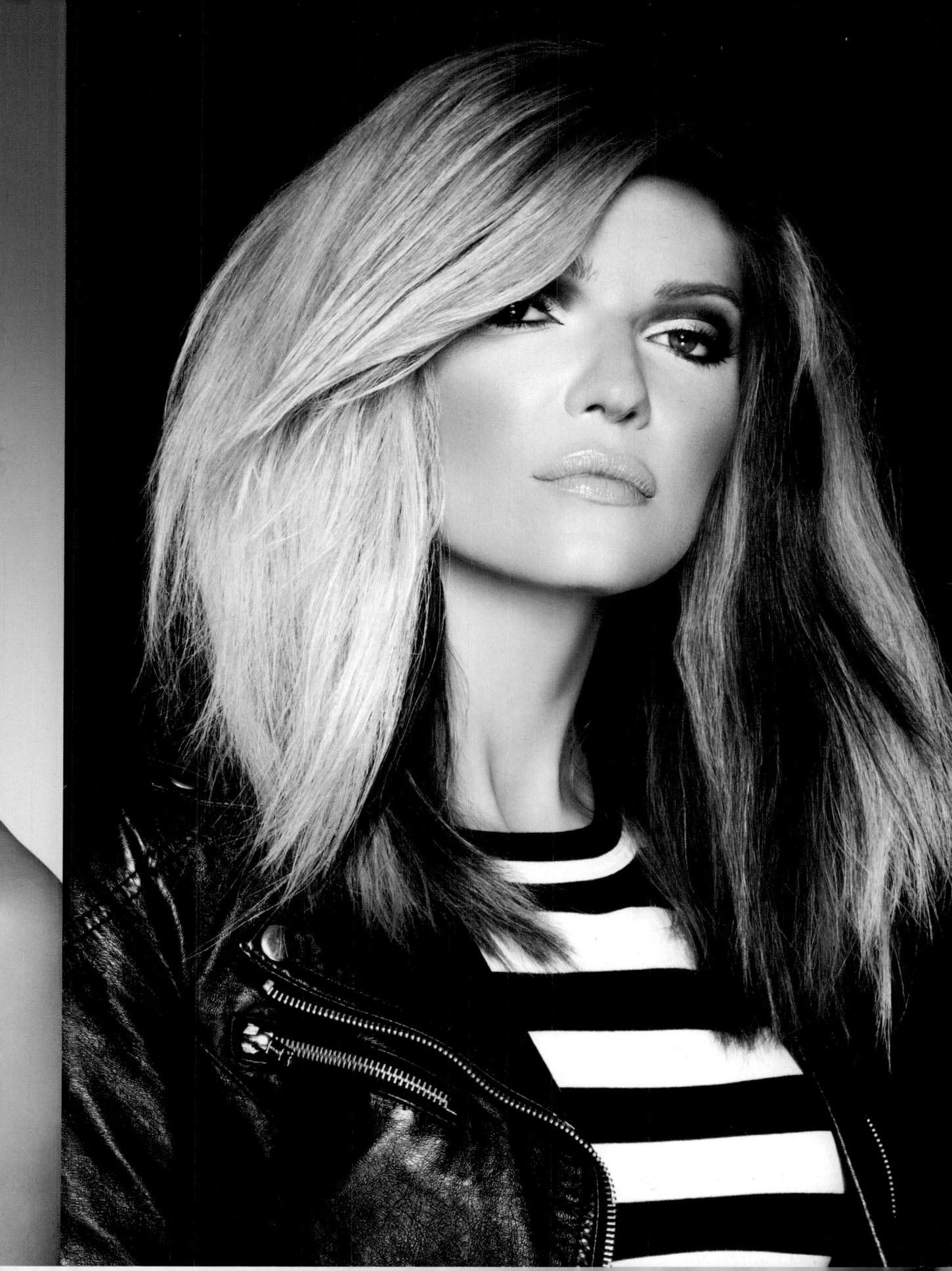

jeffree star

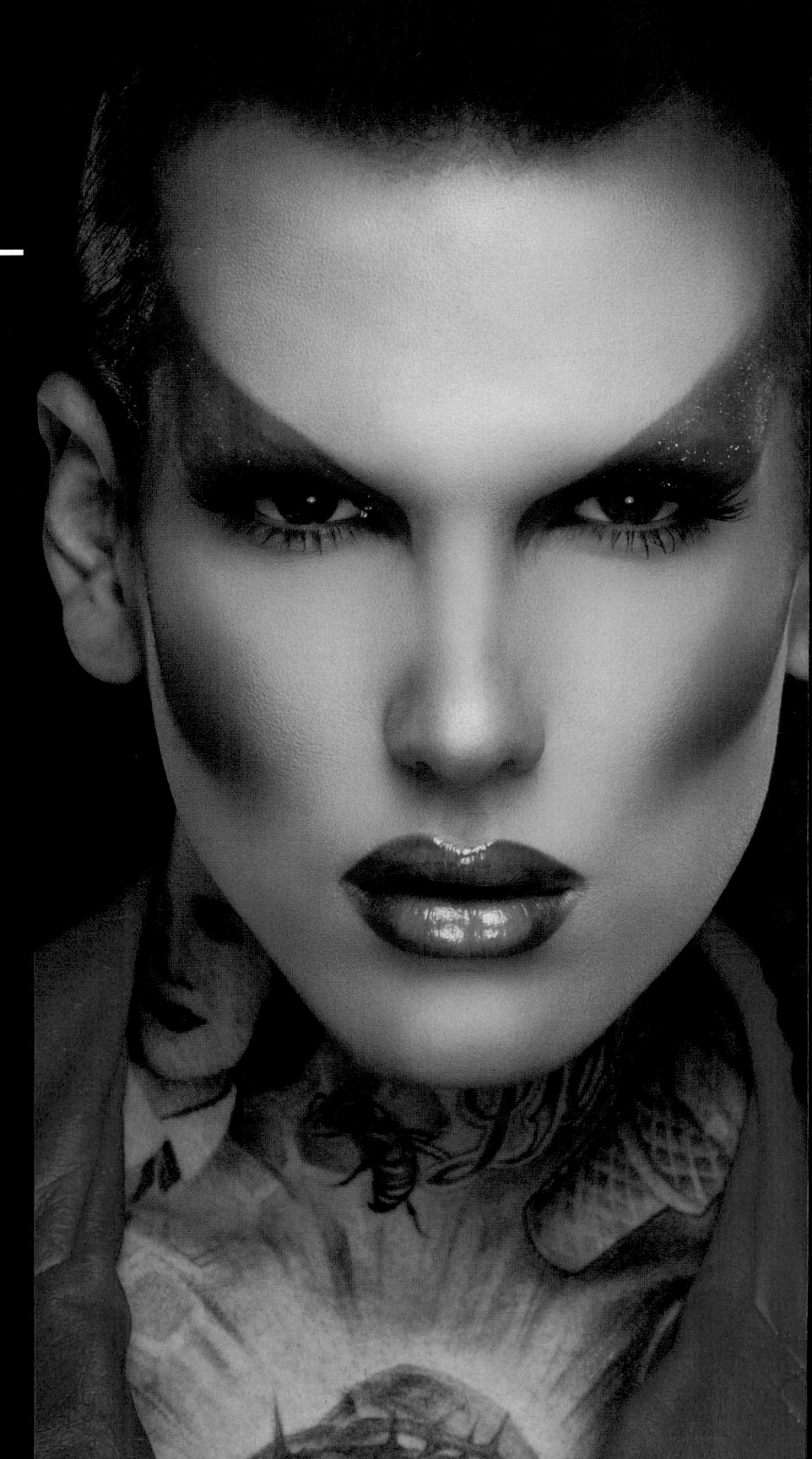

BENEATH ALL THE NEON MAKEUP, TATTOOS, AND MESSAGES OF SELF-EMPOWERMENT IS A RATHER BABY-FACED AND INNOCENT-LOOKING BOY, AND THAT'S THE SIDE OF JEFFREE I WANTED TO SHOW. AS A PERSON, HE'S NOT AT ALL HARSH—THOUGH HE DOES PRIDE HIMSELF ON PUSHING BUTTONS—BUT RATHER VERY SWEET.

Part of what drew me to Jeffree is his unapologetic sense of self. He's got this **confidence** that's rare in anyone, and it's infectious.

JeFree is an underground pop icon. He's a post-modern version of the kid who dreams of hitting it big—and comes to Hollywood to make it happen. There's not really one way to classify Jeffree. He works as a model, DJ, club singer, makeup artist, and fashion designer, depending on the day. He found his fans in that most millennial way: through *YouTube* and *MySpace*, where his music and dance videos have been downloaded millions and millions of times. Soon, he'll release an album produced by music mogul Akon. But he's probably best known for his very unique look, a transgressive, gender-bending androgyny that juxtaposes his masculine features—like the square jaw and 6'1" height—with pink hair and a penchant for neon makeup.

I am so inspired by Jeffree and his extreme individuality. He reminds me of David Bowie's Ziggy Stardust era, which was a big influence on me growing up. Jeffree definitely speaks to an audience that needs someone like him to look up to, someone who can't—or won't—be labeled or put into any sort of box. Although he was born and raised in fairly well-to-do Orange County, California, he didn't always have the easiest life: His father died when Jeffree was small, and his mother, a model, worked long hours away from home. Jeffree spent a lot of time alone, but that's also how he began to develop his creative side, playing around with makeup and music and clothes. I believe that people who draw inspiration from their disadvantages—rather than getting stuck in self-pity mode—are destined to overcome them. And Jeffree did just that. Eventually, he started working as a makeup artist, commissioned by celebrities like Nicole Richie, Paris Hilton, and Kelly Osbourne, and then branched into other pursuits as they struck his fancy.

Part of what drew me to Jeffree is his unapologetic sense of self. He's got this confidence that's rare in anyone, and it's infectious. He often speaks to his fans about the importance of self-image and self-esteem, and he advocates for the LGBT community through his performances. At the same time, he's always reinventing himself and pushing to uncover the true meaning of life and his purpose as a human being and an artist. He's always evolving, never sitting still, and amazingly productive.

Beneath all the neon makeup, tattoos, and messages of self-empowerment, though, is a rather baby-faced and innocent-looking boy, and that's the side of Jeffree I wanted to show. As a person, he's not at all harsh—though he does pride himself on pushing buttons—but rather very sweet. For our "before" shot, we went with the usual hot pink to-the-max look he favors—here is a man who seriously knows the transformative powers of makeup—but agreed on transforming him into a fashion-forward young man for the "after." Part of Jeffree's androgyny aesthetic includes a total lack of eyebrows—I'm not sure whether he's shaved them or waxed them, or perhaps lasered them completely—so the eyebrows here are ones I attached one by one with glue. I covered up his many tattoos—he has, he says, "too many to count"—and swiped his lips with a clear gloss. It's funny to me that his new look is one that might seem "traditional" but to Jeffree is so out of character, even a little perverse. It just goes to show you that there's no one way to define what's "normal."

the quick turnaround face

BY NOW, WE'VE DISCUSSED THE MANY WAYS in which feeling beautiful can elevate your confidence, improve your mood, and, well, help you feel more empowered to go out and get what you want from life. By facilitating beauty, makeup—the right sort of makeup, that is—can help get you there. The only problem: Who has the time to give herself a full-on makeover every morning of the week? Or in that sliver of the day between work and your drinks date with the girls? Not you! I know that, on average, most of you aren't willing or able to spend more than a dozen or so minutes on makeup. Fear not: You don't need to.

the weekday face

HERE'S THE SCENARIO (tell me if it sounds familiar): You got in late from a night out with the girls, your alarm didn't go off (or maybe you forgot to set it), and you have about half an hour to get ready or else you'll be late for your morning appointment. Don't panic. As I've done with this model, a fresh, flawless face can be had in six easy steps, with a time investment of 15 minutes, tops. (Just don't do this while you're driving—please! I see so many women trying to apply mascara while they're driving to work or to an audition, and they're in the wrong lane.)

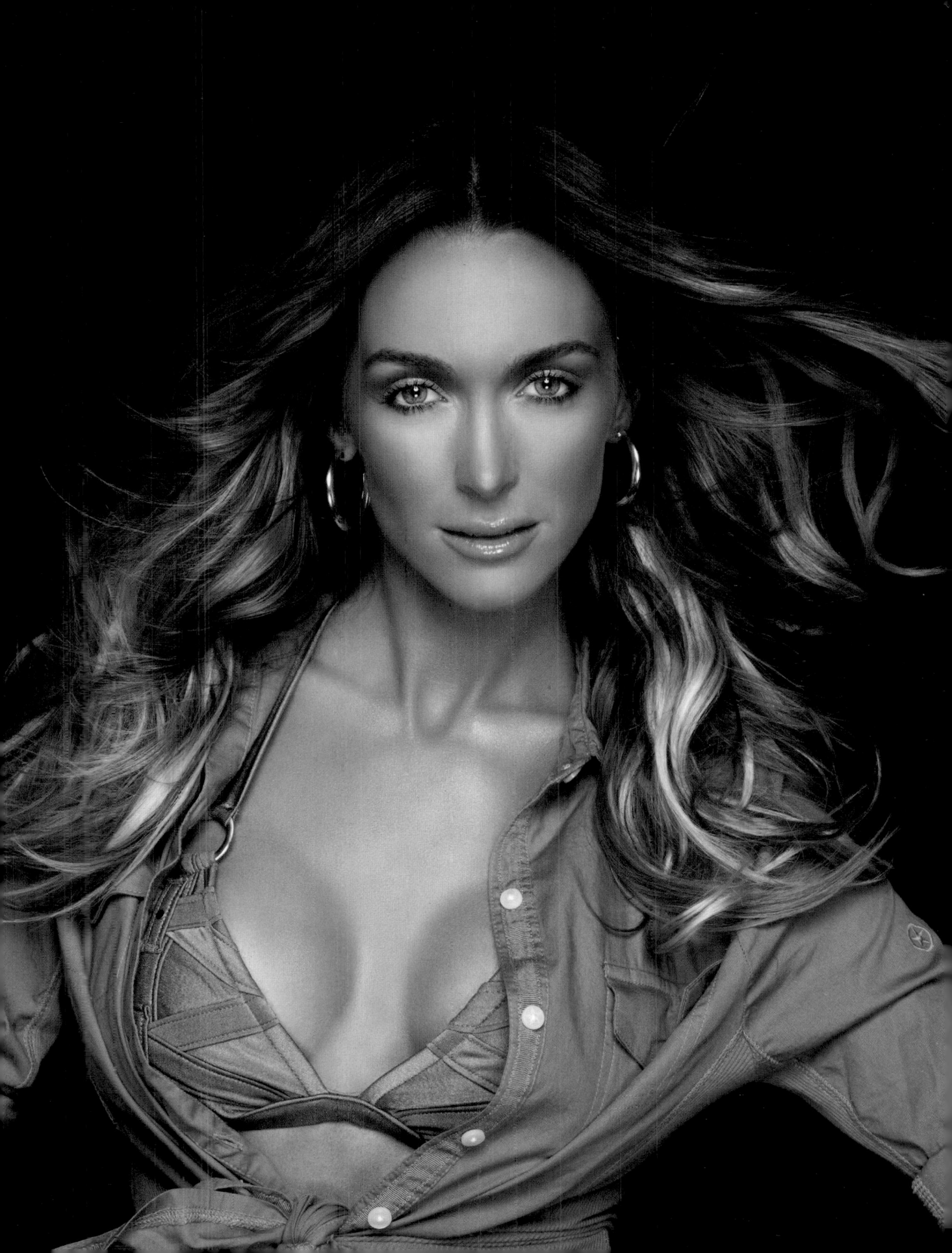

HOW TO: THE 15-MINUTE FACE

1 Moisturize. Start the day, always, with a good eye cream and moisturizer. Eye cream should be applied along the bone of your eye socket—both below the eye and above it, near the brow line—with special attention paid to laugh lines. Just don't put eye cream right at the inside corners of your eyes. That can block the tear ducts and actually create under-eye bags. Wait a few minutes after you moisturize and then use a tissue to blot your face. You want your face to be supple, but you don't want the makeup to slide right off of it.

2 Conceal. Applying concealer beneath the eyes will give the illusion that you've actually rested. Using your finger, dab it right up under the lash line, from corner to corner. You can also use concealer as a highlighter: on the center of your chin, the tip of your nose, the middle of your forehead, and the top of your cheekbones, forming a C shape from the end of your eyebrow to the top of your cheekbone. You can also apply a little concealer in any creases around the nose because it's a popular place for broken capillaries. And be gentle—you don't need a lot of concealer for it to do what it needs to do. Go light.

3 Apply foundation. I always use a cream foundation. I think cream foundations work best because they combine with the skin's heat to mold and blend seamlessly. Often, liquid foundation skips, or grabs in dry spots, making it look obvious. It doesn't moisturize skin, unlike cream foundations. Apply with a brush, working in a circular motion from your collarbone up to your neck, and then onto your face. The circular motion keeps the foundation from being too heavy and helps create a soft, even appearance, while also saving you on foundation—you're not burning through product, just creating a thin base of color.

4 Add color. With blush, placement is everything. Load the brush and then tap off the excess. (Unlike with foundation, I prefer a powder blush to a cream because it allows for a more natural application.) In a circular motion, apply color to the apples of the cheeks. Set the face with a translucent powder—always translucent. Because you've already chosen a foundation that matches your skin tone, you don't want your powder to change the color of the foundation. Don't forget to powder the eyelids, though go easy under the eyes—too much powder there can create makeup face. And wipe away any excess with your brush. The key to creating natural makeup is to really work your brushes—blend and blend until you can blend no more!

5 Set the eyes. Curl your lashes with an eyelash curler and then lock in the curl with a quick coat of mascara. Start with the wand at the base of the lash line, load it up with mascara, and then pull it out and up—this will help avoid clumping and get the darkest results with the fewest coats (one!). Then choose an eye shadow. For day, I suggest staying in a neutral palette, like beiges and browns. Load up your eye shadow brush and tap off any extra. Apply the shadow to the lid from the crease to the ridge of the brow bone, to create depth. Then use a short shadow or liner brush to apply the same shadow beneath the eyes, really close to the lash line. Blend with your finger.

6 Line the lips. Find a lip liner that's close to your natural lip tone. Draw in faint lines along the edge of your lip. Don't go too heavy—a little definition to keep the gloss in is all you need. Resist the urge to overdraw to give yourself fuller lips—all you'll give yourself is a clown face. Instead, to create the illusion of fuller lips, use the liner to connect the two lip peaks just below your nose. Feather and smooth out the liner using a lip brush (some better liners come with one). Then fill in with gloss. For day, you don't want anything too shiny or glossy—a little bit of shine is okay. Find a neutral shade that works with your skin tone and daytime wardrobe and apply with your finger, in a vertical manner, from the inner part of the lip outward.

TIP: Don't let your makeup be distracting. During the day—whether you work in an office or in a creative field—people shouldn't be looking at your makeup more than they're listening to what you have to say.

PRODUCTS

> Japonesque Precision lash curler

> Body Bling Platinum

> Georgio Armani Luminous Silk foundation in 05

> Make Up For Ever Star Powder eye shadow in Copper

> Dior Addict Lip Glow

FRANK ON HAIR

This model really is the fresh-faced, California girl next door. I wanted to give her big, but effortless, hair. I used a bit of Oribe Original pomade on her wet hair, avoiding the roots, and dried her hair until it was almost completely dry. Then I worked in a few soft rollers, in smaller sections around her face and in bigger sections on the sides and back, and dried the hair completely. I created the loose waves by running my fingers through her hair, with a bit of pomade. You really can't go wrong with this style; it's meant to look effortless because it pretty much is.

TIP: To create the illusion of fuller lips, use the liner to connect the two lip peaks just below your nose.

TIP: To get a great eyelash curl, warm the metal of the curler with your fingers. Then place the curler as close to your lids as possible—get in there really tight!—give a good pinch, hold for maybe 10 seconds, and release.

Finding the Right Foundation

Listen, we've all seen those ladies on TV whose neck is white and face is brown. We don't want that.

1. Make sure your face and neck know each other. The best place to match your foundation with your skin color isn't on your wrist or even your face—it's on your neck, just below your chin, where the sun never shines.

2. You want to match your foundation to the lightest skin you've got so that you don't get that pancake makeup look.

3. Always use a foundation brush to apply. I like goat-hair brushes.

4. Apply in a circular motion until fully blended.

xhoana xheneti

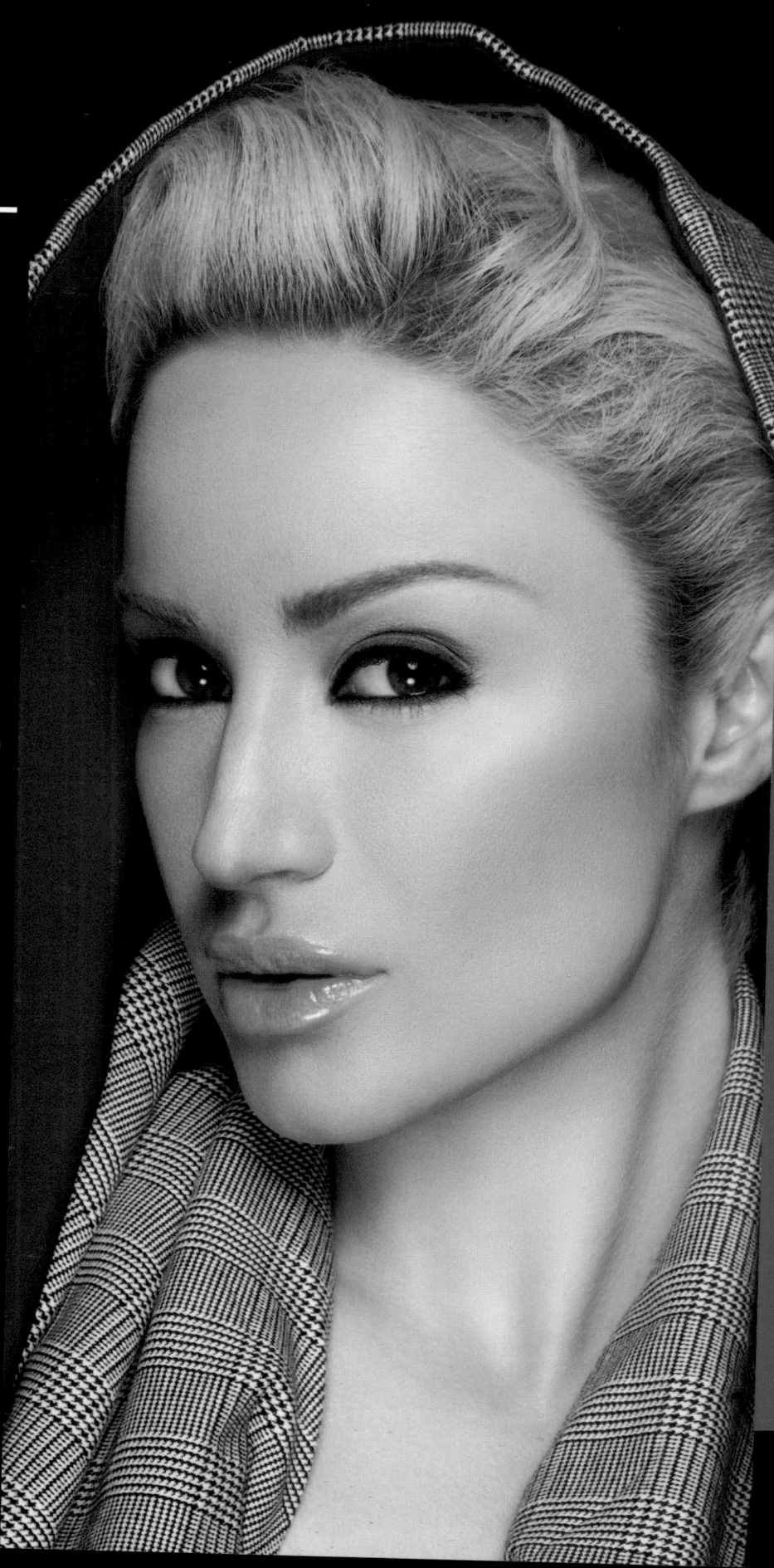

XHOANA DOESN'T WANT TO *BE* MADONNA—SHE HAS A STYLE ALL HER OWN. BUT I SEE A LOT OF MADONNA IN HER: SHE'S CROSS-CULTURAL, EXPERIMENTAL, AND FEARLESS. LIKE MADONNA, XHOANA STARTED OUT AS A DANCER. AND I KNEW THAT—NOT UNLIKE THE MATERIAL GIRL—XHOANA WOULD BE UP FOR ANYTHING.

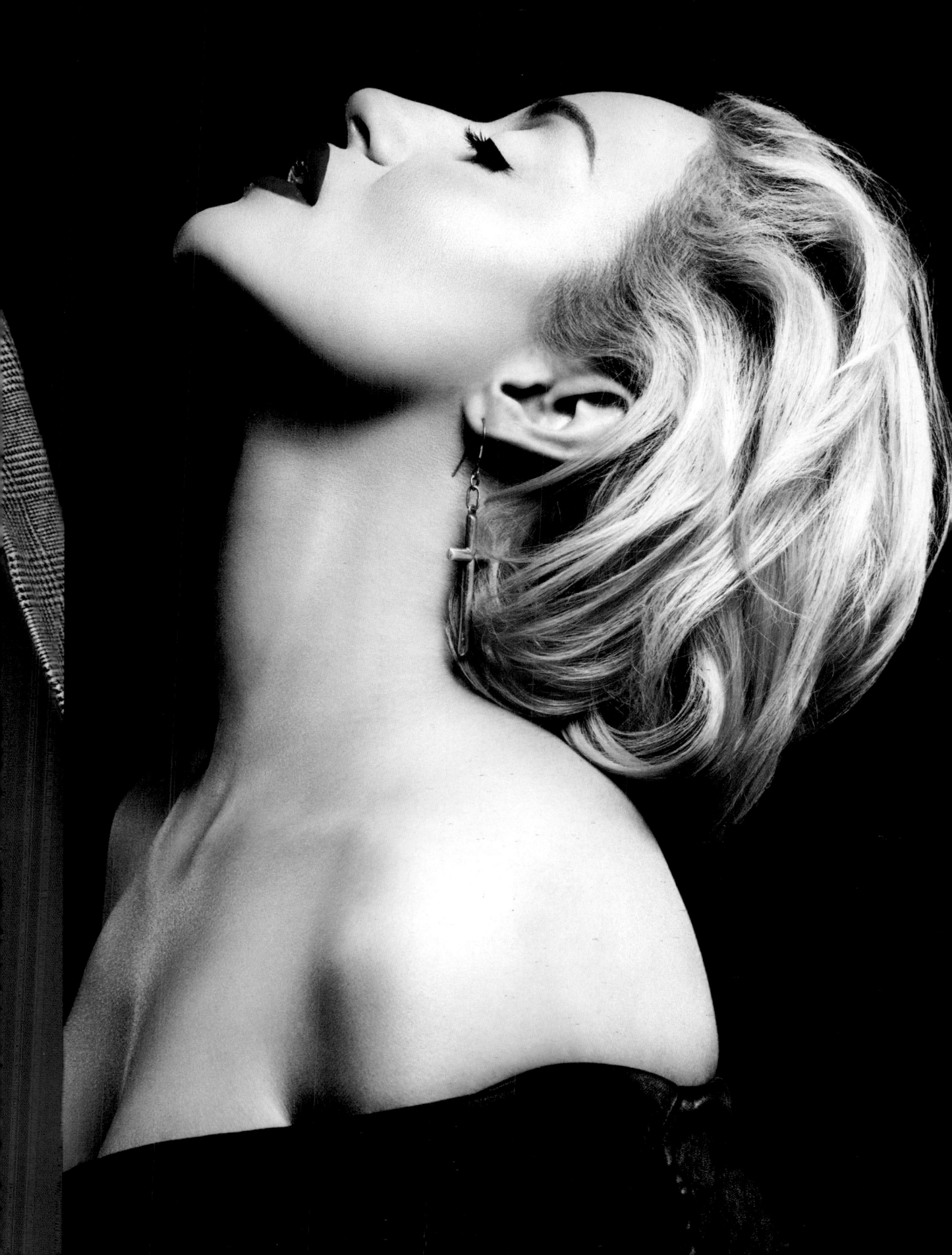

Believe me, when Xhoana is singing, you **can't** *not* dance.

Xhoana is an Albanian beauty (the *Xh* in her first and last name is pronounced like a *J*, as in *Joanna*). She is one of the many girls who come to L.A. with a dream: In her case, to make it big as a pop and dance star. And she's well on her way, performing regularly in clubs and music venues throughout Hollywood and West Hollywood and garnering a following with her electro, "superpop" beats and sweet vocals in upbeat songs like "Dolce Vita" and "Ride It," inspired by the classic film *Rebel Without a Cause* (which, by the way, Xhoana totally is). As a performer, she's glittery and inspiring and infectious and a little bit naughty, all at once. Believe me, when Xhoana is singing, you can't *not* dance.

I decided to use makeup to turn Xhoana into Madonna because, well, what's a Hollywood reinvention story without Madonna? Madonna is a woman—a legend, really—who has made a decades-long career out of constantly reinventing herself. It's exciting, and it keeps her fresh. No matter what stage she's in, Madonna is never boring. Everyone I know favors a specific Madonna. Are you into tomboy Madonna? Material Girl Madonna? Ashtanga, yoga-buffed Madonna? See what I mean? Never the same.

Xhoana doesn't want to *be* Madonna—she has a style all her own. But I see a lot of Madonna in her: She's cross-cultural, experimental, and fearless. Like Madonna, Xhoana started out as a dancer. And I knew that—not unlike the Material Girl—Xhoana would be up for anything. We chose Madonna as she was portrayed on her *True Blue* album cover, circa 1986: glamorous, sexy, head thrown back and all throaty as if she had all the self-confidence in the world, even though she was only twenty-eight at the time. Xhoana's transformation was a snap; the girl is beautiful. The lips and nails are red and pouty, the eyes are bare, and the porcelain skin is flawless. Best of all, though, is her huge heart of gold, which needed absolutely no help from me at all.

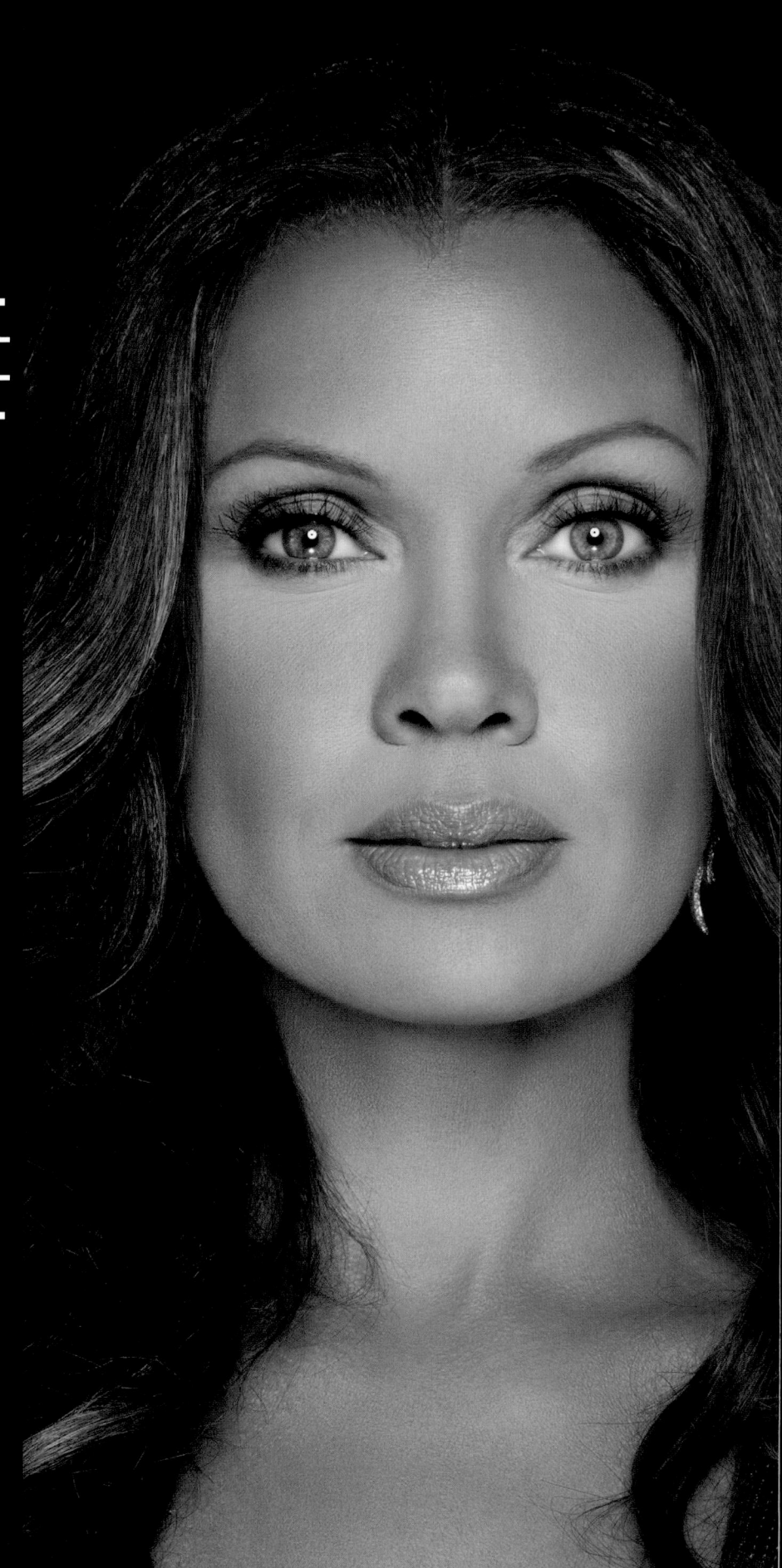

vanessa williams

VANESSA WILLIAMS IS MANY
THINGS TO MANY PEOPLE—IN
BOTH HER PERSONAL AND
PROFESSIONAL LIVES—AND I
WANTED TO HAVE SOME FUN
WITH THOSE VARIOUS SIDES
OF HER PERSONA.

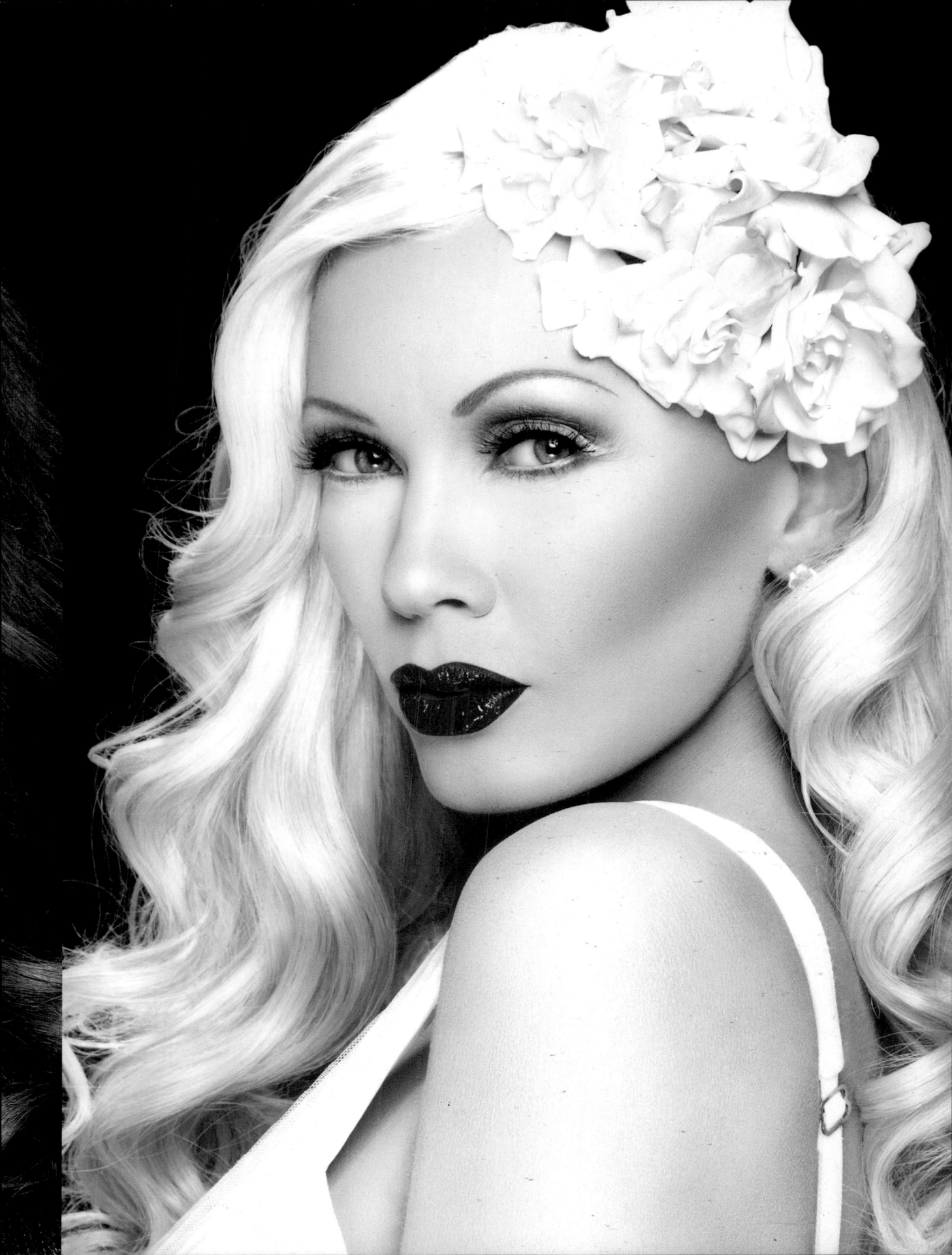

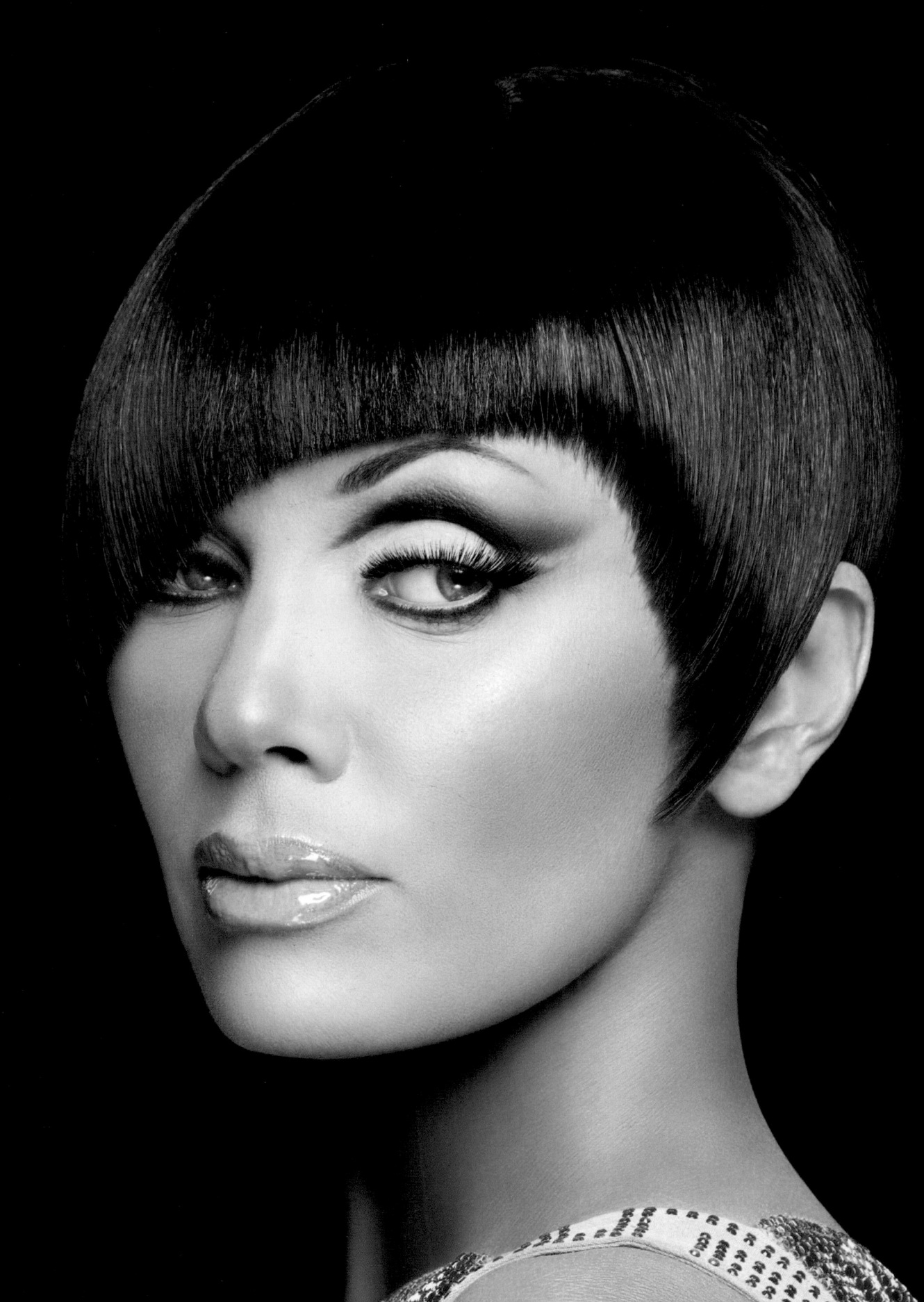

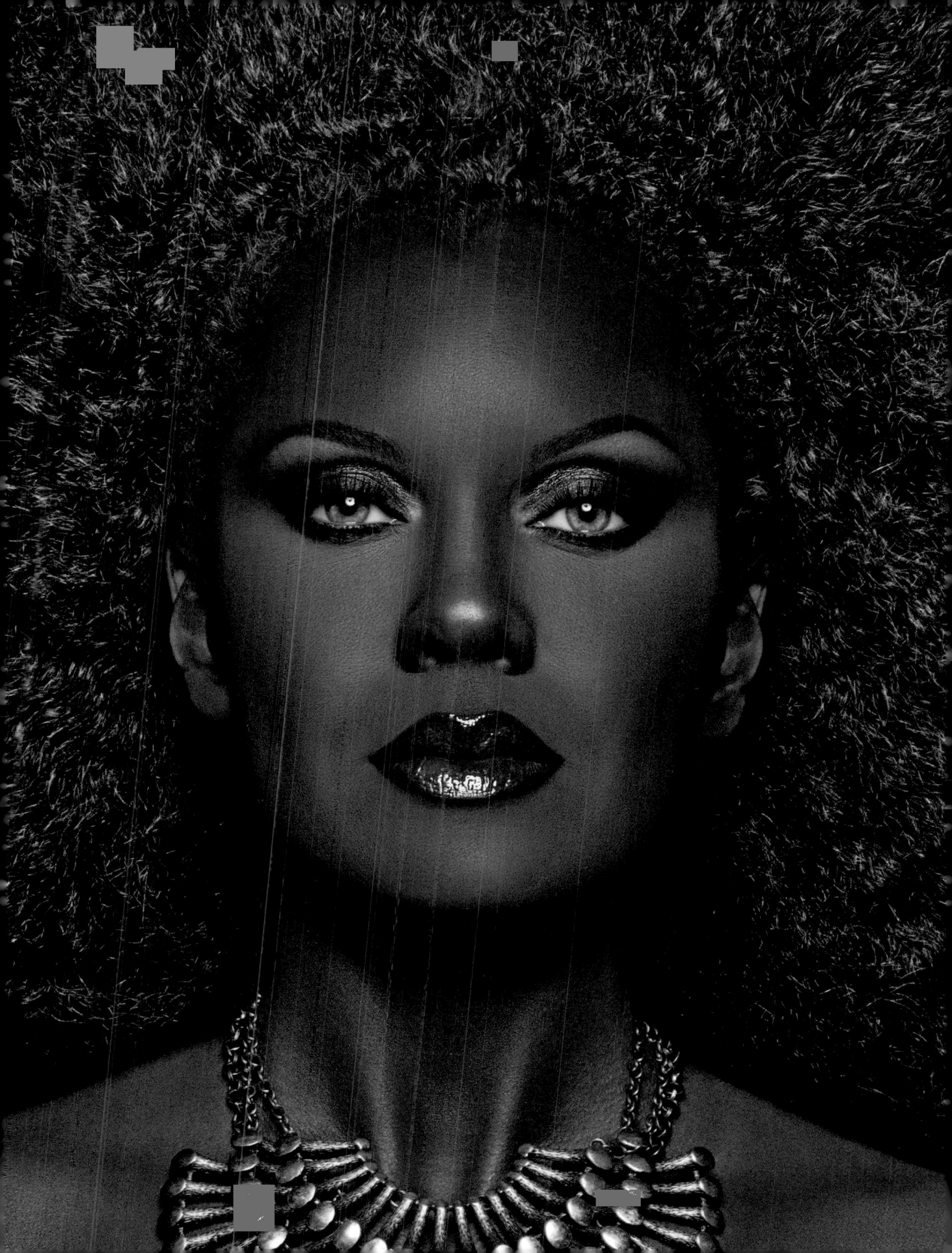

Vanessa commands **respect** without being bitchy, and let me tell you—that is rare out here in these parts!

Vanessa has had such an amazing life—from beauty queen (the first black woman to be crowned Miss America!) to chart-topping singer to amazingly talented film and television actress. And let's not forget mom (to some seriously well-mannered kids, by the way). And she's still going strong, every single day. What I love most about Vanessa is that she's such a fighter, and has overcome so many obstacles in her life but that she's not combative. She's one of the kindest and most pleasant people I've ever worked with, always laughing and smiling, without that need to control everything. She commands respect without being bitchy, and let me tell you—that is rare out here in these parts!

Of course, Vanessa's winning attitude is likely due to the fact that she doesn't need to try to be anyone else. She just is. It's because of this confidence that I wanted to make her the centerpiece of this book. Vanessa is many things to many people—in both her personal and professional lives—and I wanted to have some fun with those various sides of her persona. The first look is pure red carpet Vanessa: Classic, strong, sexy—the look, and the woman, that ties all the others together. In the Veronica Lake homage, I sought to make a statement about Vanessa as a classic beauty, while also calling attention to

Vanessa's white heritage. I made her skin tone really fair, and Frank gave her a platinum blonde wig with fresh gardenias. For the '60s transformation, I envisioned putting a super-stylized, Peggy Moffitt–spin on the Diana Ross look. Just transforming Vanessa into Diana Ross would have been too obvious; the mod flair was our way of putting our own, modern stamp on it. Plus, I don't think anyone's ever seen Vanessa with super-short hair, and I was fascinated by how this could totally transform a look. The Nubian princess transformation—which was Vanessa's own idea—was just over-the-top drama coupled with raw, natural beauty, and I loved that I could give life to her vision.

By far Vanessa's best quality is her ability to make others feel grounded and safe and as if she'll always be there for them. If I need her, I know I can always reach her. That's a tough thing to do when you have that many people surrounding you all the time. I'm honored and grateful to call her a friend.

VANESSA SAYS ...

The most amazing thing about Scott isn't that he's an artist. Of course he is—but there are lots of those around L.A. Scott is a genius. And I don't toss that word around casually. Over my long career, I've worked with countless makeup artists. Unlike most, Scott knows how to get exactly what you ask for, as well as what you didn't even know to ask for. That's the difference between someone who's an artist and someone who's brilliant.

The first time we worked together was in New York, for an *E!* taping. While I was filming *Ugly Betty*, Judith Light had come to the set with Scott's first book, which she was featured in. He'd gotten his hands on her and totally transformed her, and I couldn't get over how exquisite she looked on those pages. So I called him, and we've worked together hundreds of times since. Scott just makes my day so much easier; how I'm going to look becomes one less thing to worry about. And he's not just servicing the makeup, but constantly reinventing his technique all the time. While I'm always surprised by what he can do, I trust him completely. I never stop during the process or question what he's doing, even when I don't recognize myself. Now that he's living near me in Los Angeles, I'm lucky enough to call him a dear friend, too.

So of course I agreed to take part in this book. When Scott was first describing some of the looks he wanted to create, I got so excited. As an actress, I'm always channeling other characters, and this was a chance to embody four different personalities in a purely physical way. The Nubian princess was my idea, something I wanted to try simply because I never had. When he was prepping me, there was a mirror to my right. At one point, I turned and caught a glimpse of myself and was like, Whoa—who is that? He made my skin tone a few shades darker—it was crazy, and surprisingly liberating.

Together, the set-ups really challenged the notion of beauty and race, which I found fascinating. Over the years, I've worked with makeup artists who don't necessarily know how to handle my skin. Some want to make it darker; others want to make it lighter. The difference with Scott is that he's never, ever looked at me as either black or white, one or the other. He's just looked at me as a woman. He knows how to carve out a woman's best features and make her look healthy by working with bone structure and shadow, and that has nothing to do with the color of her skin.

Scott knows how to carve out a woman's best features and make her **look healthy**, and that has nothing to do with the color of her skin.

—Vanessa Williams

the first-aid kit

HANDS DOWN, THE BEST TIP for achieving flawless makeup application is to start with skin that's been well taken care of. Although makeup can cover up blemishes, it can take a lot of work to hide flaws in a natural way. Better to put that effort into helping ensure your skin stays healthy and vibrant in the first place. The good news is that it's never been easier to maintain healthy skin. Science has helped educate us on what it takes to keep skin clear, and there's an abundance of effective skin-care products—some high-end, some affordable—designed to make good skin possible.

makeup-ready skin

CLIENTS OFTEN ASK ME: "How does [insert celebrity name here] look so good? It must be genetics." And while, yes, genetics does play a significant role in skin health, the simple, basic truth is that good skin is the reward for diligent care. Celebrities with good skin work at it, just like the rest of us do. They eat right, get enough sleep, limit their alcohol intake, and exercise regularly. They wash off their makeup before going to bed, and they visit their dermatologist whenever they're experiencing an unusual flare-up. They drink lots of water.

Maintaining good skin is pretty basic, after all, and can be achieved by following one simple tenet: You get what you give. The better care you take of yourself, the better your skin will look. That is, the healthier you are on the inside, the healthier you will look on the outside. For this model, I sought to create a natural, no-makeup look. Her short, boyish cut reminded me of the androgynous look of the '90s, made popular in part by CK One, the Calvin Klein fragrance that was marketed to both men and women. I wanted to steer her toward a more gender-neutral, natural look. Her flawless skin gave me that option. Because I didn't have to worry about covering up imperfections, I could focus all of my efforts on creating a fresh, dewy, naturally striking face.

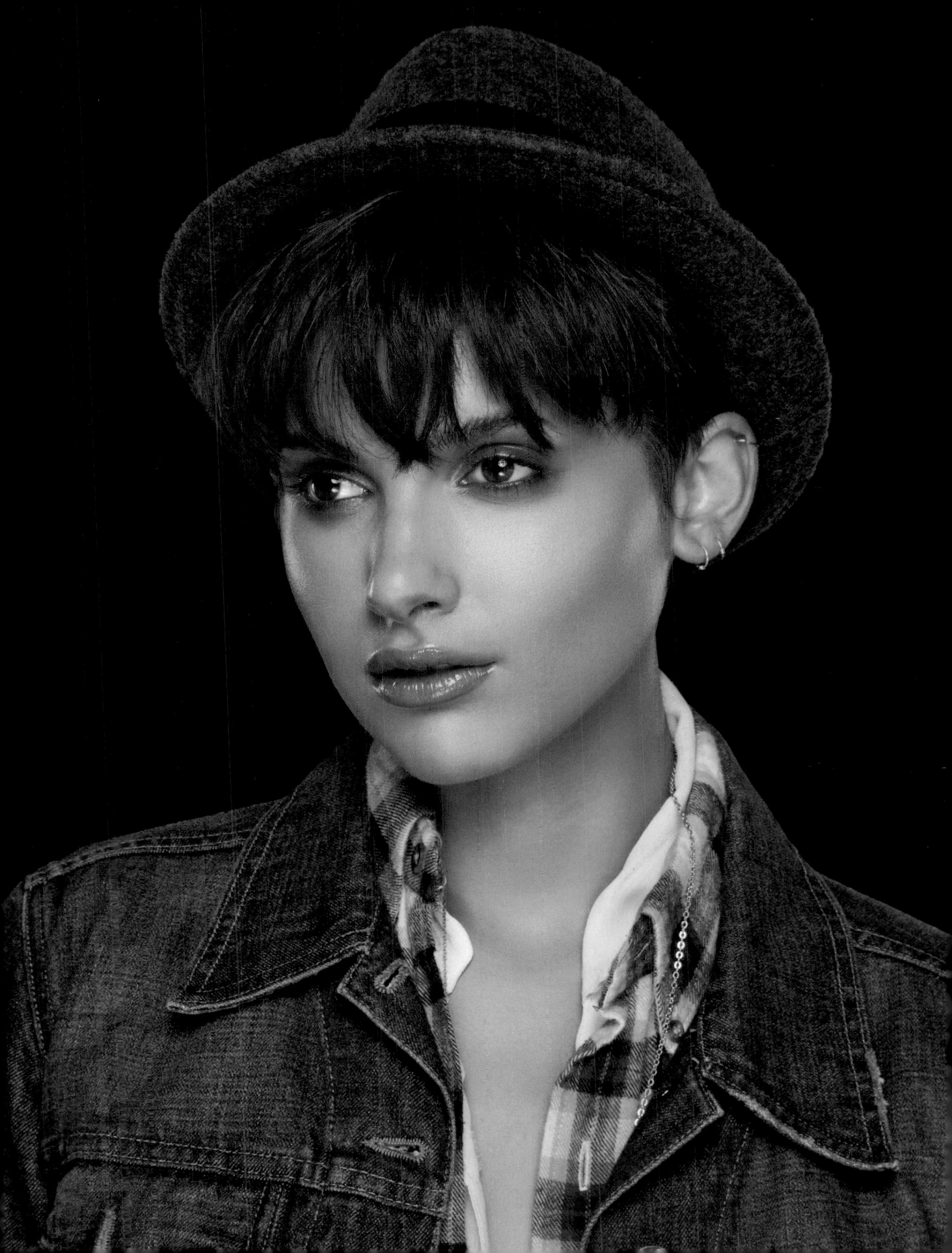

HOW TO: FLAWLESS SKIN

Here, I'm giving you my ten commandments for flawless skin. Follow these, and you will never be happier with the state of your face.

1 Moisturize. A good moisturizer is a wise investment. You don't need to spend a lot of money to get a good one, but if you're working with a limited budget, a good moisturizer is more important than, say, a pricey mascara. If you can afford a department store brand, I like moisturizers by Dior, Guerlain, La Mer, and Dr. Hauschka. A good drugstore option is Olay. If you can splurge on a few other items in your beauty arsenal, also invest in a good eye cream and an overnight moisturizer; cells regenerate while we sleep and are better able to absorb topical moisture during this time. Something else you might not know: Skin tends to get drier as we age, making it more susceptible to damage and infection. Wrinkles aren't caused by dry skin, but by damage beneath the skin.

2 Eat right. I love chocolate; I could eat it all day long. But too much chocolate—as well as too much caffeine, sugar, dairy, white flour, fried food, and alcohol—can wreak havoc on your skin. Adequate water intake is also essential to good skin. The more water you drink, the better your skin will look. Drinking water helps increase blood flow, which is directly related to better skin health, and flushes out toxins, which can lead to breakouts. How much water you drink is up to you, but a general guideline is two quarts (two liters) a day and more if you're exercising vigorously.

3 Exercise. Like drinking water, exercise helps stimulate blood flow and circulation, while also helping the body rid itself of toxins. It doesn't matter whether you're doing yoga or running or playing tennis; just move. The more you sweat on a regular basis, the clearer your skin will be. Just remember to hydrate well before and after a workout.

4 Get enough sleep. Sleep is the time for our bodies to heal and that includes our skin. Too little sleep can leave skin looking sallow, cause extra stress (and therefore breakouts), and limit the time for self-repair. It can also suppress the immune system, leading to breakouts, rashes, and eczema. As we age, too, lack of sleep affects us more, showing up the next morning in the form of dark under-eye circles, fine lines, and dull complexions. Aim for at least seven hours a night. And, if you can, try to make that uninterrupted sleep; intermittent sleep isn't as restorative. So if you need to spend a little more on cozy sheets and comfy pajamas, do! It's money well spent.

5 Watch your sun exposure. It's better to stay out of the sun entirely. Barring that, be sure to wear a sunscreen with an SPF of 30 or higher on your face every day, even if you'll only be in the car. Although a nice glow can make skin look healthy, there's just no reason to get that glow from the sun or tanning beds anymore. There are plenty of amazing self-tanners and body makeup products (like Body Bling!) that can give you color while saving your skin from irreversible damage.

6 Exfoliate. It's essential to exfoliate to remove dead skin cells, which can block pores and trap bacteria, inhibit topical moisture from getting in, restrict collagen growth, and make skin appear drier than it really is. Two to four times a month is a good gauge, depending on your skin type; basically, whenever your skin is feeling or looking dull and dry is a good time to exfoliate. Use a gentle scrub or glycolic-based toner or if you have extra-sensitive skin, washing your face with a washcloth can often be exfoliating enough. Just don't overdo it: More is not better when it comes to exfoliating, and too-aggressive exfoliating can strip away healthy cells in addition to the dead ones. If your skin feels irritated or looks red after exfoliating, you're doing it too often.

7 Meditate. Scientists are learning more and more every day about the link between the mind and the body. Meditation has been proven to reduce blood pressure and the stress hormone cortisol, while increasing production of the youth-related hormone DHEA. Meditation can also help you sleep better and make more conscious choices when it comes to your diet. If you can't meditate every day, aim for once a week to start and gradually increase. Or simply indulge in a hot bath or a romp in the sack! What you're aiming to do, most of all, is find a way to relieve tension and relax in a natural way.

8 Compensate for slipups. If you're going to go out for a late night or a few cocktails, be sure to drink a full glass of water and take two ibuprofens or an Alka-Seltzer tab before going to bed. A vitamin B_{12} supplement can also help. This routine will keep your skin from losing too much moisture overnight and also help prevent the next morning's inevitable greasy spoon binge. And always—always—remove your makeup before going to bed, no matter how tired you are.

9 Get a professional opinion. If you have bad skin or are experiencing breakouts, it's really important to see a dermatologist. He or she can help evaluate any possible issues with your diet or determine if you have a hormone imbalance or a thyroid issue.

10 Moderate. This may be the last, but most important, rule. "Everything in moderation" is a phrase to live by when it comes to keeping your skin looking and feeling great. Living to extremes can show up on your face. But it's important to have some fun, too. Laughing keeps your face muscles supple, while relieving tension. Friends bring us joy inside, which will make us look better on the outside. What's more, dancing is an amazing workout. So remember, it's important to follow the rules, but it's okay to break them once in a while, too. Just refer back to rule #8 and compensate for any overindulgence.

TIP: If you have bad skin or are experiencing breakouts, it's really important to see a dermatologist.

Once your skin is in top shape, you can work almost any look, including the no-makeup look, which is what I used for this model. Because her skin was in such good condition, makeup was a snap. Instead of powder, I used concealer and highlighter under her eyes, on the tops of her cheekbones, on the tip of her nose, and on her chin to enhance her already dewy skin. I kept her eyes simple: I used a brown shadow a few shades darker than her skin tone to create depth and definition on her lids and beneath her eyes and a single coat of mascara. I brushed her eyebrows up and set them with hairspray.

One key aspect of the no-makeup look is creating cheeks that look just-flushed. To achieve this, I applied a wine-colored cream blush on the apples of her cheeks using my fingertips and then blended along the cheekbone using a goat-hair blush brush. On her lips, I used a neutral beigy lipstick, with a swipe of clear gloss on top.

PRODUCTS

> Bobbi Brown Foundation stick in Honey

> Make Up For Ever translucent powder

> Georgio Armani Eyes to Kill mascara in Steel Black

> Nars cream blush in Cactus Flower

> Chanel Rouge Allure lipstick in Enivrée

TIP: If you're going to have a late night or go out for a few cocktails, be sure to drink a full glass of water and take two ibuprofens or an Alka-Seltzer tab before going to bed. A vitamin B12 supplement can also help.

TIP: Red skin? Try toning inflamed and rosy skin with a few drops of Visine pressed into skin a few minutes before applying your foundation.

FRANK ON HAIR

This model came in with a short cut, which I find incredibly sexy on a woman. I flatironed the cut so that it would fall flat around her face and eyes and gave her piece-y bangs using Oribe pomade and my fingers. Here's an example, too, of the perfect marriage of hair color and skin. The reddish tint in her hair plays off the olive tint in her skin, while almost exactly matching her eyes. This was her natural color with a bit of reddish enhancement. In most cases, the best hair color for you will be one that's very close to your natural color. It's rare that the most flattering hair color will be more than a few shades away from your natural hue.

The Hair Connection with Frank Galasso

Just as your face reflects what's going on inside, so does your hair. Clients tell me, "My hair is falling out," or "My hair is too dry/fine/oily/easily damaged." Although a good hair product can work wonders for whatever issue you're facing, really, that's just a Band-Aid. In most cases, these are issues that can be fixed by addressing an underlying health issue. Taking care of yourself will also benefit your hair. Here are a few things to keep in mind:

1. Eat right. If you were born with fine hair, changing your diet won't suddenly give you thick, lustrous locks, but it can make a difference. Your hair typically grows about ½ inch (1.3 cm) per month, and the quality of that growth will depend on what you're putting into your body during that time. Protein and iron are most important, and as much as you can, you should try to get these nutrients from food and not simply from supplements. In all cases, nutrients from food will be more effective than nutrients from pills and powders. Foods that are particularly beneficial to hair health include wild salmon, leafy greens like spinach and kale, carrots, beans, nuts, and eggs.

2. See your doctor. Blood tests can determine whether a hormonal or other imbalance may be causing issues with your hair. Women who are or were recently pregnant or nursing, as well as women who are going through menopause, may experience hormonal imbalances that can affect skin and hair. Improperly working thyroids can also affect the hair, as can certain medications. I can often tell what sort of medication a woman is on simply by feeling her hair. The hair tells a story.

You should start thinking about **prevention** when you're in your twenties.

—Jessica Wu, MD

Skin Health with Dr. Jessica Wu

Dr. Jessica Wu—a board-certified dermatologist and an assistant clinical professor at the University of Southern California School of Medicine—is one of the most successful dermatologists in the country and a very close friend. You'll see more of her later in this book when she lets me give her a rock 'n' roll transformation (chapter 8). But first, you'll hear from her as a professional, and one at the top of her field, who recently wrote *the* book on skin health—literally—called *Feed Your Face: Younger, Smoother Skin and a Beautiful Body in 28 Delicious Days*. She was kind enough to agree to chat with me about the book and her thoughts on skin-care in general.

Scott Barnes: First of all, congratulations on *Feed Your Face*! I've read it, of course, and it's amazing. So informative—and I thought I knew just about everything there was to know about taking care of your skin.

Jessica Wu: Thank you! One of the things I talk about throughout the book is how we're always learning. Our skin really is the key to our overall health; how our outer layer looks or feels paints a pretty good picture of what's going on inside. Therefore, it's extremely important to pay attention to what your skin is telling you, or trying to tell you.

SB: It's so true. I know instantly when a woman I'm working with hasn't been eating right or getting enough sleep by how her skin feels when I go to apply makeup. Though makeup can cover up a lot of indiscretions, makeup is always better on skin that's hydrated, clear, and starts out looking good.

JW: And even more than beauty, skin is often the first (and sometimes the only) sign of serious illness elsewhere in the body. For example, if your liver is in bad shape, you'll get jaundice, or turn yellow. If you have especially pale skin or you're losing more hair than usual, that can be a sign of anemia. People with lung disease can also appear pale and sallow, because they're not getting enough oxygen to the skin. And if you're crash dieting, you might look gaunt, as if your skin were sagging. That's why every time you visit a doctor—any doctor, not just a dermatologist—he or she will, or should, check your skin as part of the overall exam.

area, triggering inflammation in the form of redness, heat, and swelling. That's why your eyes will puff up during allergy season, why you'll spike a fever if you have an infection. Typically, this response is temporary. For some people with imbalanced immune systems, however, that inflammation never really dies down, and the longer their body stays inflamed, the worse it is for their health.

Recently, chronic inflammation has become a hot topic in the medical world as more and more studies suggest that it's a root cause of conditions ranging from heart disease, cancer, and Alzheimer's to osteoporosis and other diseases associated with aging. Doctors now think that cardiovascular disease, for example, is caused in part by inflammation of the arteries, not just an accumulation of plaque. Long-term inflammation can damage healthy tissue, including your arteries and your joints.

SB: And inflammation can also lead to bad skin?

JW: Absolutely. Inflammation is a hallmark of skin conditions such as acne, eczema, psoriasis, rashes, and even sunburn. While you might be tempted to think of acne as a form of infection (due to the pus), it's really your body's inflammatory response that produces redness, swelling, and whiteheads. In fact, a number of the antibiotics we use to treat acne are prescribed not for their ability to kill bacteria but to reduce inflammation. Learning how to manage and prevent inflammation is important for your overall health and is essential for maintaining the health of your skin. And eating the right foods is one of the most effective tools in regulating and preventing inflammation. Altering your diet can help modulate the effects of inflammatory conditions such as eczema and acne as well as help slow the signs of aging.

SB: What are some of the most prevalent problems that can be addressed by changing what you eat?

JW: Acne, wrinkles, and rashes, in that order. What's striking to me is how many women of all ages have acne. We're taught in medical school that acne is a condition that happens in your teenage years and you grow out of it, but clearly that's not true. It's persistent through your 20s, 30s, 40s, and beyond.

SB: So where's a good place to start, diet-wise?

JW: One of the first things to know for overall good skin health is that it's essential to get enough vitamin D. Vitamin D is extremely important not only in preventing osteoporosis in adults but for bone health in general. It helps your body absorb calcium from the GI tract, and it aids in muscle function and reduction of inflammation. But there are only a few ways to get vitamin D in the body. The first is with foods like milk, egg yolks, salmon, and tuna. You can also take nutritional supplements. But many experts maintain that the best way is to get vitamin D from the sun. Here's how: Our skin naturally contains something called 7-dehydrocholesterol. When 7-dehydrocholesterol is exposed to UVB rays from the sun, it turns into vitamin D. The tricky part, of course, is how to get vitamin D while avoiding the dangers of UV light? (And there are dangers: premature aging, sunspots, and skin cancer, to name just a few.) I certainly don't recommend that any of my patients stop wearing SPF. That's because studies have shown that regular use of sunscreen does not significantly interfere with your body's ability to produce vitamin D, meaning that you can still reap the benefits of the sun without compromising your safety. There is also no consensus as to what constitutes an adequate level of vitamin D, and the ideal amount may be different for different people. If you're concerned about getting enough, talk to your doctor about taking a supplement. But please, don't sit in the sun unprotected. And please: Skip the tanning beds! Though owners of tanning salons like to say that tanning beds can help with vitamin D production, that's not true at all. Beds emit mostly UVA rays, and it's UVB rays that produce vitamin D.

SB: *Feed Your Face* includes a meal plan. Is the plan condition-specific?

JW: It is. It's hard for everyone to avoid everything, so I try to tailor my plans to what a patient's most pressing issue is. For acne, I have people avoid what I call the "white devils," which are sugar, refined carbs, and dairy. The reason for dairy is that even if you're drinking organic milk, the dairy still contains cow hormones that can interact with your own hormones, increasing oil production and clogging your pores. Sugar, meanwhile, is very inflammatory. When you look at a pimple, whether it's a whitehead or an under-the-skin cystic bump, that swelling and redness represents inflammation. And refined carbs—like flour, white bread, pasta, white rice, and potatoes—get broken down quickly into sugar in your system. When you have that craving for chips or bread—like, say, when you're PMSing—that's when you should try to be as strict as possible and not give in, which can make your PMS breakout worse. In those cases, instead of the doughnut or cookie, try a square of dark chocolate.

SB: What about what to avoid to reduce wrinkles?

JW: Sugar, again. It's really amazing how even a few days off of sugar can make you look like you've had a facelift. No kidding. That's because sugar gets broken down in your bloodstream into glucose. That glucose then attacks your skin's elastin and collagen, which are what make your skin thicker, more resilient, plumper, and springier. They make the skin glow. Back when we were growing up, many of us heard that the more oil we ate, the greasier our face would be—that fatty, fried foods like chocolate or chips would cause breakouts. But it turns out it's not the fat or oil content of a food, but, rather, the effect that food has on blood sugar that leads to skin issues like pimples, rashes, or wrinkles. When your blood sugar spikes, so do your insulin levels—and so does your oil production. And unfortunately, sugar is everywhere, even in places you never expected, like crackers, salad dressings, lunchmeats, and cereal. That's why I tell my patients to try to eat like a hunter-gatherer. You cannot hunt a cracker.

SB: That's true. Are there some foods that we think are good for us but are actually doing more harm than good?

JW: Yes. In the book, I name a number of "good for you" foods that are actually pretty horrible because of how drastically they can cause your blood sugar to spike. This list includes pretzels, raisins, grapes, rice cakes, and fruit-on-the-bottom yogurt. Salt is another culprit that can lead to puffy eyelids, under-eye bags, swollen legs and ankles, bloating, and acne flare-ups.

SB: There are also some foods that you can add to help slow signs of aging, correct?

JW: Yes, for sure. Green and yellow vegetables, for example, are proven to reduce wrinkles. In one study, those who reported eating more green and yellow veggies had fewer crow's-feet around the eyes. So when you're making salmon or steak or chicken for dinner, go light on the rice and potatoes and instead load up on green and yellow veggies like spinach, broccoli, green and yellow peppers, yellow squash, and yellow tomatoes. Yellow tomatoes are my favorite because tomatoes also contain lycopene, which is also helpful in ensuring skin health. Meanwhile, adding foods with natural anti-inflammatory potential, like omega-3s (found in walnuts, salmon, and flax seeds) can help calm the skin. Omega-3s have been shown to help replenish your skin's natural oils that are lost over time.

SB: What about supplements? Can women take supplements to get some of these vital nutrients?

JW: For certain things, like Omega-3s, you could take supplements. But I'm always encouraging my patients to get their nutrients from food rather than to rely on supplements. That's because food comes with added benefits, like protein that will moderate your blood sugar or the antioxidants that will help minimize skin-damaging free radicals.

SB: Of course, what people really want to know is: How fast does this work? How quickly can a better diet result in positive changes in our skin?

JW: For some people, as quickly as two weeks. But I don't generally advise a binge and purge approach. For many of my patients, eating well becomes a lifestyle change. It's sort of hard to go back to their old ways. They begin to lose weight, lose the bloat, and feel better overall and start to love what they see. They bring their family and friends in on it because everyone wants to know what they've done to look so good. One reader tweeted me a photo of some fish tacos with avocado and black beans her boyfriend had cooked for her. It was pretty cute.

SB: I tell you all the time that I think it's hilarious that you wrote a book about food. I've been to your house: You've got booze and Botox in your fridge. You don't even cook!

JW: Haha. That's why this isn't a recipe book and why it's a book for real women of all kinds. I'm not going to pretend to be a chef. But I can help you make smart choices whether you do cook or, like me, you prefer to grab and go. That's why the 28-day meal plan includes suggestions for what to eat at the most popular chain restaurants, like Starbucks, Applebee's, and the Cheesecake Factory.

SB: So through all of this, you've also changed how you eat, I take it? Your skin does look amazing.

JW: I used to be a salad and bread girl: Bagels in the morning and salad for lunch, then pizza for dinner. And my skin did not look good. I broke out a lot. I was also "skinny-fat"—I looked thin, but I was soft and out of shape. I huffed and puffed going up the stairs. People say that all Asians have great skin. But I have my passport photo from ten years ago and I think I look younger now. And that's because I eat much better.

But even more than my own personal transformation was seeing the changes in my patients, especially my celebrity patients. These are women (and men, of course) who are very in tune with their skin. They have to be; it's their livelihood. They're always very critical, looking at themselves on camera and in photos. And more and more, these celebrities were coming in and telling me how much better they thought they looked. And that's when I realized: I'm onto something here.

SB: Above all, of course, your skin is a reflection of yourself.

JW: You got it. As I say again and again in the book, perhaps the most important function of the skin is also the easiest to understand. I mean, hello! The skin is your body's largest organ. It's what your man touches when he caresses your leg or kisses your neck. It's the first (and sometimes only) thing we see when we look in the mirror. Waking up with clear, smooth skin is like having a good hair day: It can make you feel confident and sexy. But wrinkles, blemishes, and sunspots can have the opposite effect: They can sabotage your self-esteem. That's why my role as a dermatologist is not unlike being a therapist. Many of my patients come in feeling down, maybe a little depressed about how they look. Whether it's the teenager with acne who is slumped and slouched and has her hair in her eyes or the woman with sun damage who is too embarrassed to wear a strapless dress because of the blotches on her chest, my message has always been the same: You don't have to live with skin you don't like.

transformations

kathy griffin

FOR OUR SHOOT, I WANTED TO UNLEASH KATHY'S INNER BEAUTY AND STRENGTH WHILE CALLING ON THE PROVOCATIVE NATURE OF HER PERSONALITY, WHICH IS HOW I CAME UP WITH RECREATING HER LOOK TO EMBODY THE WILD, TONGUE-IN-CHEEK VERSION OF RAQUEL WELCH IN *ONE MILLION YEARS B.C.*

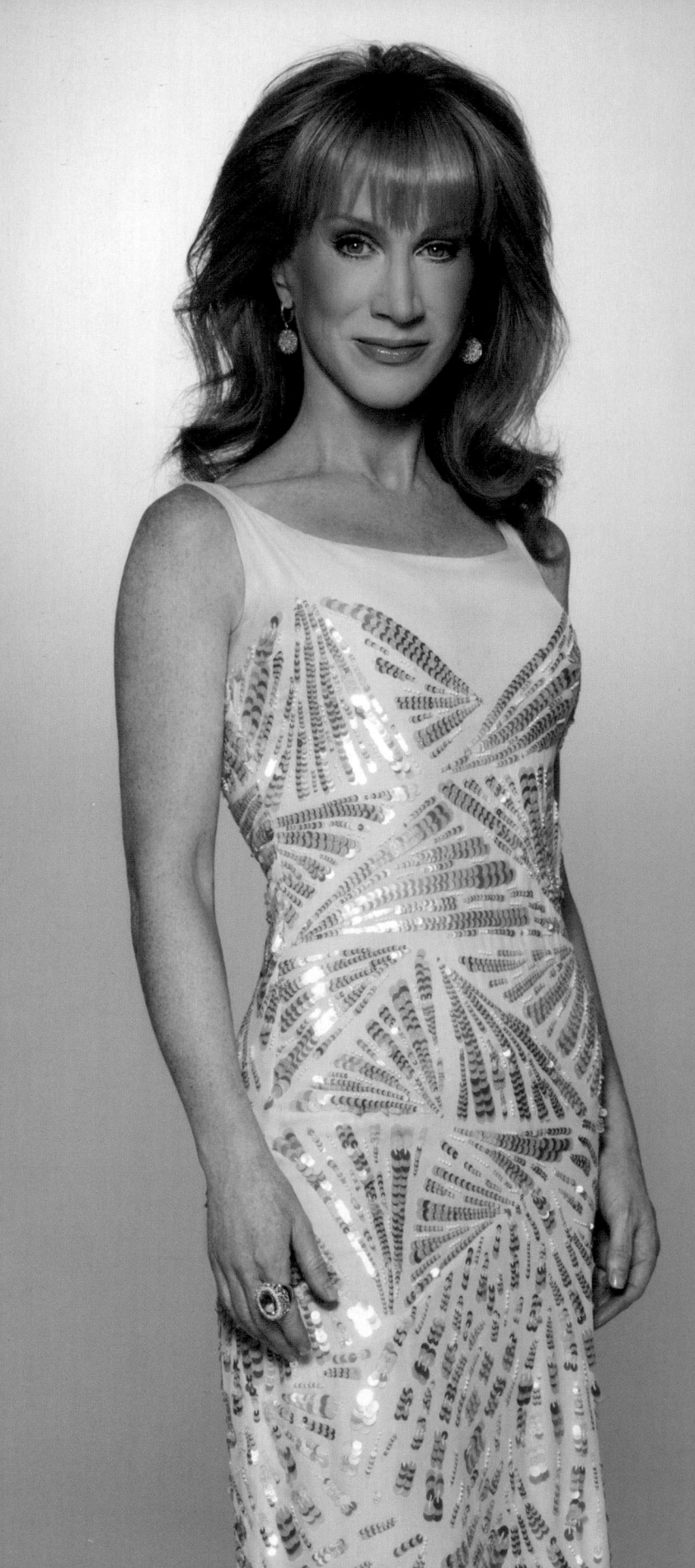

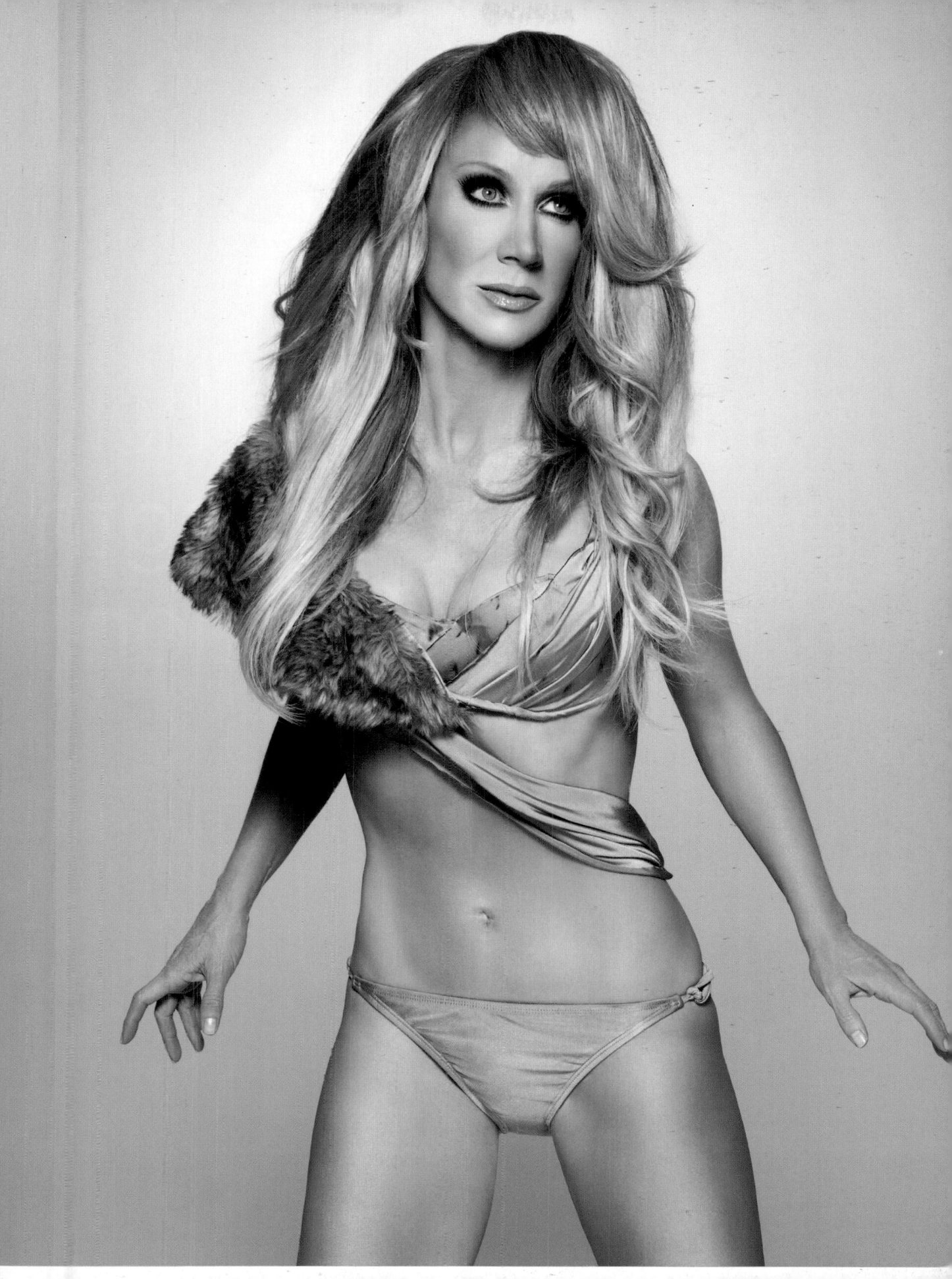

madeleine stowe

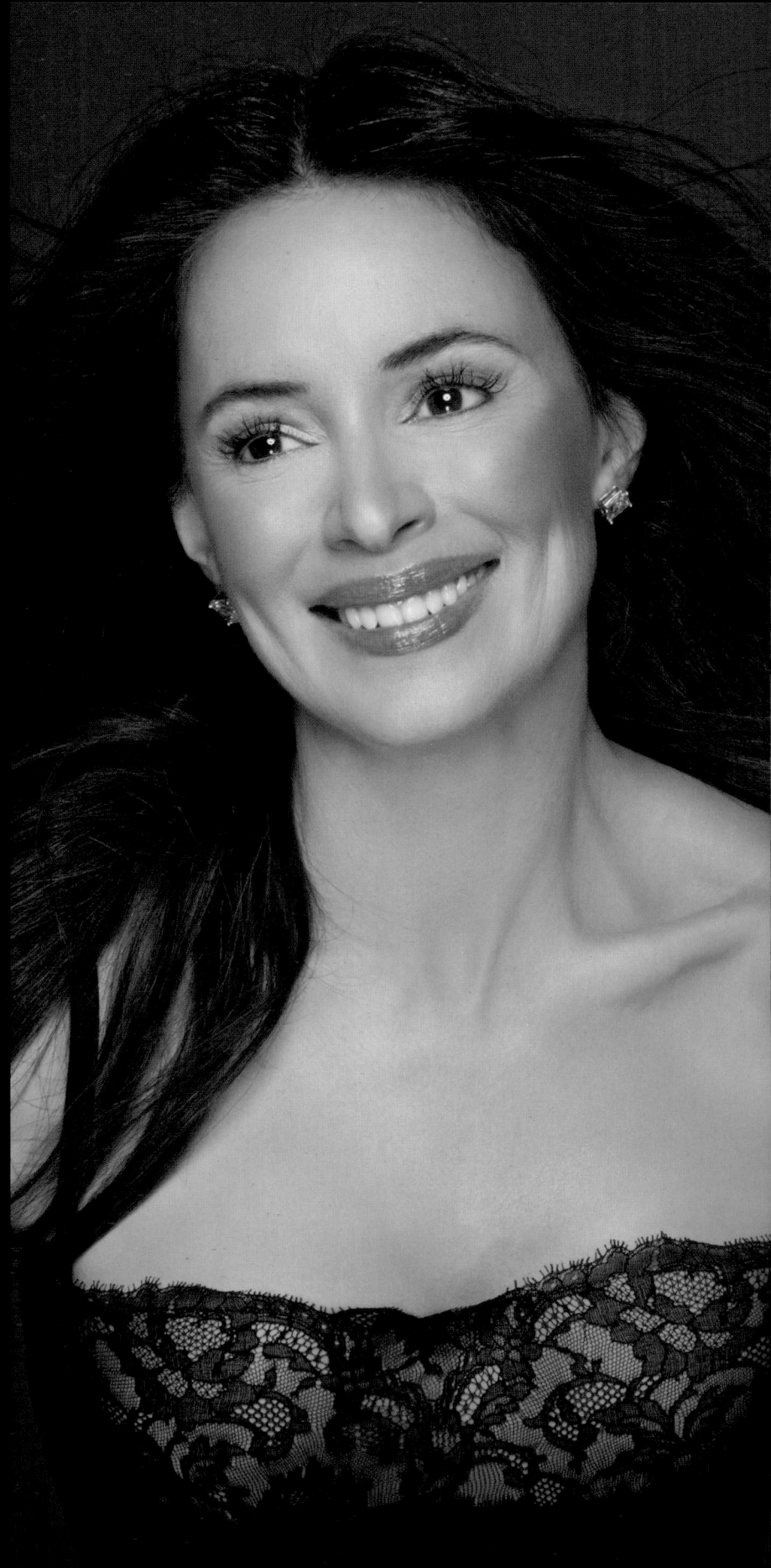

MADELEINE CURRENTLY STARS ON THE ABC DRAMA *REVENGE*, PLAYING A RICH HAMPTONS VILLAINESS. I WANTED TO PLAY UP THE DRAMA AND THE MORE ANIMALISTIC, PROVOCATIVE SIDE OF MADELEINE'S TV CHARACTER.

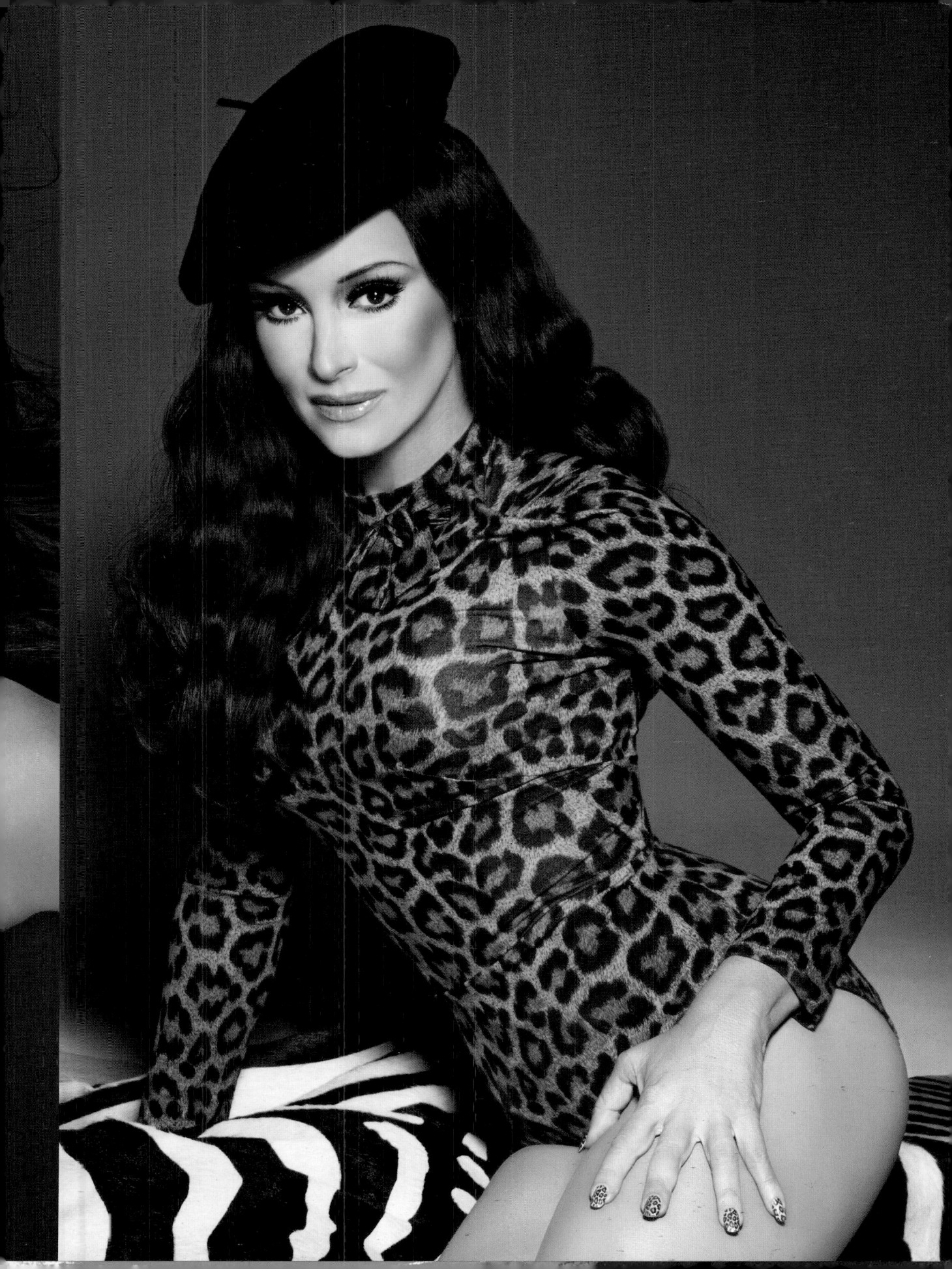

the vintage hollywood starlet

THE RED LIP IS VERY OLD HOLLYWOOD. It became popular in the 1920s, when actresses and anyone else likely to be photographed would wear bluish red lip color to make the lips show up in photos. Back then, the photos were all black and white, and so the red would blend to become a gray. But because these actresses would also be seen out in public, the red lip became trendy among "real" women.

Although the red lip has such rich Hollywood history, I have to be honest: I don't always love it. Red lips are a commitment, for one, but two, not everyone can wear them. If your lips are small, red can make them appear smaller, like a little zipper. Red looks best, in my opinion, on a full lip.

That said, the red lip can be one of the easiest ways to take your daytime look out on the town or create drama for a black-tie event. (You never want to wear red in the daylight—too harsh.) Even the most carefully drawn lip shouldn't take you more than three or four minutes. Voilà: instant glamour.

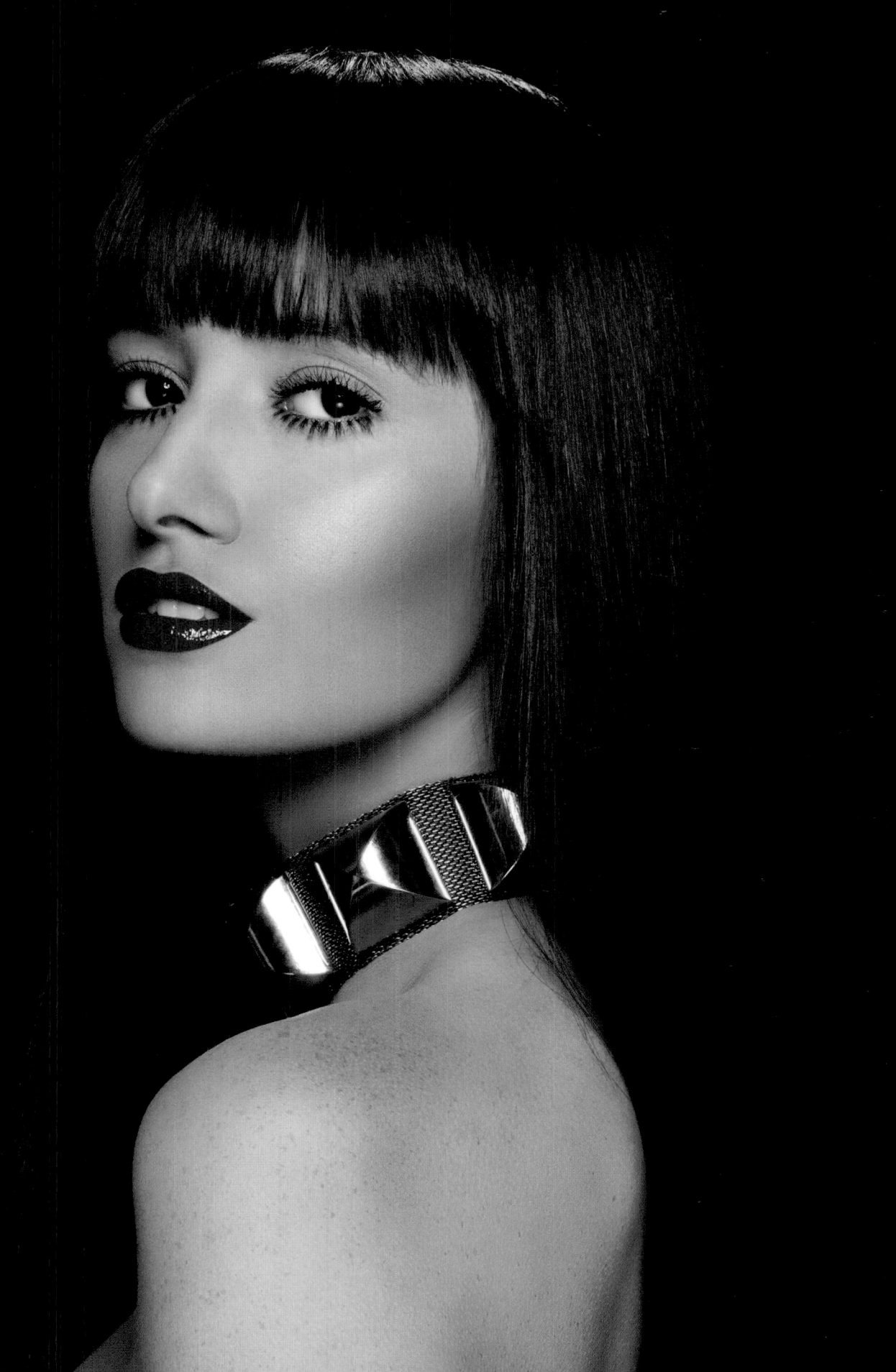

HOW TO: THE PERFECT RED LIP

First, choose your color: One reason red doesn't always look good on women is because they're wearing the wrong shade. It's key to select a shade based on your skin tone.

> Fair-skinned women should look for shades with blue undertones, like cherry.

> Medium-skinned women should look for true reds—poppy or orange-red.

> Darker-skinned women should look for darker, "blood-red" shades like plum red or burgundy.

Line your lips, following your natural lip line. Red has a tendency to bleed, so lip liner is essential. If you want to create a fuller lip, you can raise the top lip line a bit. Never try to make your lips wider than they are, though; that'll create a clown effect.

Fill in the lip with the same pencil to create a solid red lip. Apply a single coat of red lipstick and then a top coat of either a clear or a red glaze for shine. For both, use a lip brush for even, precise application. Here, our model had full, very geometric lips. I used a Nars lip pencil, Dior Rouge lipstick in Ara Red, and Dior Addict Ultra-Gloss in Little Red Dress.

Here's a trick to remember: When you're finished applying lipstick, put a cotton swab in your mouth, press your lips together, and pull it out. This'll get rid of any lipstick on the inside of your lips, which can bleed onto your teeth.

This model's skin was a bit freckly, but I liked that: I used Dior AirFlash foundation, applied with a foundation brush, which gave me the control I needed to let some of the freckles come through.

And because I always follow the philosophy "eyes or lips—never both," I kept her eyes subdued. I applied a strip lash to both the top and the bottom lashes, but kept them bare. False lashes on the lower lid can be very effective at subtly opening up the eye. I used a beige shadow, no eyeliner, and a single coat of mascara on the top and bottom lashes. To highlight her cheekbones, I applied a gold highlighter on top of the cheekbones and a rose-brown blush just beneath them.

TIP: False lashes on the lower lid can be very effective at subtly opening up the eye.

PRODUCTS

> DiorSkin AirFlash spray foundation in Sand

> Nars lip liner pencil in Jungle Red

> Dior Rouge lip color in Ara Red

> Dior Addict Ultra-Gloss in Little Red Dress

> Make Up For Ever Star Powder in gold

FRANK ON HAIR

This model had a very geometric haircut, with long layers and blunt bangs. And because her lip is so strong, I didn't want her hair to have to compete with her face. I did a simple, straight look, achieved with a flatiron (my favorite is the T3 ManeTamer). After, I sealed the ends with a bit of Oribe Original pomade and sprayed a light coating of Joico's Brilliantine Spray Gloss shine spray.

TIP: In my opinion, you have to have a full lip to rock a red. That said, it can be one of the easiest ways to take your daytime look out on the town.

formations-trans

brittny & lisa gastineau

I LOOK AT BRITTNY AND SEE OLD HOLLYWOOD GLAMOUR, WITH THE DARK HAIR AND LIGHT EYES OF ELIZABETH TAYLOR. LISA'S UNDENIABLE BOMBSHELL QUALITY INSPIRED ME TO TRANSFORM HER INTO BRIGITTE BARDOT, ONE OF HISTORY'S BIGGEST AND MOST OUTSPOKEN SEX SYMBOLS. LISA, LIKE BRIGITTE, ALWAYS SAYS WHAT SHE'S THINKING, AND LOUDLY.

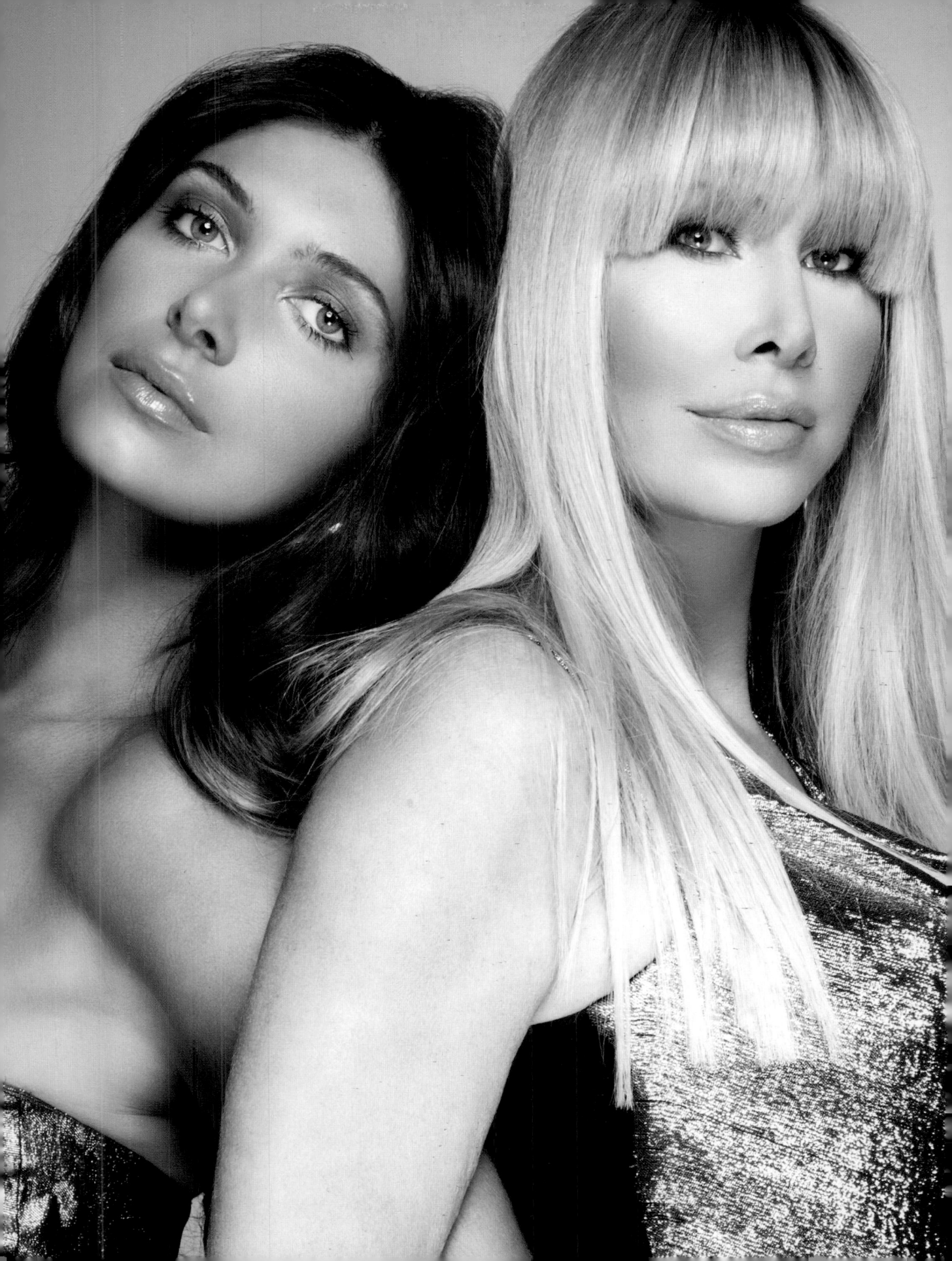

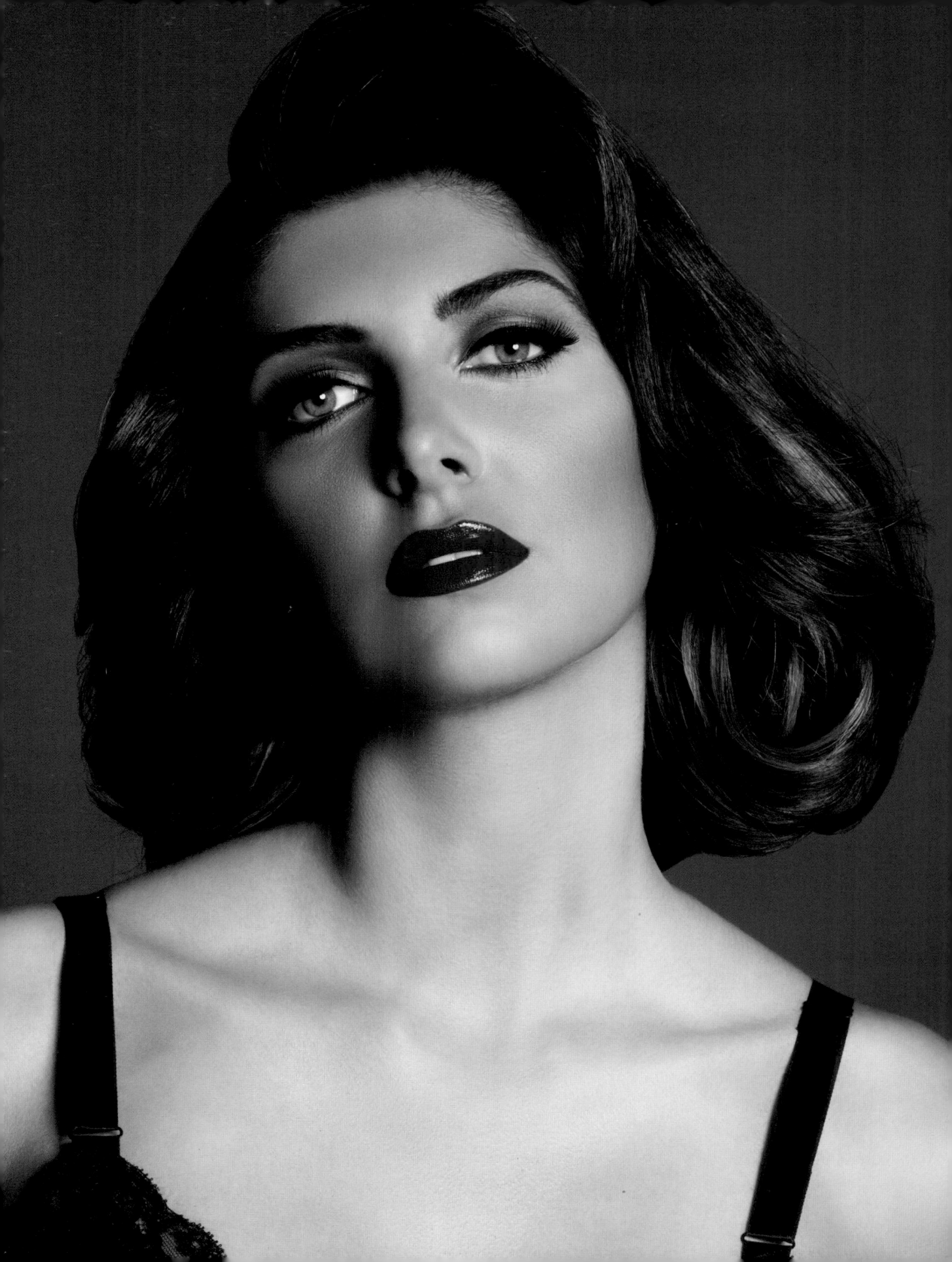

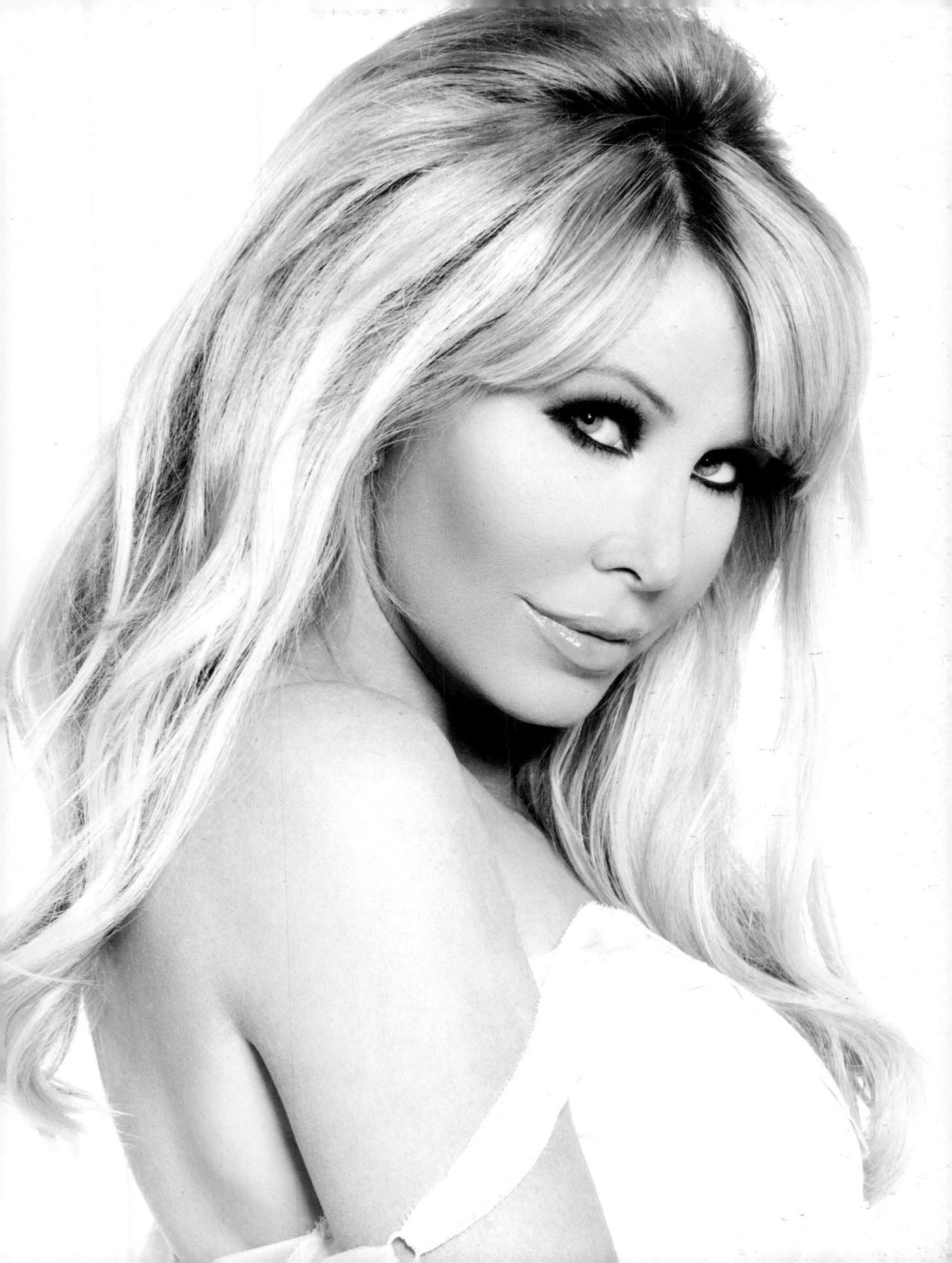

Brittny is most definitely a modern girl, but her face is impossibly **classic**.

brittny gastineau

I know a lot of inseparable mother-daughter pairings, but the Gastineau girls truly take the cake These two are like peas in a pod. Which, if you have ever watched their *E!* show, you know. I met Lisa first, but it's impossible to get to know Lisa without getting to know her only daughter, Brittny. And once you do, it's impossible not to love her. Brittny is warm, funny, beautiful, and an amazingly loyal friend. She's someone I feel lucky to have in my corner, always.

I look at Brittny and I see old Hollywood glamour. She's most definitely a modern girl—when she's not modeling for magazines and print ads, she designs a jewelry line with her mom, called Trés Glam—and runs with a very current pack of Hollywood jetsetters. With her big, light eyes standing out against her long, chocolate brown hair, it's a combination that gives her an innocence and a youthful glow. It's hard not to look at her and see that other icon of dark hair/light eyes, Elizabeth Taylor.

To transform Brittny into La Liz, I drew attention to her big eyes with some black eyeliner all around the eye and purple shadow. I played up her gorgeous, full brows by enhancing them with a dark brown brow pencil and brushing them up with a brow brush; I then set them with some hairspray. But I went relatively light-handed with the eyes because I also wanted to give her a big, glamorous red lip. To me, this is the pièce de résistance for the old-school Hollywood brunette look. And Brittny wears it like she was born a star. Which, really, she was.

BRITTNY SAYS ...

To me, Elizabeth Taylor is the ultimate beauty, and it was amazing fun to be transformed into her. Obviously, she was an icon of physical beauty and talent, but there's an inner glamour about her, too. That's why she didn't even need to try to be sexy; she just was. And, personally, I've always identified with her a little bit because we share similar eyebrows: When I first began modeling, makeup artists always tried to tweeze my eyebrows, especially those little hairs toward the center that stand straight up. But I used to protest: That's my Elizabeth Taylor staple! She had big brows and those little center hairs, too. Small, subtle things like that can change the whole shape of your face; those individual quirks make you, you. What I love about Scott is that he knew this from the start. I never had to tell him: Don't touch my brows!

My eyes are my favorite feature, for sure, and when I'm on my own, I love to make them really dramatic. When I go out, I always wear a smoky eye—black rims, super-black mascara. I almost never do a red lip, like I'm wearing here, which made it really fun to play around with for the day. I love the look, but it's a *look*. It's special occasion and a definite commitment. For one thing, red lips are not super-practical. They're hard to wear without having your lip color run or get all over your teeth. For another, red lips are hard to pull off if your lips aren't symmetrical (or if you don't have someone like Scott who can make them appear that way). It draws a lot of attention to your mouth. Sometimes, that's a good thing. I tend to talk a lot, though, so I don't always need the help!

My eyes are my favorite feature, for sure, and when I'm on my own, I love to make them really **dramatic**.

—Brittny Gastineau

No matter what persona she's embodying, Lisa is consistently **glamorous**.

lisa gastineau

Lisa and I met after I donated some Body Bling to an event she was hosting to benefit skin cancer research. Skin cancer prevention is a cause that's close to my heart—my brother died of melanoma. Turns out, it's a cause close to Lisa's heart, too. A few years back, Lisa was diagnosed with melanoma. She was lucky: She had two surgeries, but she got to avoid chemotherapy and radiation. Now, she is active in fundraising for cancer research and awareness, and she speaks out about the dangers of tanning beds, which she says contributed to her cancer. She advocated for the ban on underage tanning in California, which passed last year and prevents kids under eighteen from using tanning beds. Instead, Lisa is a big believer in self-tanners and bronzers. When I moved to L.A., we met and became fast friends. You could sort of say that Body Bling brought us together!

I love Lisa's passion for life, generosity, and huge heart. She adores her family and would do anything for them. An unabashed romantic, Lisa first became known for dating bod-faced men like football star Mark Gastineau, whom she married, Sylvester Stallone, and Billy Idol. But most people know her these days as being something of reality TV royalty, having been a pioneer of sorts of the genre since 2005, when her show with only daughter Brittny, *Gastineau Girls*, debuted on *E!*. The show followed Lisa and Brittny as they looked for love in New York

and Brittny went after a modeling career, with consistently drama-filled results. Lisa has since had her hands in many pots: She's been a boutique owner, jewelry designer, TV personality, and above all, mom. She and Brittny remain super close. But no matter what persona she's embodying, Lisa is glamorous. I've never known a woman who so embodied the glamour that is Hollywood. She just oozes it, even on those days she's running around doing errands in her best sweatpants with her hair pulled back into a ponytail. Her makeup is always perfection: This is a woman who loves to get her pretty on. It's easy to see why she's so irresistible to men.

Because of Lisa's undeniable bombshell quality, I was inspired to transform her into Brigitte Bardot, perhaps one of history's biggest sex symbols, and an outspoken one at that. Lisa, like Brigitte, is a woman who always says what she's thinking, and loudly. To conjure up Brigitte, I went straight for Lisa's big blue eyes, rimming them with black Maybelline liner and applying a black shadow on the lids and beneath the lower lash line. I used strip lashes to create enormous volume and then added even more drama with a single coat of black mascara. The smoky, smoldering eye really takes over, and so I left the rest of her face moderately bare, with a bit of blush for definition and a quick swipe of pink gloss. And here we have a knockout, in every sense of the word.

LISA SAYS ...

Brittny calls me the ultimate glamour girl, and she's not entirely wrong. I love being made into a goddess; I love feeling pretty. That's because makeup, if done correctly and worn with confidence, can inspire you to act and even speak differently. That's why getting made up is so special and why a makeover can really change a woman's entire outlook on the world and herself. Makeup, or having the chance to feel pretty at all, can inspire a whole new way of thinking about yourself, which can be truly transformative. It can give you the confidence you need to make a change in your work or your relationships, even if it's just a little boost. Who's to say you don't deserve that? Every woman deserves to feel her best, as often as possible.

That's not to say I'm resolutely high-maintenance. I'm a big fan of ponytails and full-on glam makeup. I wear my hair in a pony about 50 percent of the time. It works; it's easy. I feel like I can have bad hair and still present my best self, as long as I have good makeup. In my opinion, however, great hair and bad makeup do not work.

I loved the idea of being transformed into Brigitte Bardot—my dream come true! When you think about Brigitte Bardot, you think about the eyes and lashes—those deep, sexy, I've-got-something-you-want eyes. But the truth is that Bardot's look was not just about the eyes and lashes—it was about the entire face. The face is balanced, with only one standout feature, but the others (like the cheeks and lips) are undoubtedly strong enough to stand up to the heavy eye. And it's a real art to be able to create this balance, like Scott does. In my perfect world, I'd wake up in the morning looking like Brigitte Bardot. In fact, I've always said that my alter ego wants to be a platinum blonde. When you think platinum blonde, you think bombshell: less girl next door and more va va voom. Maybe someday I'll do it, even though I haven't been the girl next door for quite some time now!

In my **perfect** world, I'd wake up in the morning looking like Brigitte Bardot.

—Lisa Gastineau

the club princess

I'M CONSTANTLY INSPIRED BY JAPANESE GIRLS. Take a walk around the Harajuku district in Tokyo, and you'll see the cutest girls who know how to use makeup to express themselves and their moods. It's a fun, lighthearted look that's ultimately also a great, cost-effective way to be trendy and current without spending a fortune. Don't have the cash for leather or sequins? Who cares? You can achieve the same look with some fun makeup for a fraction of the cost.

Here, we see that bold makeup can turn anyone into a superstar. Although clearly not Asian, this model has delicate features that are the perfect palette for enhancing one aspect in a dramatic way. She's a great example of how the Tokyo look can work for anyone, whether you choose to go all the way with it with the hair, as Frank did for our model, or make it work in your own way. The best part is that there are no rules.

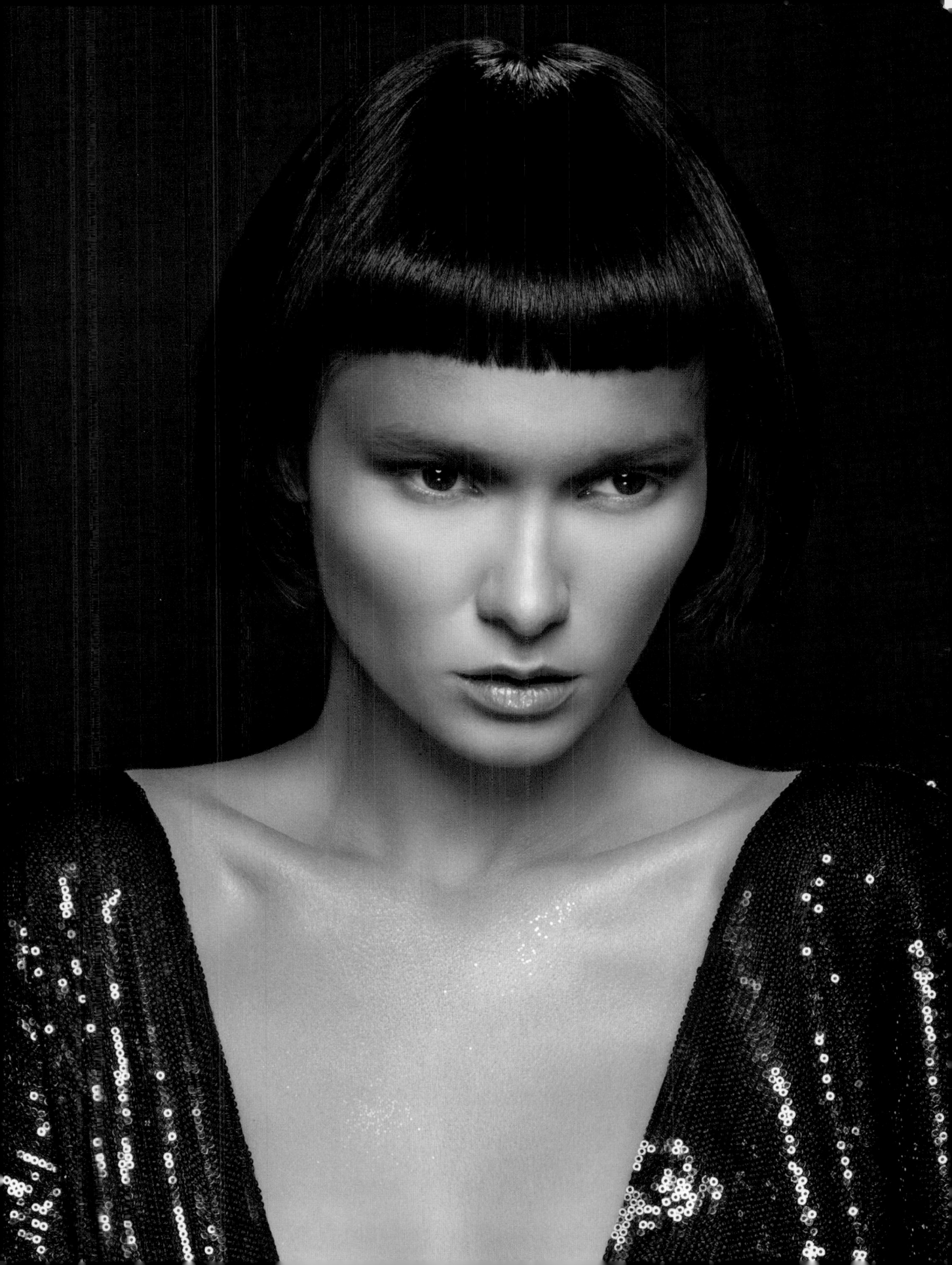

HOW TO: NEON EYES

Begin by priming your face with your usual concealer/highlighter/cream foundation routine, including a base around your eyes and especially on your lids. Neon colors always seem to run more easily, so this is important.

Choose a color. Make Up For Ever is a brand that I use often, and it offers a wide variety of boldly colored shadows. You can also use a bright blush in place of shadow, if you're staying in the pink tones, like I did here. Here, I chose the brand's HD blush in Fuchsia, which is a cream blush, and applied a bright pink shadow on top. The brand also offers a multi-purpose cheeks/lips/eyes product called Aqua Cream, which comes in an assortment of bright shades.

I used a bit of concealer across her brows to make them lighter, then applied the shadow. For a subtler look, apply the shadow exclusively to the part of your lids beneath the crease. Or take it all the way, like I did here. After covering the lids beneath the crease, apply your cream or powder shadow along the brow bone from the outer corner of the eyes to the inner corner, extending the color onto the sides of your nose.

I kept the rest of her face entirely nude, with no blush or mascara, though I did use a bit of blush as a highlighter just above her temples. For her lips, I chose a pink a few shades lighter than the eyes, which is a nice look, especially if you've got lips that tend to be on the redder side.

TIP: A bright blush can double as a bold eye color.

TIP: Make bright makeup stand out even more by leaving the rest of the face completely nude.

PRODUCTS

> Chanel Perfection Lumière foundation

> Dior Skin loose powder in transparent medium

> Make Up For Ever HD blush in Fuchsia

> Make Up For Ever matte eye shadow in Neon Pink

> Chanel Lèvres Scintillantes lip gloss in Chelsea

FRANK ON HAIR

In addition to having a clear Tokyo influence, this look felt very futuristic to me, between the makeup and the clothes. I called on one of my favorite movies of all time for inspiration: *Tron*. This is a wig that I cut into a bob that's structured and unstructured at the same time. The ends are choppy and layered, and there's an element of asymmetry. If you want to do this with your own hair, it's an easy look for any stylist to achieve, but it works best on straight hair. The super-short bangs play up her delicate features, call attention to her eyes, and are undeniably dramatic.

other ways to use makeup as an accessory

Glitter. Glitter on the eyelids can be fun and festive. For a subtler look, dab your pinky finger into a pot of glitter—Make Up For Ever and Urban Decay make some great ones in a rainbow of colors—and press into the center of your lid. For full sparkle, you can extend the glitter up to your brow bone and toward the outer corners of your eyes. Or try using a brush to dust glitter over the apples of your cheeks. A few brands even make lip gloss and mascara infused with glitter. Just be sure not to "drip" glitter all over other areas of your face, and even when you're having fun, it's best to limit the glitter to one feature.

Neon lips. Lipstick is bigger than ever, and a bright, neon pink, orange, or red can add some drama to a look without being clownish. Start with a liner and layer it. Fill in your lip line—using a single stroke, if you can—and then your entire lip. Apply your lipstick on top of the liner for a matte look or lipstick and gloss for a wetter look. For the best results, you'll want to pare down the rest of your look, keeping color elsewhere on your face to a minimum. M.A.C. makes some great bright lipsticks.

Minx nails. I'm a huge fan of Minx nails, flexible polymers applied to nails, like a sticker, and set with heat. They're mess-free, eco-friendly, and long lasting and come in hundreds of colors and patterns, from lime green to cheetah print to a mirror effect.

Applying Self-Tanner

As we've discussed, sun exposure can cause irreversible damage, in the form of sunspots, quicker aging, wrinkles, and cancer. But a nice glow can make skin look healthy and more toned, helping muscles and bones stand out. Luckily, there are plenty of amazing self-tanners and body makeup products that can give you color and change your skin tone while saving your skin. These can come in handy during red-carpet and black-tie events (especially during the winter), when you've got exposed arms, legs, and shoulders; a good self-tan can also let you get away with wearing a minimal amount of jewelry. Applying self-tanner and body makeup, like my Body Bling, can seem tricky, but it's really quite easy.

1. Place a pea-size amount in your hand and rub your palms together. You don't need a whole lot to get coverage.

2. Work the tanner or makeup into your body like a moisturizer, rubbing vigorously and evenly. Don't be afraid of it. If you're using a makeup product like Body Bling, it will look dark at first but will soon absorb into your skin. Rub until coverage is even. You can use this on your chest, neck, arms, legs, and back (get some help for that last one).

3. Avoid the areas around your fingernails and toenails, which can absorb too much color. Orange nails and cuticles aren't pretty.

trans-formations

shannen doherty

OFTEN IN HER ACTING ROLES, WE SEE SHANNEN AS THE MEAN GIRL, WHO WEARS MEAN GIRL–APPROPRIATE DARK MAKEUP SHADES. HERE, I WANTED TO MAKE SHANNEN SOFT AND PLAYFUL, WHICH IS A SIDE OTHERS RARELY SEE BUT WHICH SHE MOST DEFINITELY POSSESSES.

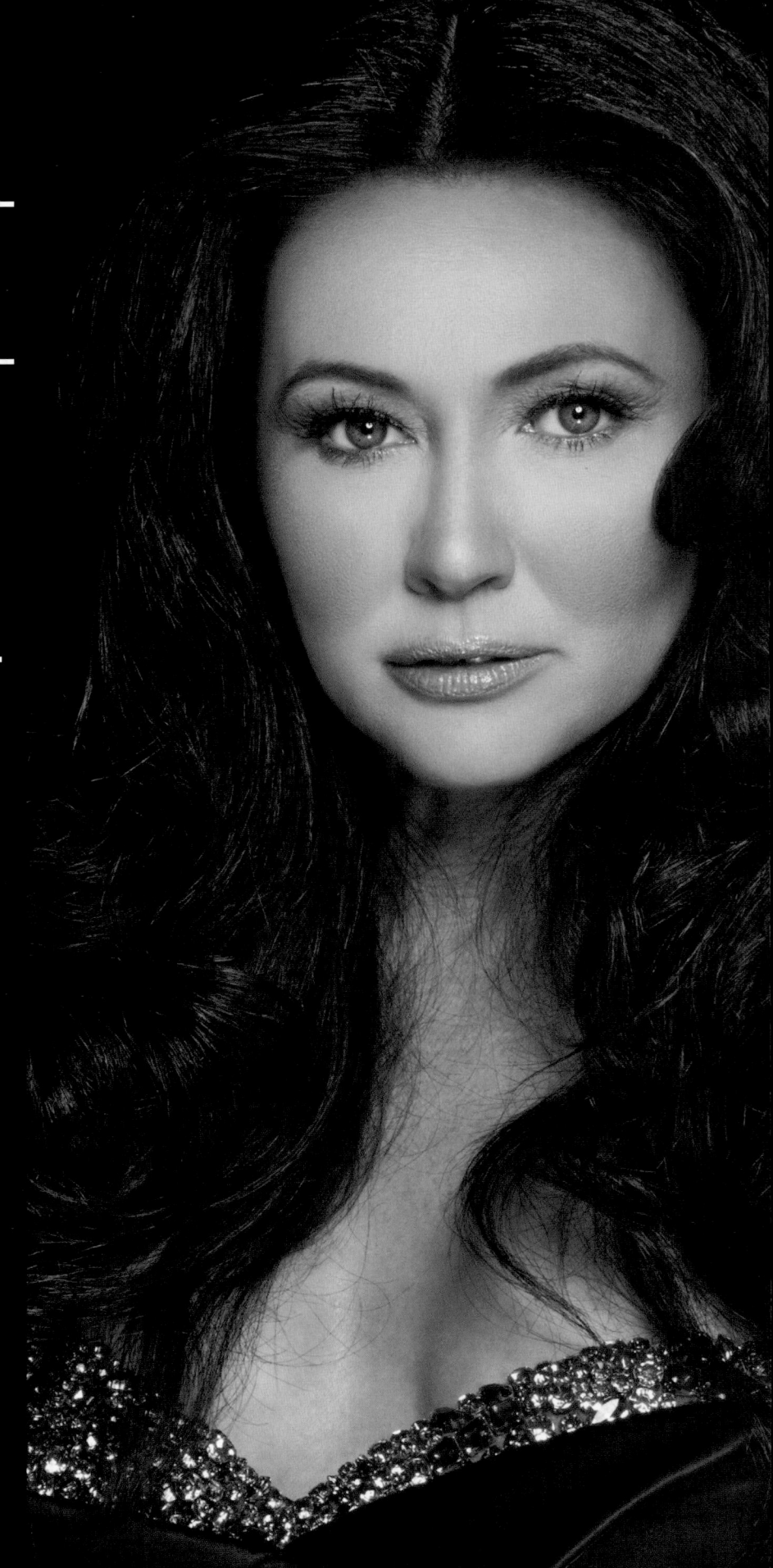

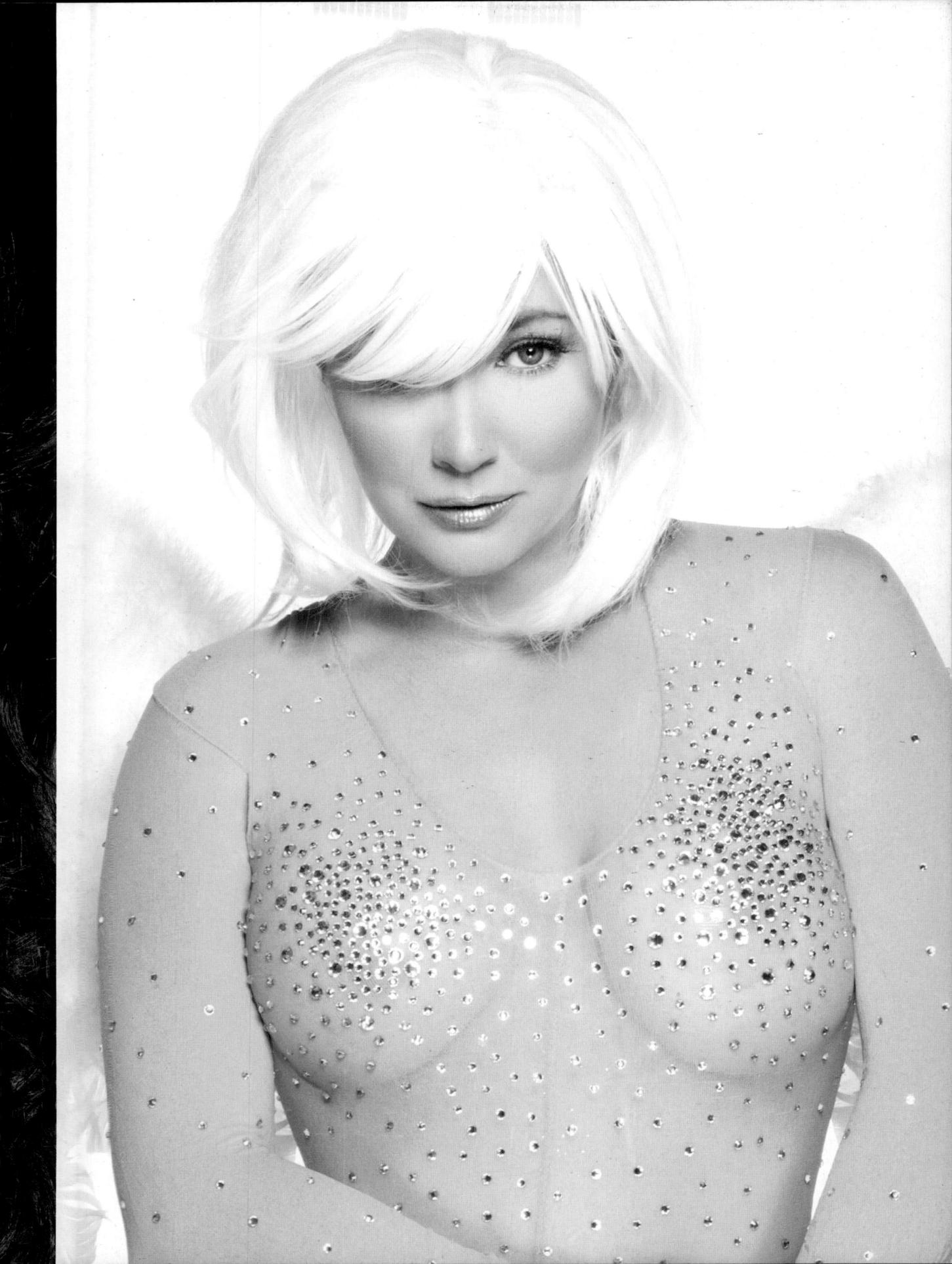

Despite Shannen's bad girl rep, I could see the **vulnerability** in her and wanted to convey that to others.

I met Shannen for the first time not that long ago. I have to admit, I was a little nervous beforehand. She's got this reputation for being—shall we say—difficult or, at least, opinionated. Not that I'm not used to women who know what they want—quite the contrary. And I celebrate that. But Shannen, well, I heard she could be particularly tough to please.

Then I got to know her. The first thing I loved about Shannen was that she knows she's got this *Heathers*-sort of mean girl reputation. And she doesn't really care—because that's not at all who she is, and what does it matter what other people think? I quickly figured out that despite her bad girl image, she is, in reality, quite vulnerable, sweet, and beautiful. She has managed to hold on to a strength of character that can be truly tough to maintain in Hollywood, where there are lots of bitchy, ruthless, cutthroat people around every corner. It's not always the easiest place to play nice, which is why it's understandable when people develop tough skins and, sometimes, tough attitudes. But throughout her long career, Shannen has survived by always retaining her classiness. And I'm here to tell you she's an absolute doll to work with.

That's where the inspiration to transform Shannen into an angel came from. Often in her film and TV roles—whether it's from *Beverly Hills 90210* back in the day or more recently on *Charmed* and *Mari-Kari*—we see Shannen as the mean girl, who wears mean girl–appropriate dark makeup shades that make her face appear even more severe. That's part of creating her character. Here, though, I wanted to make Shannen soft and playful, which is a side others rarely see but which she most definitely possesses. To transform her into an angel, I worked exclusively in light shades. I wanted to show that you can access the same amount of drama in a reverse sort of way—as opposed to the drama she usually gets from darker colors—and without using a ton of makeup. I used beige shadows on her eyes, no eyeliner, and just a few individual lashes scattered across the lash line. Her blush was a beigy-coral; again, I wanted to create warmth, so I used a pink Chanel gloss on her lips. It's a great less-is-more look that can work for lots of women, and I think it helps lend a youthful glow, too. The white wig Frank chose completed the look—what an angel, my Shannen.

lisa pliner

AS A FASHION DESIGNER, LISA IS ALWAYS THINKING ABOUT THE FUTURE: WHAT'LL BE HOT AND FRESH THE NEXT SEASON, WHAT PEOPLE WILL WANT TO BE WEARING. WITH THAT IN MIND, I SET OUT TO TRANSFORM LISA INTO SOMETHING FROM THE FUTURE, SOMETHING BEYOND OUR WORLD.

As a busy working mom—she and her husband adopted adorable Starr from Kazakhstan in 2005—Lisa is already something of a **superwoman**.

Lisa is a stunningly successful shoe designer and a true artist. Her mother, a fashion designer, encouraged Lisa's interest in the arts. After studying fashion and fine art in Paris, Houston, and Siena, Italy, Lisa went to work for Gianni Versace—perhaps her most fortuitous move ever. Through her job with Versace, she met her future husband, Donald Pliner, a designer who enlisted Lisa as a creative collaborator in his Miami-based shoe line. He also, of course, counted her as his muse. I mean, just look at her!

A few years back, inspired and encouraged by her husband, Lisa launched her own collection of shoes. I've had the privilege of working with Lisa on a few of her print advertising campaigns, and though I'm not her target audience, I can honestly say the shoes are unbelievably gorgeous. It's no surprise she's got a ton of celebrity fans. As a fashion designer, Lisa is always thinking about the future: what'll be hot and fresh the next season, what people will want to be wearing. And Lisa is incredibly inventive, so she excels at this skill. With that in mind, I set out to transform Lisa into something from the future, something beyond our world. As a busy working mom—she and Donald adopted adorable Starr from Kazakhstan in 2005—Lisa is already something of a superwoman. I wanted to capture that side of her persona and make it visible to the world.

Frank transformed Lisa's long, blonde locks into a sleek bob, and then I went to work on her face. The first step was a dramatic cat eye, with a heavy-handed black liner applied to her top and bottom lash lines, as well as to the crease of her eyelids. I took the "wing" almost all the way to that line. Across her lids, I used a sparkly gold shadow and then finished the look with a coat of mascara. With such a dramatic upper eye, I didn't even need to worry about false eyelashes. I then blocked out, with concealer, the outer portion of her eyebrows, for even more edge. And the rest of her face I left neutral, aside from a swipe of frosty pink gloss to her lips. The results: otherworldly, don't you think?

8

the eyes have it

EVERYONE LOVES A SMOKY EYE—it's an easy way to completely transform and glam up your look, while calling attention to the facial feature that most women say is their favorite. Absolutely any face can rock a smoky eye. It's not just a simple way to take your face from day to night, but also a stellar way to make a killer first impression. And it's all-occasion, too; a smoky eye can make you look and feel like a super-model even when you're just running around in jeans and a T-shirt

the smokin' smoky eye

REMEMBER MY PHILOSOPHY: EYES OR LIPS—NEVER BOTH. When you go all out on the eyes, you want to keep the lips neutral; they shouldn't compete. For this smoky eye, I chose to use exclusively charcoals and blacks, with a bluish brown beneath the eye. That serves to soften the look, so you're not winding up with big, black raccoon eyes. It takes a bit of the edge off, and so even though the eyes are dramatic, the face looks soft.

Here, I also chose to enhance the brows. To do that, I shaded the brow line with a red-brown powder. When filling in brows, you want to match your pencil or powder shade to the highlights in your hair.

The model's lips were naturally quite red, but because I wanted to emphasize the eye, I chose to neutralize them with a nude gloss by Dior. Here's a tip for choosing the perfect nude lipstick: It should be a slight shade darker than your skin tone. Otherwise, your lips can look too white and chalky, almost dead.

On her cheeks, I used a blush in the same tonal range as her lip, but a bit deeper—a nude, fleshy pink, like a rose. And because she has great cheekbones, I only used a bit of highlighting powder, in a few shades lighter than her natural skin tone.

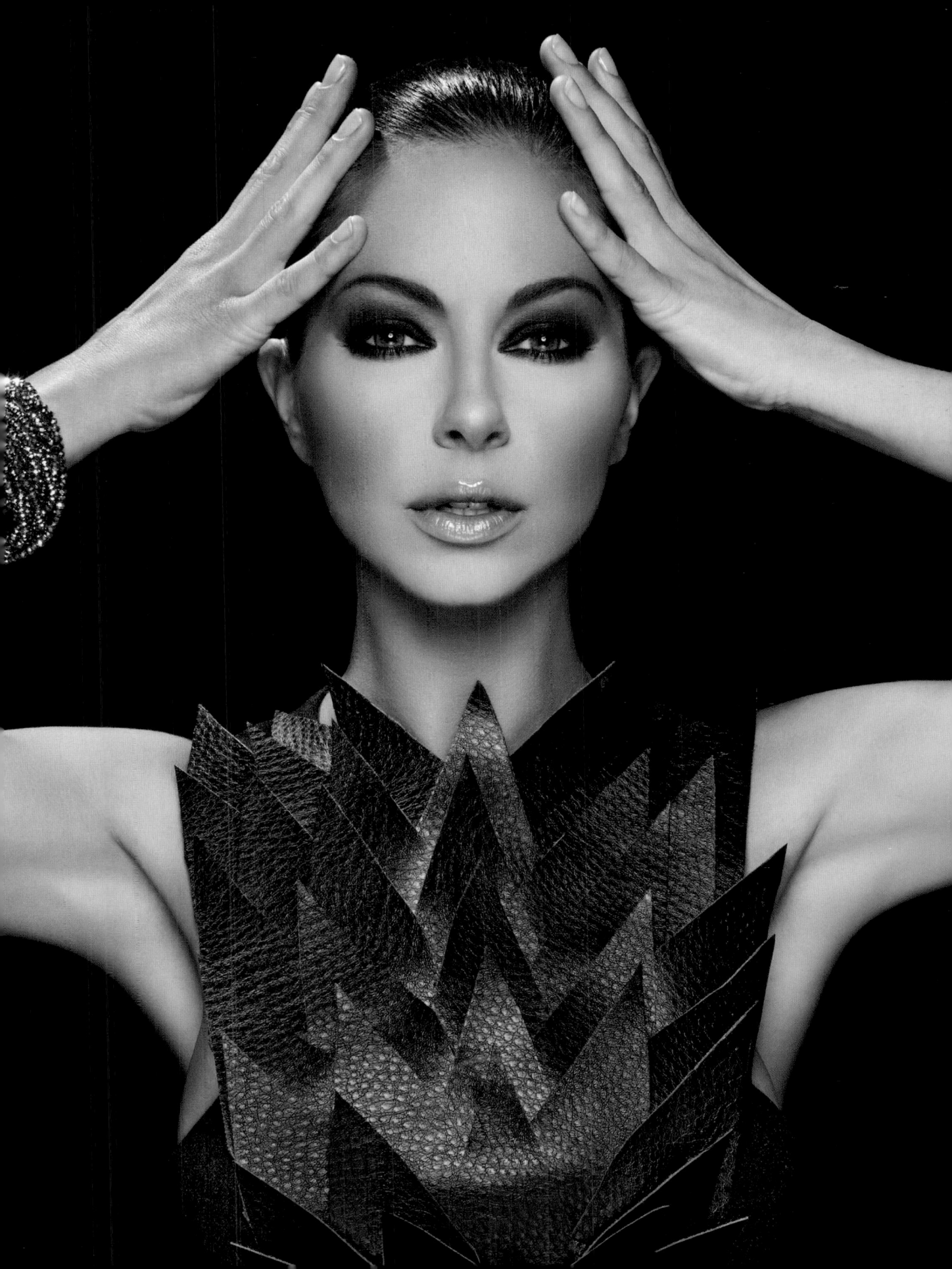

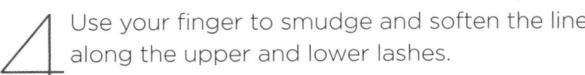

HOW TO: THE PERFECT SMOKY EYE

The great thing about the smoky eye is that it doesn't always have to be perfect. There's room for error. But watch out for some of the smoky eye pitfalls. Messy can be sexy, but it can also be a mess.

1 Choose a black pencil. I like Maybelline's Expert Eyes pencil in Velvet Black. It comes two to a pack and is, in my opinion, still the best pencil on the market. Before using, soften the tip by waving it through the flame of a cigarette lighter a few times. This will help the pencil go on easier and reduce the need to pull, which can create wrinkles. Let it cool before using (test it on your hand first).

2 Evaluate what your eye looks like. If your eye is round, you want to avoid putting too much darkness in the middle of the eye, beneath the pupil. Instead, darken the outside edges to elongate the eye and make it appear more almond shaped.

3 Rim the inside of the eye. Work the pencil in between the lashes, being sure to get the space just under the lid. (Not over the top, where you'll draw later, but right in between the lashes.) Don't be afraid to color back and forth a bit. This isn't like shaving; you don't have to feel like you can only move the pencil in one direction.

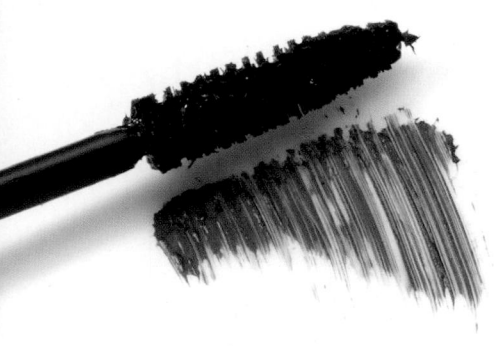

4 Use your finger to smudge and soften the line along the upper and lower lashes.

5 Don't let watery eyes ruin your work. To reduce tearing, inhale sharply through your nose a few times. It really works!

6 Don't go Goth. A smoky eye doesn't mean a black eye. Many women think that, on top of black eyeliner, you also need black eye shadow to do a smoky effect. But after using black eyeliner, I mostly rely on grays and browns. It gives you the smoky effect without being too heavy or intimidating.

7 To create depth, use a matte brown shadow on the lid, filling in up to the brow bone and beneath the eye.

8 Then bring in the black. When buying black eye shadow, you want to make sure you're getting one that's dense and covers really well. We've all bought those eye shadows that turn out to be more blue or purple once we get home. With a decently pointy brush (not too small), apply your shadow, starting right in at the crease of the eye and outlining the eyeball on top of the lid.

9 Once you get the shape, you can play with making the shading bigger and blacker and crazier, as far up to your brow bone as you wish. Leave the lid open or fill it with shadow: black, gold, glitter, or another color of your choice. Have fun with it.

TIP: Clean natural nails elongate the fingers.

TIP: Use a toothbrush or soft shoe brush to put the finishing touches on a slicked-back hairline.

PRODUCTS

> Maybelline Expert Eyes pencil in Velvet Black

> Dior Rouge lip color in Nude Blush

> Make Up For Ever Star Powder in black

> Bobbi Brown Foundation stick in Porcelain

> Georgio Armani Eyes to Kill mascara in Steel Black

FRANK ON HAIR

Instead of just slicking her hair back into a bun, I wanted to do something interesting. Like I always say: Get inspired by the old, but always make it fresh and new. First, I used a hard hold gel and dried the hair. If you slick back hair when it is wet, it can be very severe. Then I created a big roll in the back by pulling a ponytail halfway through a simple elastic. I finished the look with Oribe Original pomade and set it with Joico's JoiFix hairspray. I like to think that if Audrey Hepburn were alive today, this is how she'd wear her hair.

TIP: A good hair pomade is not too waxy, not too greasy. Put a little in between your palms and rub until your hands are completely covered. Then just wipe the hair. (It'll make your hands extra soft, too!)

the lash queen

I LOVE FAKE EYELASHES, and I use them all the time to make a woman's eyes appear bigger and, of course, bring some drama to a look!

This model reminded me very much of Diana Ross. She has huge, huge eyes that always seem to scream, "I'm awake!" But they're also her best feature, and I thought, let's just go all the way with it—in a way, accentuating the eyes with false lashes can minimize any bulbousness. I applied strip lashes to both her top and her bottom lashes. I also used some individual lashes for even more volume, applying them in different directions for a "starburst" effect and using extra in the outer corners to make her round eyes appear more elongated.

I finished the look with white eyeliner "winging" out from each corner of her eye. This gave her an almost futuristic look, while also serving to further elongate her eyes. African-American skin can handle a lot of color, so don't be afraid to use it—just be sure to limit it to one facial feature. The rest of her face I kept fairly neutral, though I applied a rosy blush high up on her cheeks almost to her lower lids to draw even more attention to her eyes.

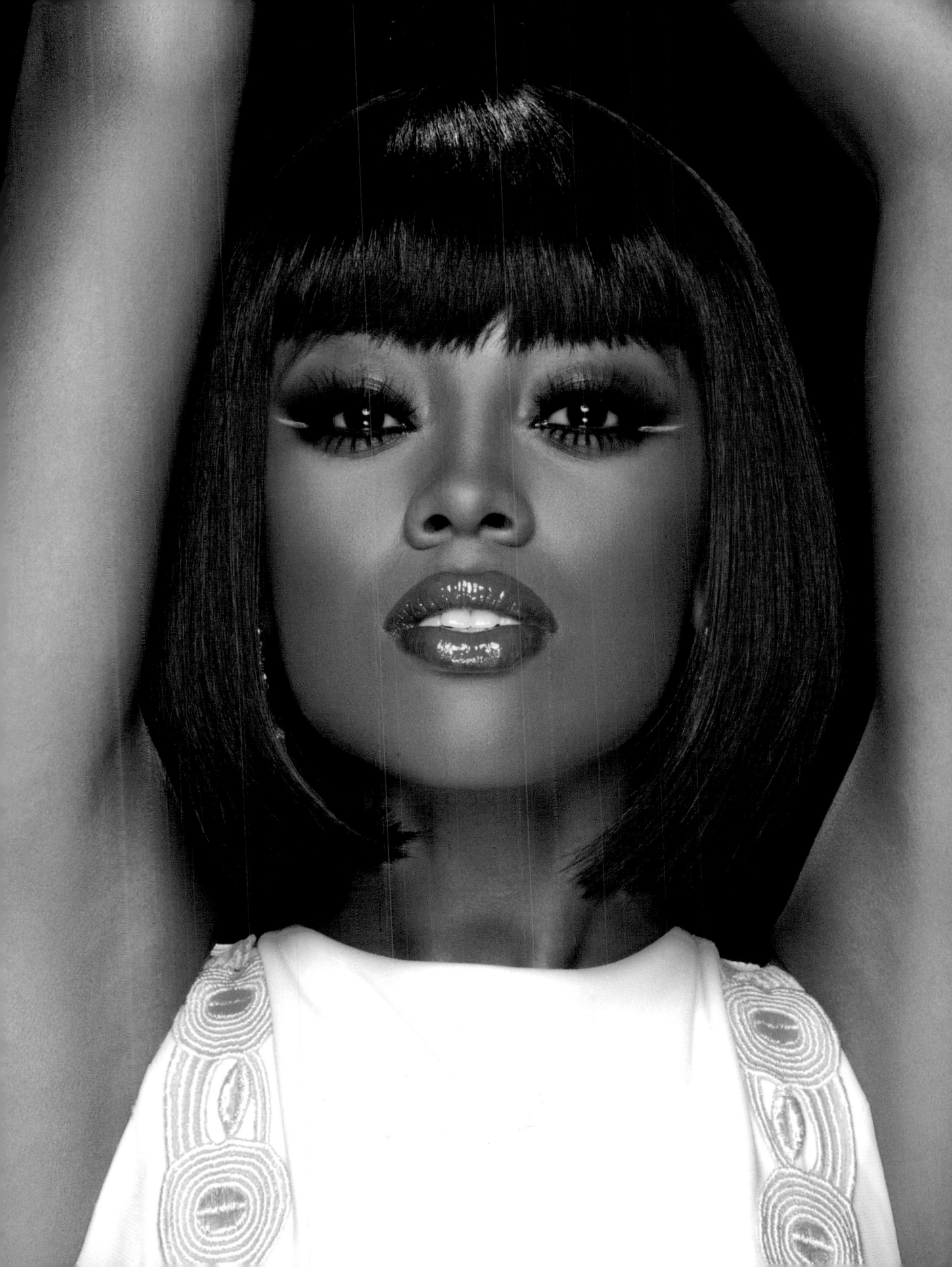

TIP: When filling in brows, match your pencil or powder to the lightest shade in your hair.

PRODUCTS

> Anastasia Beauty Express for Brows and Eyes

> Georgio Armani Eyes to Kill mascara in Steel Black

> Bobbi Brown Extra Repair Foundation in Chestnut

> Guerlain Terracotta bronzing powder in 04

> Chanel Levres Glossimer lip gloss in Coral Reef

FRANK ON HAIR

This cute little bob is a wig. Wigs are like contact lenses: You can use them to switch up your look. There are so many natural-looking wigs, and not all of them are super expensive. Hair and makeup should be fun. There are no hard and fast rules. The best part about a wig: Your hair will look great all night!

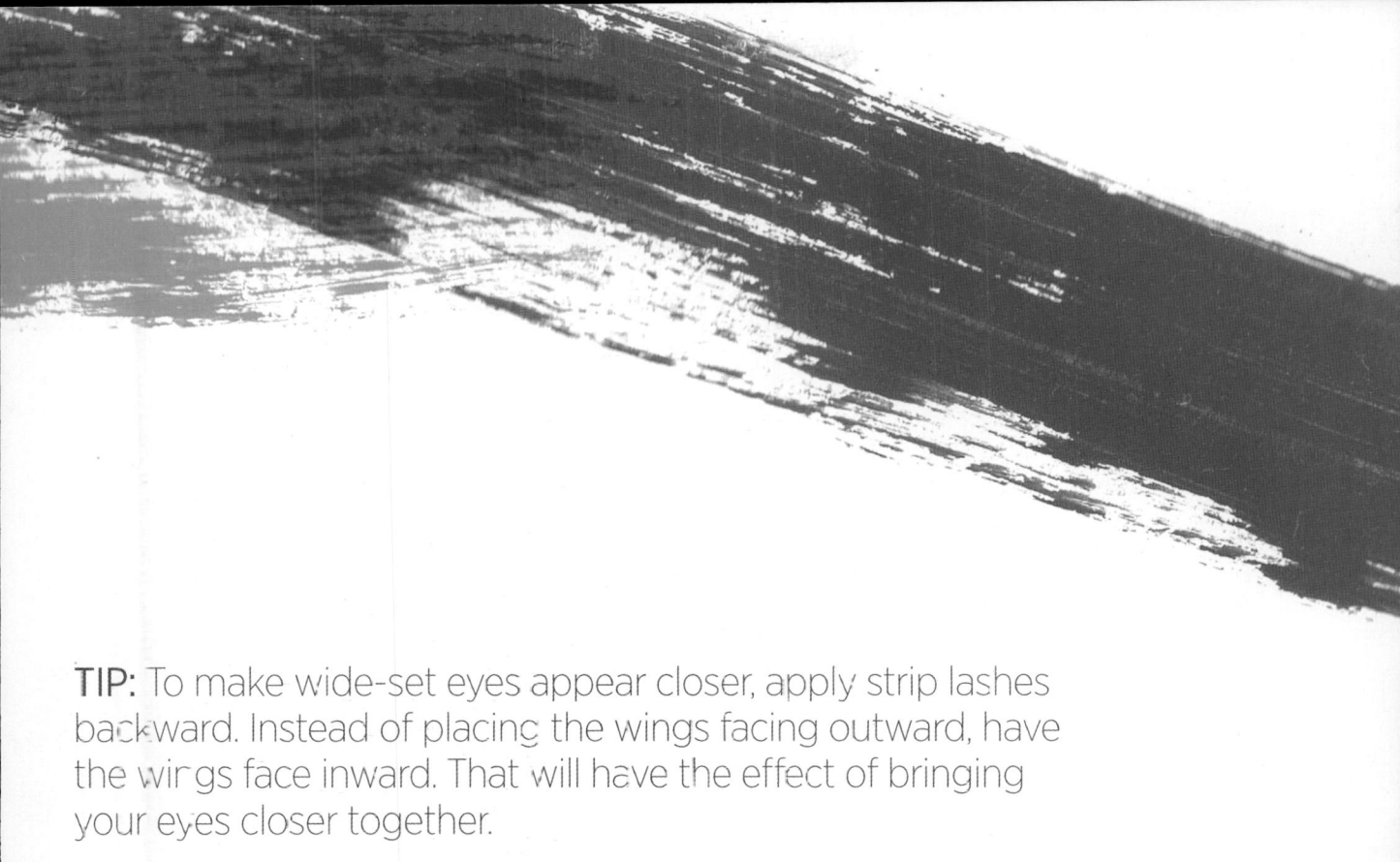

TIP: To make wide-set eyes appear closer, apply strip lashes backward. Instead of placing the wings facing outward, have the wings face inward. That will have the effect of bringing your eyes closer together.

What to Do with Round Eyes

When applying lashes, it's important to evaluate the shape of your eyes. If your eyes are very round, you want to avoid putting too much dark color—either with lashes or eyeliner—in the middle of the eye, beneath the pupil. Instead, focus color on the outside corners of the eye to make the shape appear more almond. Exaggerate the outer corners. Strive for symmetry. Not all of us were lucky enough to be born with it, so we need to create it ourselves.

trans-formations



kristin cavalleri

I HAD THE IDEA TO MAKE KRISTIN INTO A HARD-EDGED POP STAR, WHICH IS FAR FROM THE GIRL-NEXT-DOOR IMAGE—AND LOOK— SHE HAS THUS FAR PROJECTED. LET'S GIVE HER A KICK-ASS LOOK, I THOUGHT, AND ELEVATE HER PERSONA FROM SUPER-CUTE REALITY STAR TO AVANT-GARDE POP STAR.

dr. jessica wu

JESSICA IS ONE OF THE
HOTTEST DERMATOLOGISTS
IN THE COUNTRY. WHAT MOST
OF JESSICA'S PATIENTS DON'T
KNOW, HOWEVER, IS THAT SHE'S
AN ADVENTURE FIEND. FOR
HER TRANSFORMATION, I KNEW
INSTANTLY WHAT I WANTED TO
DO: TURN HER INTO HER TOUGH-
AS-NAILS ALTER EGO,

all-out glam

THIS MODEL IS A CLASSIC AMERICAN BEAUTY, with a fresh-faced girl-next-door vibe and beautiful blonde hair. But for her big night out look, I wanted to create a bit of drama. That meant giving her an all-over bronze glow, thanks to airbrushing and some Body Bling, and emphasizing one feature: her eyes. At the same time, I played down the rest of her face, keeping her cheeks and lips neutral and using color there only to balance out her smoky eyes. Because I wanted the focus to be right on those piercing blue eyes, I also used the airbrush to tone down her brows so that they blended in with the rest of her face.

Airbrushing can be a great technique to use for holiday and red-carpet looks. Sending light to the center of the face—which is what airbrushing does—can brighten evening looks and help you look your best in photos. A lot of makeup artists use airbrushing to cover the entire face, but I use it mainly for highlighting and contouring.

As with most red-carpet looks, though, the end result is made possible by this model's clear, undeniable confidence, which comes through even in a photo. She looks good, and she knows it. Feeling good about yourself: That's the most irresistible transformation of all.

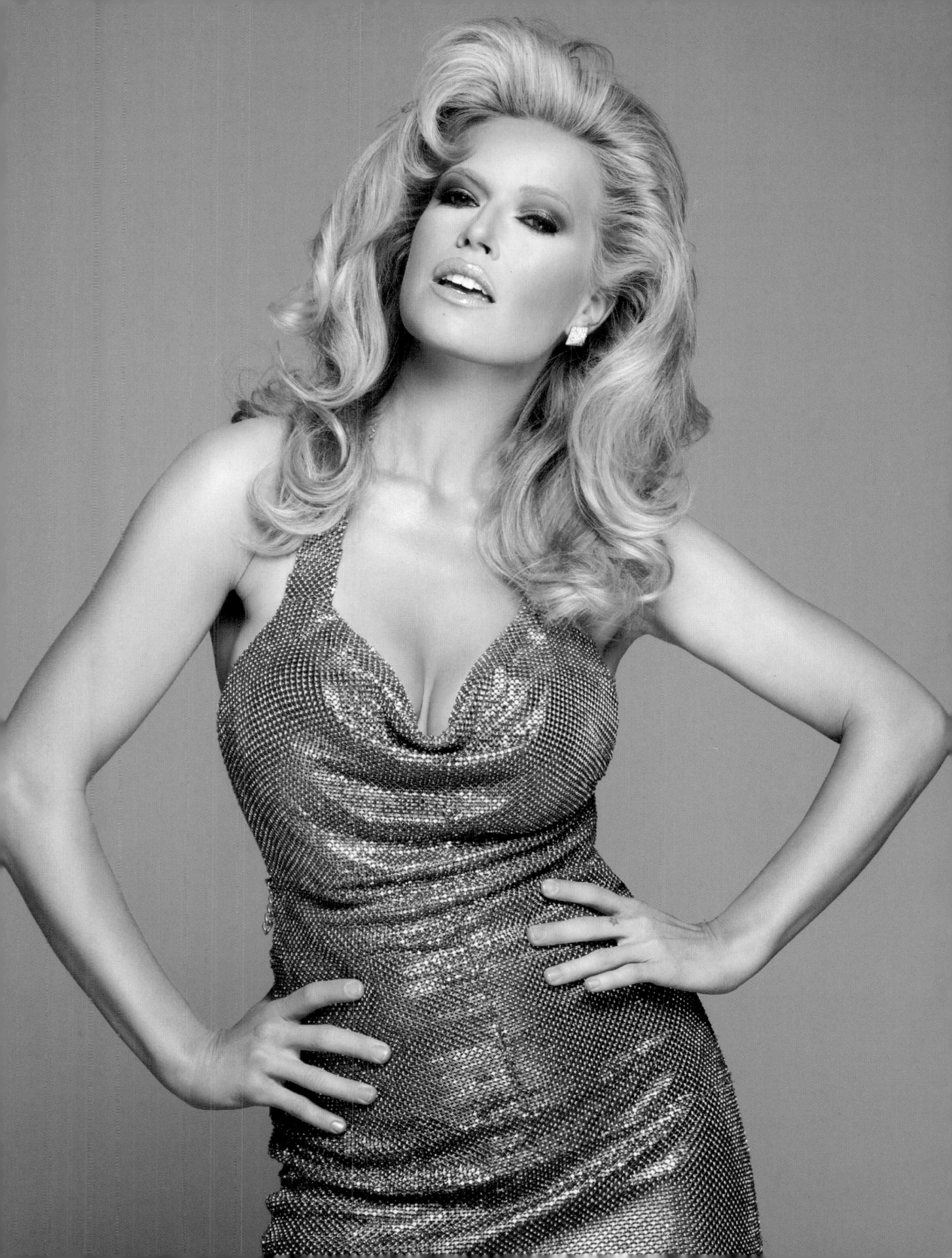

HOW TO: HIGHLIGHT AND CONTOUR USING AN AIRBRUSH

Airbrushing is an easy way to ensure natural-looking coverage. To start, work the airbrush around the perimeter of your face, covering a bit of the hairline. Then hit the spots you'd hit with the traditional highlighting and contouring techniques we learned earlier in the book: the tops of your cheeks, the center of your forehead, the bridge and tip of your nose, and your chin. In this model's case, I also used the airbrush to tone down her brows, skimming the brush over the hairs of her brows and rubbing in a bit with the tips of my fingers. Keep the airbrush at least 6 inches (15 cm) away from the face; too close and you'll get too much concentration of color.

Using a blush brush, apply blush to the apples of your cheeks in a circular motion. This will also help blend any excess foundation from the airbrush.

Using a highlighter brush, apply powder or cream highlighter to the same places you hit with the airbrush, as well as the brow bones and the inner corners of your eyes. I like a gold highlighter for most skin tones. Then apply the rest of your makeup as you normally would.

TIP: Airbrushing can be a great, simple technique to highlight and contour the face.

PRODUCTS

> DiorSkin AirFlash spray foundation in Cameo

> Guerlain Terracotta bronzing powder in 02

> Dior 3 Couleurs Smoky Ready-to-Wear Smoky Eyes Palette in Smoky Black

> M A C. Cremesheen lip glass in Boy Bait

> Nars blush in Orgasm

FRANK ON HAIR

To create this model's big, full hair, I used Oribe Volumista and then set her damp hair in classic rollers and let it air-dry for about half an hour. Then I dried her hair with the rollers in, removed them, and teased the top of the hair for added volume. I set the look with Joico's JoiFix spray.

TIP: When airbrushing, keep the airbrush at least 6 inches (15 cm) away from the face; too close and you'll get too much concentration of color.

TIP: Classic polish-free nails complement any look.

creating the look:

effortless siren

NOT ALL RED-CARPET OR EVENING LOOKS REQUIRE PILES OF MAKEUP in order to stun. In fact, some of the sexiest evening makeup is really minimal. This minimalist approach tends to work best on women with darker skin and hair. These women often have already striking features that need little enhancement. Piling dark makeup on someone with dark hair can be too much color; everything looks dark. And remember: Evening looks are about having fun.

For this model, I wanted to create a sultry look without a lot of effort. I wanted smoky, but I wanted a lightness, too. So I avoided blacks and relied instead on burgundies, browns, tans, and taupes. These are all good shades to use to accentuate the features of a brown-eyed girl without turning her Goth. After perfecting the base with highlighting and contouring, I applied a taupe shadow to her lids, using a darker brown shadow in the crease. I gave her a quick swipe of black mascara—only a coat—but left off the false lashes (too much). Her cheeks got that fresh, flushed look from a burgundy-toned blush and a luminizing powder applied to the apples of her cheeks, to help brighten her skin for photos. And her lips are nearly bare. In fact, I toned down the natural redness of her lips using a base of cream foundation and then applied a neutral, taupe lipstick.

Ultimately, this is a great day-to-evening makeup look. In the end, her glamour comes from her outfit, her hair—which Frank discusses on page 201—and her posture, because being red-carpet ready isn't only about your face. It's also about how you carry your whole body.

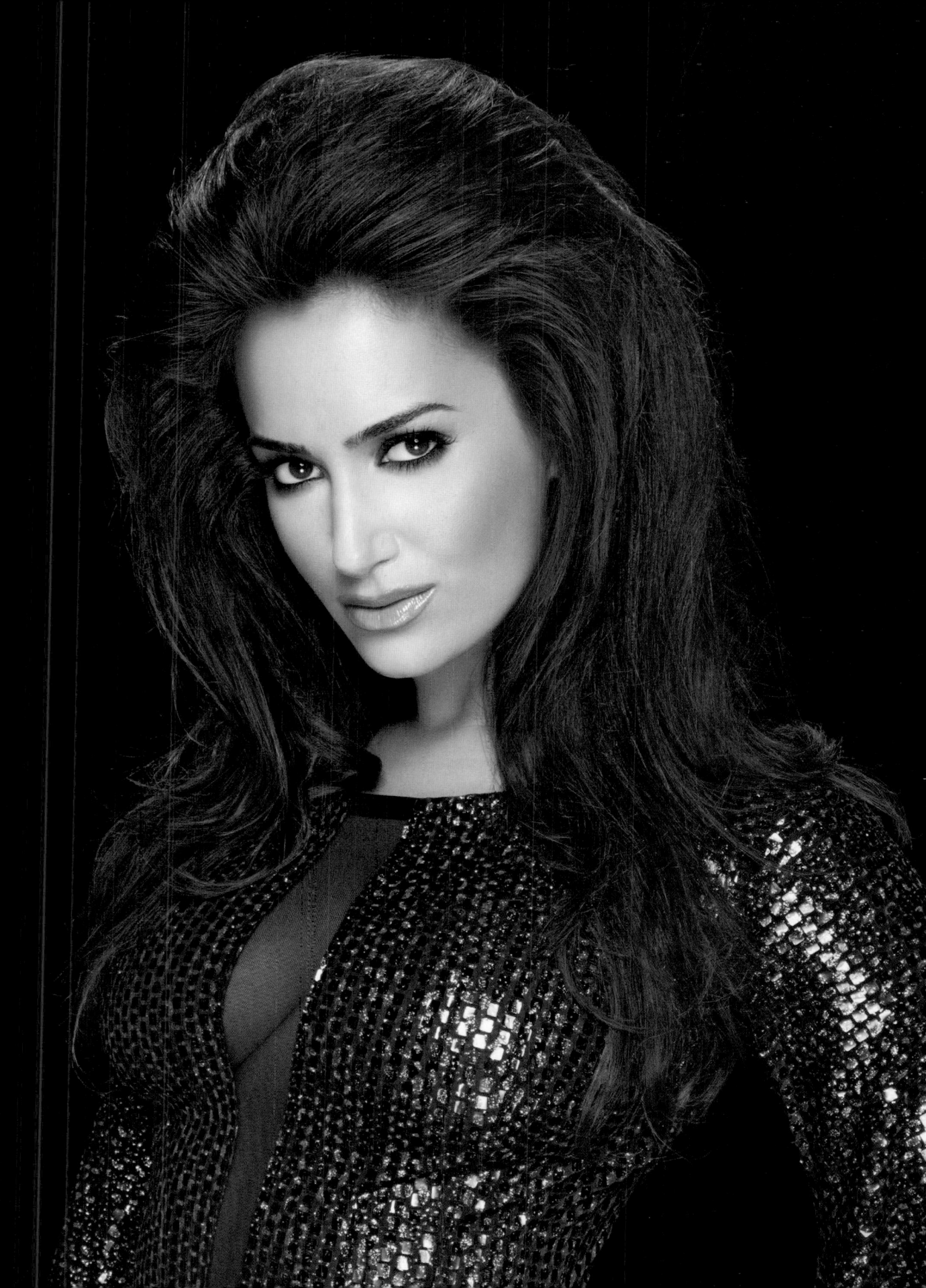

HOW TO: LOOK GOOD IN PHOTOS

In our shutter-happy times, there's no escaping the camera at most weddings and evening events (not to mention the pictures inevitably posted online the next day). Contrary to popular opinion, though, anyone can learn to be photogenic, even without the help of Photoshop. It's all about learning which angles, poses, and facial expressions work best for you. Here are some easy-to-remember tips:

1 Smile with your eyes. Okay, you've heard this one before, but what does it mean? Even if you're not grinning ear to ear in a photo—or showing teeth at all—it's important to really try to let your eyes speak. Think about making them smile, even. In the end, what you do with your eyes is more important than what you do with your mouth.

2 Chin up. Even if you don't have a double chin, angling your head forward to give a shy smile can create the appearance of one in photos. For best results, keep your chin and nose parallel with the ground.

3 Perfect your angle. Slightly turning to the side, like this model, creates dimension on your face, and makes you appear less "flat." Aim for a 30-degree tilt in either direction (try it in front of a mirror first to determine which side is your better one) and consider placing a hand on your hip, which can make you appear slimmer.

4 Mind your legs. You're a lady, so why don't you stand like one? Too often I see women photographed standing around, legs spread, like football players. Take a cue from the stars in *Us Weekly* and choose one of two always flattering poses: standing with your legs crossed at the knee or standing with one knee bent and your hip cocked.

5 Keep your back straight and your shoulders down. This one's important: With your arms either on your hips or at your side, stand up straight with your shoulders back and down.

6 Reapply gloss. A dab of fresh lip gloss before a photo can help brighten your entire face.

TIP: Being red-carpet ready isn't only about your face; it's also about how you carry your whole body.

PRODUCTS

> Bobbi Brown Foundation stick in Warm Natura

> Maybelline Expert Eyes pencil in velvet black

> Nars eye shadow in Mekong

> Dior DiorShow mascara in black

> Anastasia Brow Wiz in Brunette

FRANK ON HAIR

I love giving a woman big hair. Here is an example of taking a good daytime face and using hair to make it come alive. Because the neckline of this model's dress was relatively high, I chose to keep her hair hanging down to make the look a little looser and sexier. To do this, I used a Design Collection texture spray by Joico on her wet hair and then blew it dry, focusing the heat on the roots. A good hairdryer is the T3 Featherweight Professional. Once the hair was dry, I used a comb to tease the top and sides to create volume and then smoothed over the tease by gently combing it out. I took a bit of Oribe Original pomade and ran my fingers through the ends of her hair to create some separation and then set the look with Joico's JoiFix spray.

TIP: Burgundies, browns, tans, and taupes are all good shades to use to accentuate the features of a brown-eyed girl.

Cosmetic Dermatology

A lot of clients come to see me and ask whether they should start getting Botox or other injectables, wondering when is too soon and when might be too late. At the same time, especially here in L.A., I see many women who, in my opinion, overdo it on the fillers. Their lips are unnaturally huge, and their cheekbones are completely plastic. Although beauty is a matter of personal preference—and how you look is certainly your business and no one else's—I also know that enhancing your look can be a little bit addictive. So I thought I'd ask Dr. Jessica Wu for a few words of advice on knowing when to start and—maybe more important—when to stop.

Dr. Jessica Wu Says ...

You should start thinking about prevention in your twenties. That's when many of my patients come to see me. That doesn't mean you should start getting work done at that time. In your twenties, you may still be breaking out or have issues with damaged capillaries or other problems stemming from sun damage or caused by smoking, allergies, or certain foods. Your dermatologist can help you minimize those issues with a topical cream or serum, while also talking to you about how to prevent further damage. For my patients in their twenties, I mostly talk about addressing hormonal breakouts by examining their diet. You may be able to manage, or completely avoid, flare-ups by avoiding what I call the "white devils"—milk, flour, white bread, pasta, and sugar. Give it two weeks, and I guarantee you'll see a tremendous difference.

You may also want to talk to your doctor about whether it's a good time to start using fillers. These days, people are much more aware of prevention, starting with some light Botox or Juvéderm in their twenties and thirties to address creases in the forehead or crow's-feet, rather than waiting until they're fifty to get a face lift. Many younger women are seeing signs of aging due to tanning, or they see how their mothers and grandmothers are aging. I have patients who come in and say, "I don't want to look like my mom or my grandma. What can I do now?" Of course, there's a limit. Every day I turn people away who want bigger lips or eyebrows that go up unnaturally high or who are simply too young to start altering their face.

So how to know? I tell patients that if you're not sure, ask your mother or a trusted friend or sister. Who will be honest with you? This is especially crucial if you're not sure that your doctor is on the same wavelength as you. There are some dermatologists, for example, who feel that a more dramatic look is attractive. You may not agree with that.

trans-formations

paris hilton

I DECIDED TO TAKE PARIS BACK IN TIME, WITHOUT SLOWING HER DOWN ANY. SHE CAME IN AS A 2012 PARTY GIRL, AND I TRANSFORMED HER INTO A 1970S PARTY GIRL (YOU CAN TAKE THE GIRL OUT OF THE PARTY, I FIGURED, BUT YOU CAN'T TAKE THE PARTY OUT OF THE GIRL). I WONDERED: HOW WOULD PARIS EN ROUTE TO STUDIO 54 IN THE 1970S LOOK?

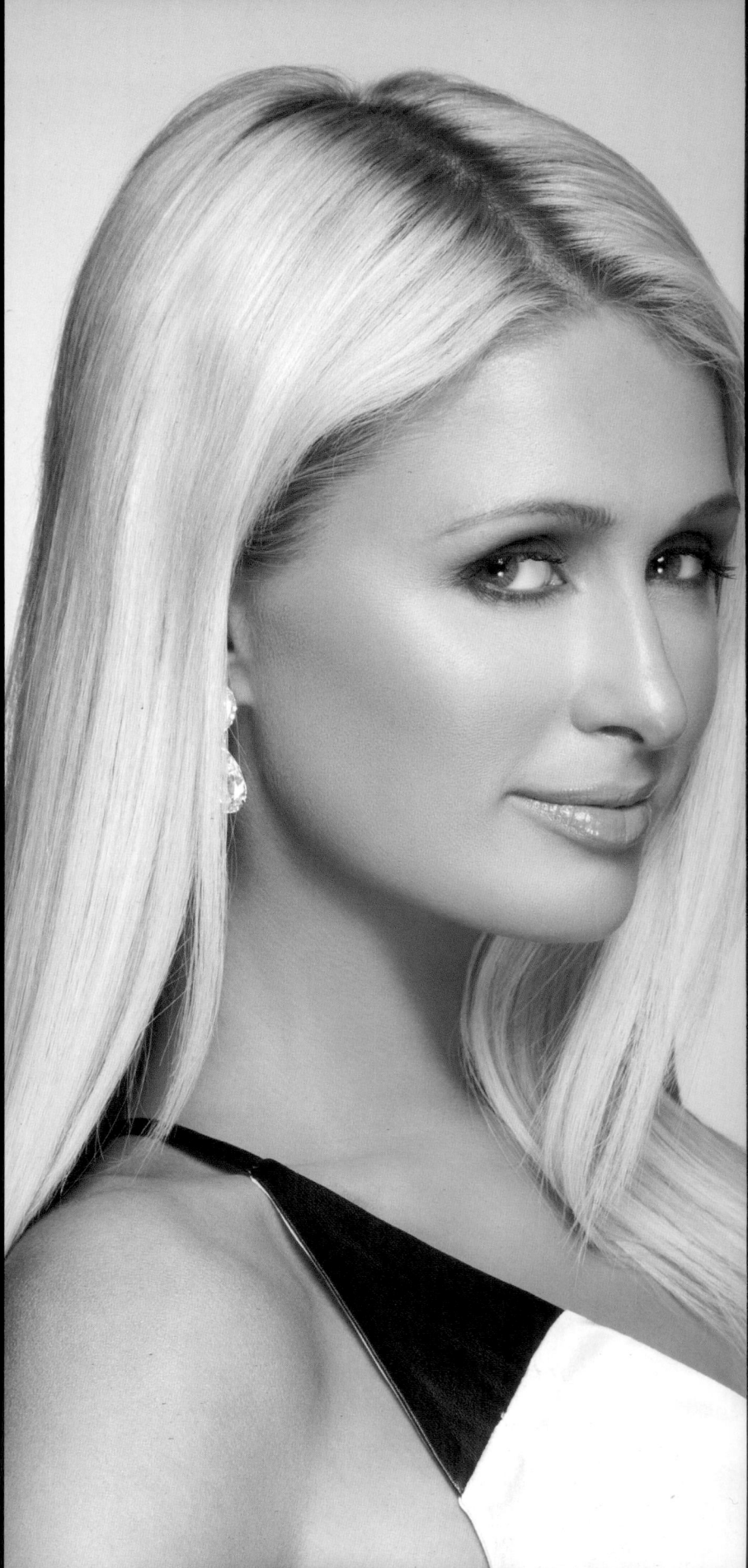

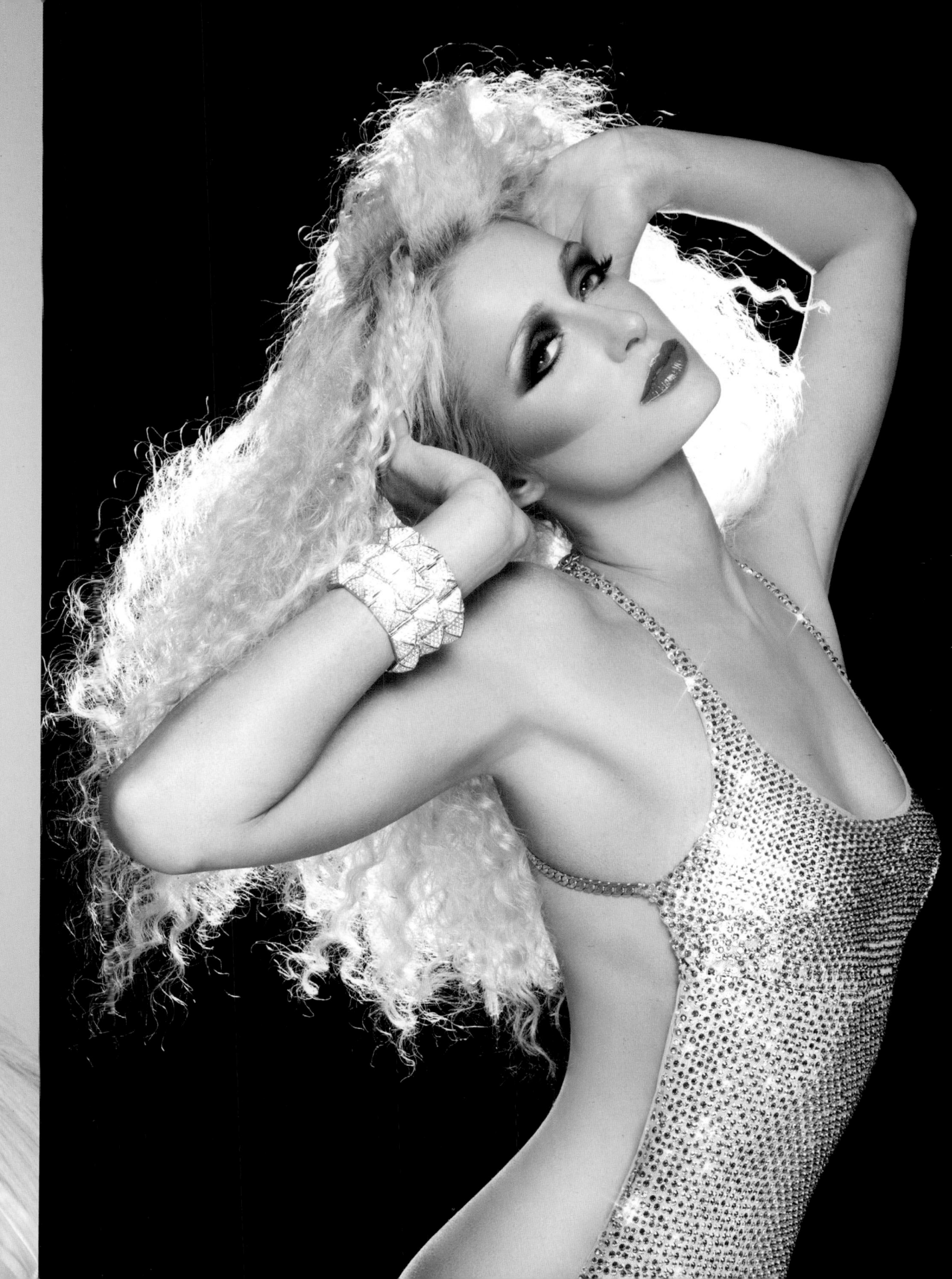

Like the modern-day Paris, her **'70s** alter ego does it all.

I met Paris years ago, way before I moved to Hollywood. Everyone knows Paris, it seems. She's nonstop, that one: the quintessential woman-on-the-go and unpredictable, always.

Of course Paris first became famous the way many girls in Hollywood do these days: from a sex tape. (A note to aspiring starlets: I do not necessarily endorse this approach!) But Paris has gone on to make a career out of being a real-life L.A. doll. Although she is the heiress to the Hilton hotel empire, Paris doesn't just sit around or waste time partying. She's a businesswoman and super creative—with a clothing line called Honey Bunches and an eponymous fragrance—as well as an ever-popular international reality star, model, actress, and published writer. Phew!

I decided to take Paris back in time, without slowing her down any. She came in as a 2012 party girl, and I transformed her into a 1970s party girl (you can take the girl out of the party I figured, but you can't take the party out of the girl). I wondered: How would Paris en route to Studio 54 in the 1970s look? And then I went to work. The result is perhaps the one instance where you don't see me choosing between the eyes and the lips and the cheeks. Like the modern-day Paris, her '70s alter ego does it all, and does it BIG. I used strip lashes and a hot pink blush by Make Up For Ever to play up the eyes; I used the same blush on her cheeks in a far-from-subtle primal streak. Her lips were just as bright, in a matte poppy hue also by Make Up For Ever. This is a full-on exaggerated version of the fun-loving Paris Hilton we know today. Just goes to show you: Girls can *always* have a little more fun.

daniella osuoba

GROWING UP, DANIELLA WAS OFTEN TOLD THAT SHE WAS A DEAD RINGER FOR BIANCA JAGGER. AT FIRST I DIDN'T SEE IT, BUT THEN WE STARTED TAKING PHOTOS OF DANIELLA AND—WOW. THERE IT WAS! SO I DECIDED TO TRANSFORM HER INTO BIANCA, ALL THE WAY.

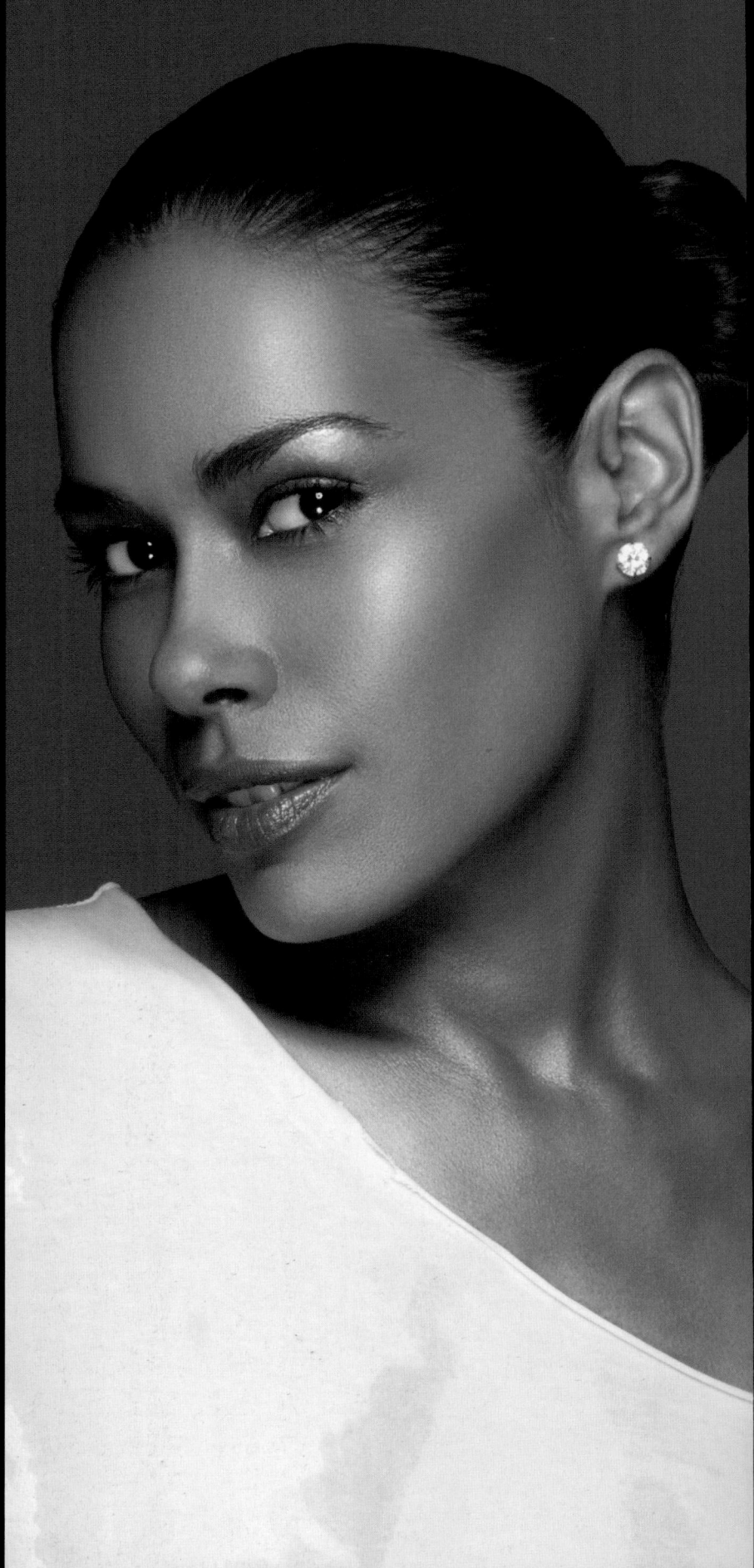

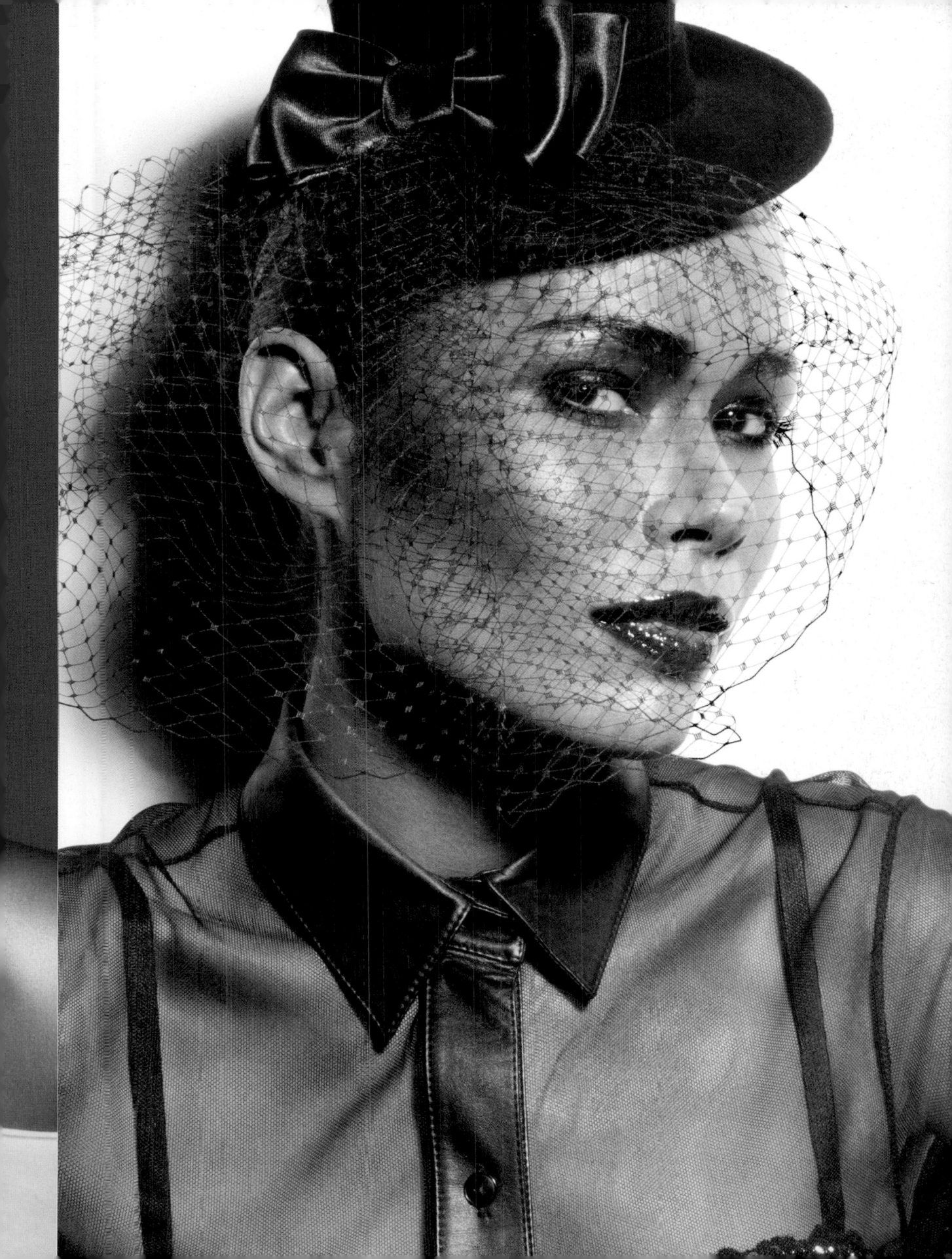

The first time we met, I was struck by Daniella's exotic beauty. I couldn't put my finger on what it was about her that I found so **intriguing**.

Daniella is a busy working TV and film actress, with roles in shows like *Friday Night Lights, One Tree Hill*, and *My Generation* and films like *The Hills Have Eyes*, *The Collector*, and the horror flick *Re-Kill*. She started out as a Ford model in New York City and became a spokesmodel for Cover Girl, then moved to Hollywood to pursue an acting career. The first time we met, I was struck by Daniella's exotic beauty. I couldn't put my finger on what it was about her that I found so intriguing. Eventually, I realized that it was the fact that I was trying, and failing, to identify what her background was—where she was from. We have that thing, still, where we have to be able to label a person. Are you white? Black? Latina? Asian? Except that it's getting so much harder to do. These days, most of us are a mix of two or more ethnicities. I think people with a variety of heritages are the most interesting to look at. And that's what it was: Daniella told me that she's Latina and Asian—her mother is Puerto Rican and her father is Peruvian-Japanese. In any case, it's a combination that works for her!

Daniella told me that one of her idols is Bianca Jagger, who was, of course, an amazingly powerful fashion icon (in addition to being Mick Jagger's wife for a time). Bianca was a fashion icon in the '70s and early '80s, during which time she was also an active girl-about-town, often seen out clubbing with her close friend Andy Warhol. For her birthday one year, she rode into Studio 54 on a white horse. She was a firecracker. She was also, like Daniella, Latina, having been born in Nicaragua.

Growing up, Daniella was often told that she was a dead ringer for Bianca Jagger. At first I didn't see it, but then we started taking photos of Daniella and—wow. There it was! She and Bianca share a similar jawline and mouth, and at certain angles Daniella really did look identical to a young Bianca. So I decided to transform her into Bianca, all the way. I applied the makeup for this look with the idea of shooting in black and white, like Bianca would have been photographed back in the '70s. I focused in on the lips, making them stand out in a deep burgundy red and used exaggerated, heavy blush in a mauve tone, with highlighting on the apples of her cheeks. On her eyes, I applied strip lashes to both the top and the bottom and deepened her already dramatic brows. The result is an all-over, attention-grabbing, old Hollywood look. With this face, you wouldn't even need a white horse to have all eyes on you. It's a look that's impossible to ignore.

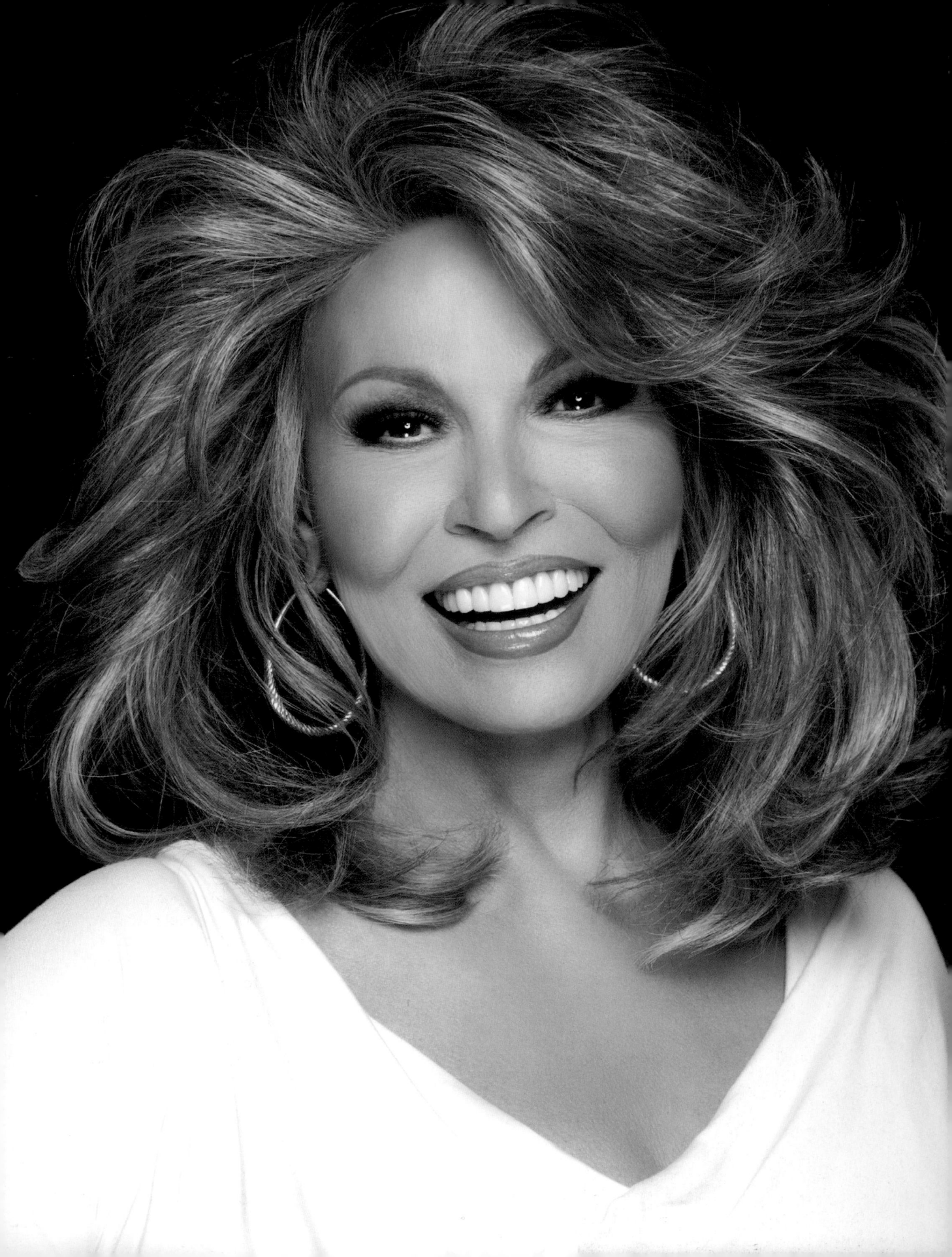

raquel welch

RAQUEL IS AN UNAPOLOGETIC MOVIE STAR. SHE IS NOT EVERY WOMAN—SHE'S FREAKING RAQUEL WELCH. SHE EMBRACES WHO SHE IS, WHAT SHE IS, AND GIVES IT ALL TO YOU.

It's not an exaggeration to say that I got into beauty because of Raquel Welch. End of story. I first remember seeing Raquel in her seminal film *Myra Breckinridge*. Of course, it was one of her most controversial movies—she played a post-op transsexual—but that's what was so amazing about it, and her. It was awkward, and uncomfortable, and not at all glamorous—pretty much all the things that Raquel is not—and yet she rocked it, and was no less beautiful for it. In fact, she was more beautiful. I have admired and respected (and, okay, have been a little obsessed with) her ever since, and much of my work with developing the monochromatic palette made famous by J. Lo was inspired by Raquel's looks in films like *Myra Breckinridge* and *One Million Years B.C.*, wearing that furry little bikini of hers. That's why in my first makeup collection I named a neutral shade of lipstick after her. "Raquel" became one of my best-sellers.

Forty years later, Raquel is still that same brazen, self-possessed, insanely gorgeous woman. And busy, too—no quiet retirement for this lady. She's got a crazy-successful wig line and makes regular television guest appearances. Recently, the guys at *Men's Health* named her the second hottest woman of all time. When I finally got the opportunity to work with my beauty icon, I was not disappointed. I just love being around her. To me, she's the epitome of a star. Everything around her lights up. She walks into a space and people go silent; she instantly commands the room, whether it's a dumpy studio or the red carpet. You're just like—wow. And she tickles me. When I'm around her, I'm giddy, like that first moment I ever laid eyes on her. At a time when celebrities try hard to be "just like everyone else," Raquel is an unapologetic movie star. She is not every woman—she's freaking Raquel Welch. She embraces who she is, what she is, and gives it all to you.

And so for this book, I chose not to transform Raquel. Why would I? To mess with Raquel Welch would just be silly. Her beauty has suited every single generation she's been a part of. We should all be so lucky.

RAQUEL SAYS ...

I had wanted to work with Scott for a really long time. Because of my interest in the beauty and fashion worlds, I keep a very short list of photographers and makeup artists I want to work with, and Scott is on that list. For a while, our schedules didn't match up, but once we found a time to work together we really hit it off. I found him to be very charismatic (and that was even before I found out he'd named a lipstick after me!).

Though I know a lot about makeup, Scott taught me quite a bit. I can't say I was surprised; he is, after all, one of the world's top makeup artists. But I'd never known about using brushes to apply foundation and concealer, which to me was rather innovative and gave a flawless finish that was exciting to see. He also introduced me to a lot of different shades I previously hadn't thought to use, like burnt gold and mahogany. He has an exceptional eye for color.

Having been in Hollywood for some time, I've seen first hand how beauty can come full circle. There's always a phase where women want to look "natural," or like they have no makeup on. Right now, though, the glamour girl rules, to different degrees, which is not unlike how I remember it being in the '60s and '70s. That can mean full-on glam, with the long hair and the smoky cat eyes and the pale mouth—as seen in girls whose beauty I can relate to like Sofia Vergara and Mila Kunis. Or glamour can mean a subtler look

that's sexy and dramatic in its own right, like you see with Charlize Theron, Jessica Alba, and Gwyneth Paltrow. But either way, we're having a moment where girls like to look pretty, and I'm glad.

I think it's essential for every woman to develop a personal style and stick with it, for the most part. You uncover a basic look that works for you and calibrate it from there. Every so often, there may be some slight change or nuance that defines the season, whether it's a softer eye or more dramatic lip, maybe some bronzer or a new blush. You might then choose to find a different way of being sexy, but you always stay true to yourself. Over the course of my career, I've varied in my look for different roles: For example, my hair went quite short like a Grecian boy for about ten years or so. I had cut it for the Broadway musical, *Woman of the Year* . . . and then I liked it! I think changes are good, as long as you make them your own.

I think it's essential for a woman to develop a **personal** style and stick with it. I did not vary wildly over the years.

—Raquel Welch

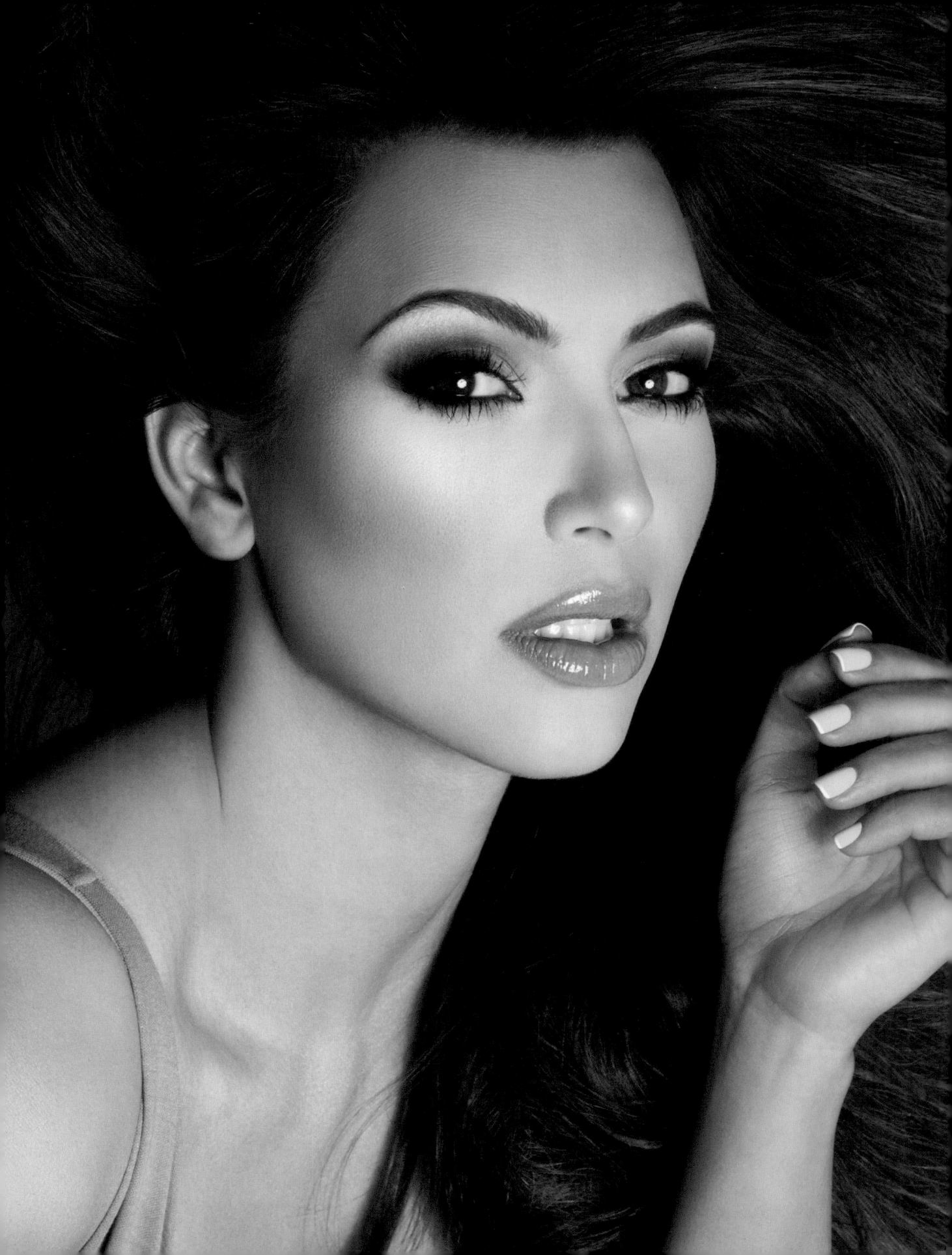

from scott

THE FIRST THING YOU NEED TO KNOW ABOUT KIM KARDASHIAN is that she works hard for this face. She really takes care of her skin and very religiously watches what she puts into and onto her body. She doesn't drink or smoke. She goes to church on Sundays. She works out every day, getting out of bed at 5 a.m. so that she can make it to the gym before starting her busy day. She's a good girl, and her healthy appearance rewards her for it. It's great to have fun once in a while, and I encourage that, but keep in mind that consistently overdoing it will show up in all sorts of ways. It's not the biggest party girls who end up looking like cover models at the end of the evening, or the next day, or even the day after that. Anyone who's ever drunk too much or gone too long without proper sleep or had too many days of junk food knows this. Overdo it for years, and time will catch up to you. Believe me.

Kim also appeared in my first book, and I said this then: Her face is freakishly symmetrical. It's what makes her so appealing to look at. That is why symmetry is something I strive to achieve when applying makeup to any face. Symmetry is pleasing to the eye; it makes you feel at ease and provides a sense of comfort. In all my years in this business, I've seen a lot of faces. And I've never seen a face as symmetrical as Kim's. Ask twenty people what they find so beautiful about Kim and chances are they can't pinpoint it. You just look at her and think, wow, she's pretty. Some people are born beautiful, and they're lucky. Others, though, like Kim, are also born symmetrical. And those women—well, they're blessed.

But all that's just superficial and doesn't even begin to describe who Kim is as a person. Sure, she's had sort of a roller-coaster year; with all that media attention, how can anyone not have a hard time once in a while? Put anyone under a microscope and you're bound to see flaws. But through it all, Kim has maintained such a positive attitude and an energetic spirit. She's one of the kindest, most selfless people I've ever known. She's been a good friend to me and to lots of others. She's a caring daughter, sister, and aunt. And that's not something you necessarily get to read about in the tabloids or see on the talk shows. Kim is a class act, an inspiration, a brilliant businesswoman, and someone I'm proud to call my friend. She's a beautiful person, in every sense of the word.

about the authors

SCOTT BARNES is a celebrated makeup artist and decades-long innovator within the beauty and cosmetics industry. He arrived in New York City in 1984 determined to fulfill his dream as a fine-arts painter. After attending New York's prestigious Parsons The New School for Design, Scott began assisting on fashion photography shoots and quickly became one of the most sought-after makeup artists in the business.

In 2000, Shu Uemura—the late Japanese makeup artist, international beauty guru, and founder of the cosmetics line that bears his name—selected Scott to revamp his Atelier Made line, which became a huge success within the fashion industry and among celebrities. Following Scott's success at Shu Uemura, he launched his own twenty-one-piece color cosmetics line, Scott Barnes Cosmetics, on QVC in April 2004. Five months later, Scott introduced 130 products at Holt Renfrew, in Canada, Saks Fifth Avenue, in the United States, and other high-end specialty boutiques in North America. A year later, the collection launched in Europe and Australia and became an overnight success, prompting *Women's Wear Daily* to name Scott the "Newcomer of the Year." He was also a finalist for Fashion Group International's "Rising Star" award.

Throughout his career, Scott has worked with world-renowned photographers, including Patrick Demarchelier, Francesco Scavullo, Gilles Bensimon, Tony Duran, Peter Lindbergh, Annie Leibovitz, Ruven Afanador, and Mark Seliger. His work has graced the covers of such leading magazines as *Allure, Elle, Harper's Bazaar, InStyle, Vanity Fair, Rolling Stone*, and *Marie Claire*; these and other magazines also regularly call on Scott for advice and to profile his work. Scott has also appeared on top national and regional television programs, including *The Oprah Winfrey Show, Extra, Access Hollywood*, and *Good Day LA*. In addition to numerous ad campaigns and music videos, Scott's work on set includes such films as *El Cantante*, which earned him an Oscar consideration. Scott was also responsible for Jennifer Lopez's memorable Cinderella moments in *Maid in Manhattan*.

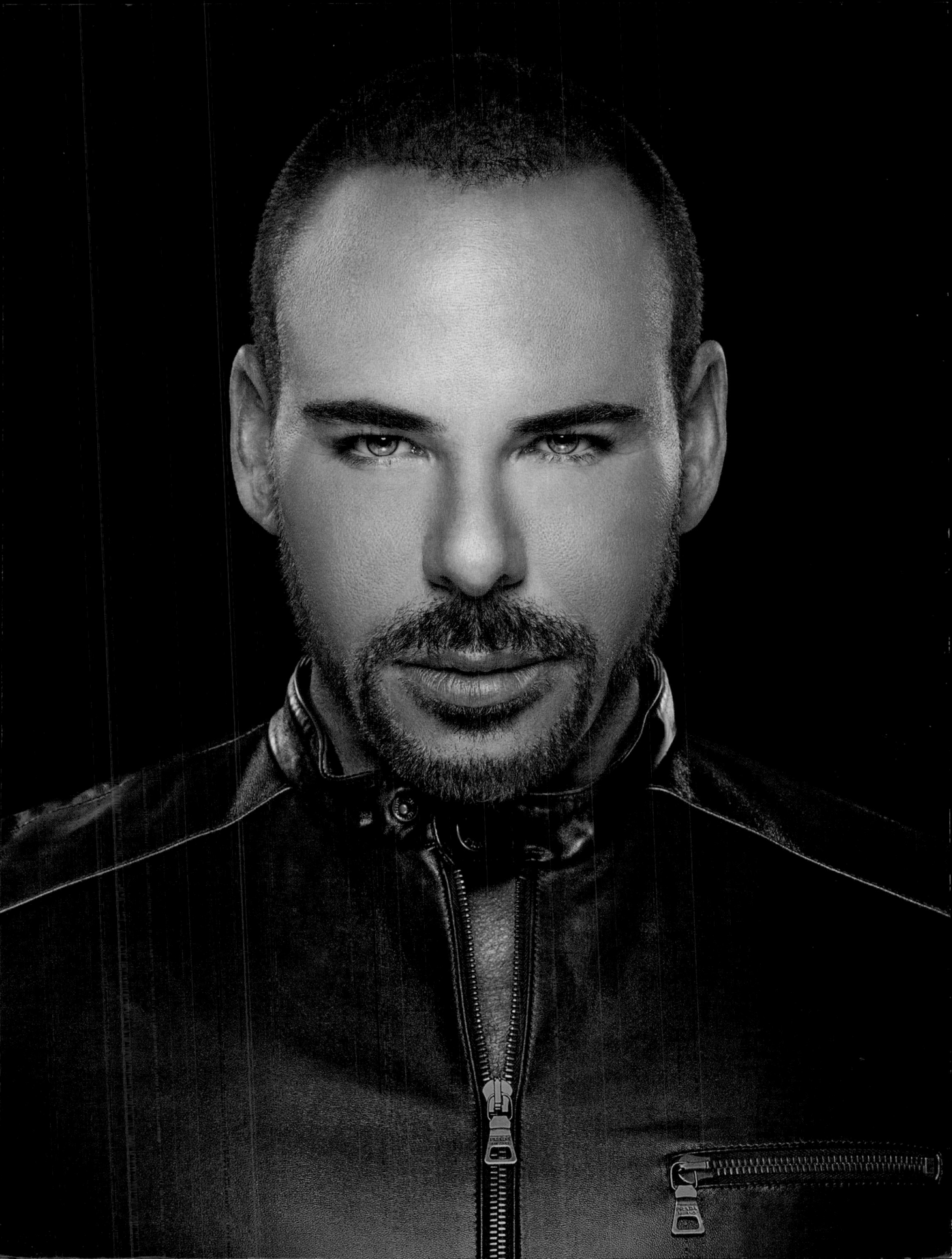

Although Scott has worked with a variety of Hollywood talent over the years, including Kate Hudson, Beyoncé, Gwyneth Paltrow, Angie Harmon, and Celine Dion, it was his work with Jennifer Lopez that inspired a veritable "monochromatic movement," popularizing a look of bronzed skin and pale lips. Described as "The Glow," this signature look became known as "lit from within" and helped launch Scott's Body Bling bronzer, which remains an international best seller years after its debut.

In 2011, Scott embarked on a new chapter in his life, relocating from New York to Los Angeles, where he quickly established himself as the go-to man for film studios, television networks, and celebrities. He has since been responsible for creating on-camera looks for Kelly Rowland, Christina Aguilera, Raquel Welch, Madeleine Stowe, and many others. This year, Scott will relaunch his eponymous makeup line, with updates to old favorites, a slate of new products based on years of research and development, and his enduring goal of making beauty accessible to all.

ALYSSA GIACOBBE grew up obsessed with fashion magazines and first began experimenting with makeup in the fifth grade with a 36-color eyeshadow palette and a preternaturally glamorous best friend.

She has been writing and editing for magazines since 1998, when she landed her first job gratefully fetching lattes and editing the horoscope and numerology pages as an assistant editor at *Elle*. She has since held staff editing positions at *Harper's Bazaar*, *In Touch Weekly*, *Teen Vogue*, and *Boston*, where she served as style director.

As a freelance writer, she now covers a range of topics that include fashion, beauty, and celebrity for magazines like *In Style*, *Lucky*, *New York*, *T: New York Times*, *Boston Globe Sunday Magazine*, and *Teen Vogue*. She has interviewed hundreds of celebrities, spent a good portion of her salary on clothes, and made herself a guinea pig for more than a few beauty experiments, writing this book included. She adheres to a single unwavering beauty rule: Never cut your own bangs.

acknowledg-ments

As always, I want to thank God for all the blessings in my life and for keeping me strong. What a year!

I would also like to thank the following people for all their many months of hard work and dedication. I could not have done any of this without each and every one of you. Thanks for sticking with me.

Fair Winds Press—and especially Will Kiester, Jennifer Grady, Kevin Mulroy, and John Gettings—for giving me another chance to share my work with the world. Jennifer Lopez for your many years of love and friendship—you will always be my first cover girl. Frank Galasso for your love and consistency. Thank you for pushing me out of the box and for everything you do. The extraordinarily talented Mike Ruiz: What a fun ride. I can't wait to do it again! Sammy and Judy, thanks for making me look so young and hip and cool. Toni Ferrara, I love your style! My models would be naked, or worse, without you. Tracey Sutter, my friend forever, thanks for being as excited about this book as I am. Alyssa Giacobbe, what can I say? (No, really, tell me what I can say). Thank you for putting it all into words.

To my dear friends and L.A. ambassadors Dr. Jessica Wu and Florin Toader, thanks for putting up with me for so long. Larry Schatz, you're like a second father to me; I can't imagine life without you. Madeline Leonard, Mardie Glen, and the entire Cloutier Remix family, I am grateful to have you on my side. Antonia Tremarchi and Kip Zachary, you keep me in line and on time! Lidia Latrowski, retoucher extraordinaire—thanks for your amazing work for the cover of About Face. And Custanera Digital for your excellent work on this one. Siren Studios, thanks for such a beautiful and inspiring workspace and Q Models—you've got the best girls in the business. Kim Kardashian, you're a beautiful cover girl; I love you, baby. Special thanks to Vanessa Williams for giving so much of yourself to me and to this project and to Raquel Welch, for being forever my inspiration. And of course to Madeleine Stowe, Candis Cayne, Paris Hilton, Erika Jayne, Ivana Milicevic, Jeffree Star, Xhoana Xheneti, Kathy Griffin, Brittny Gastineau, Lisa Gastineau, Shannen Doherty, Kristin Cavallari, Daniella Alonso, and Kelly Rowland—I love you, my sister!

Thank you to everyone else who assisted me on these shoots, including April Chaney, Enrico de Corti, Matthew Abraham, Nicole Marie Velasquez, Avo Yermagyan, Pavros Olivarez, Michael Nunez, and especially Debbie Adir. To Dior, Chanel, Nars, Make Up For Ever, Georgio Armani Beauty, Anastasia Eyebrows, Guerlain, Bobbi Brown, Lancome, Maybelline, Dr. Hauschka, La Mer, Oil of Olay, and all the other beauty brands I call on in this book . . . thank you for making my job easier.

And thanks to my entire family, especially my new friend Romeo and my dad and mom—you're my favorite people in the world, and I love you so much.